Jim Cogswell
Cosmogonic Tattoos

University of Michigan

Kelsey Museum of Archaeology
University of Michigan Museum of Art
Stamps School of Art & Design

2017

Lead support for Jim Cogswell–Cosmogonic Tattoos is provided by:
Penny W. Stamps School of Art & Design
University of Michigan Office of Research
University of Michigan Office of the Provost
University of Michigan Bicentennial Activities Fund
Kelsey Museum of Archaeology
Richard and Odette Maskell

UNIVERSITY OF MICHIGAN
BICENTENNIAL

Acknowledgments

- The joys and insights this project have brought me are a product of the network of human relationships through which it has been realized. I could never have done this alone. That would be neither humanly possible nor desirable. It is, after all, an exploration of humans constructing a world together.
- *Cosmogonic Tattoos* was initiated in memorable conversations with Terry Wilfong, who first encouraged me to propose a project for the Kelsey Museum of Archaeology and who has supported it through multiple stages of development; former Director of the Kelsey Christopher Ratté guided the project through its early years. I was constantly nourished by their studio visits and by stimulating dialogue with Catherine Brown, Karl Daubman, Laura De Becker, Elaine Gazda, Daniel Herwitz, Dawn Johnson, Diane Kirkpatrick, David Porter, Margaret Root, Ray Silverman, Carla Sinopoli, Laurie Talalay, Maryann Wilkinson, and Claire Zimmerman, and by exchanges with many others, particularly my fellows cohort at the U-M Institute for the Humanities. Alice Simsar's visits and her support for my work have buoyed me greatly over the years. My desire to do a project with the Kelsey was first prompted by reading Leonard Barkan's *Unearthing the Past: Archaeology and Aesthetics in the Making of Renaissance Culture*. I am grateful to Leonard for his friendship and support, and the intellectual challenges presented by his work.
- I extend my sincere thanks to the entire Kelsey Museum staff for their enthusiastic contributions to this project. I am indebted to Associate Director Dawn Johnson for her insightful leadership, keen eye, and firm hand on the rudder, and to Sebastián Encina, Julia Falkovitch-Khain, Michelle Fontenot, Paul Koob, Scott Meier, Sarah Mullersman, Cathy Person, Emily Pierattini, Carrie Roberts, Lorene Sterner, and Lisa Rozek.
- Former University of Michigan Museum of Art Director Joe Rosa made it possible for me to extend this project to include UMMA. The exchange of objects between UMMA and the Kelsey became the core of my design and the key to its content. As Interim Director at UMMA after Joe's departure, Kathryn Huss sustained the project with her unwavering support and good humor in the midst of a harrowing array of demands on her attention.
- At UMMA, I am especially thankful to Todd Berenz and Matthew Casadonte for their committed and adept installation assistance, and to Kristian Cho, Laura De Becker, Katharine Derosier, Dustin Dewitt, Roberta Gilboe, Bruce Glazier, David Lawrence, Pamela Reister, Ruth Slavin, and Nettie Tiso for their support. I appreciate the indulgence and good humor of the security staff at both museums during my lingering visits and long hours of installation.
- Teaching is learning, and never more so than when I turn to the skills and insights of students for my own artistic work. I relied upon Penny W. Stamps School of Art & Design undergraduate Victoria Essex (BA '18) for many essential tasks over the past two years, and Sam Bertin (BFA '18) before her. Victoria is responsible for designing the typeface found on the cover of this catalog, which is based on a Roman memorial tablet in the Kelsey collection. Jon Verney (MFA '16) had the brilliant idea that my ink paintings on mylar might be used as darkroom negatives. Acting on that hunch, I sought the advice of Sarah Posner (BA '17), who drew upon her darkroom expertise to print all of the photographs in the Kelsey exhibit. Emily Schumer (BFA '17) has been an essential member of the design process that resulted in this catalog. My sincere thanks to them all. I am deeply indebted to the
- U-M Institute for the Humanities for the Faculty Fellowship that made it possible to devote myself to realizing this project over the past year. Gary Krenz, Executive Director of the U-M Bicentennial, generously embraced it as part of the University's celebrations. Karl Longstreth graciously made the Clark Library's facilities available to us. And Mary Alice Bankert has provided support and encouragement throughout the process. I can hardly believe my good fortune that my sister-in-law and fellow artist Margaret Couch Cogswell volunteered three weeks of her time to help me with the Kelsey installation.
- Dean Guna Nadarajan has been a strong champion of our creative work as faculty members at the Stamps School of Art & Design. I cannot thank him enough for his encouragement, his funding support for this project from the School's Opportunity Fund, and his contributions to the realization of this catalog.
- The catalog is the result of the extraordinary efforts of my colleague at the Stamps School Franc Nunoo-Quarcoo, from whom I always learn so much. I am profoundly grateful to Franc, and to the essay contributors to this publication: Karl Daubmann, Daniel Herwitz, Ray Silverman, Terry Wilfong, MaryAnn Wilkinson, Claire Zimmerman, and our editor Lisa Bessette. Special thanks to Patrick Young and to David Turnley for their brilliant photography and to Levi Stroud for his video documentation.
- This project could not have become a reality without the creativity, skill, and persistence of Dave Michalak and the team at Imagecrafters, Inc., Vickie Peterson and Katlan Michalak, who fabricated all of my adhesive vinyl designs; our twelve years of work together have been a delight.
- Finally, I feel gratitude beyond measure to my father, James Cogswell, whose compassion for the displaced and the dispossessed taught me to search for deeper human meanings in the movements of peoples and things.
-

Jim Cogswell

This publication is presented in conjunction with the two-part exhibition *Cosmogonic Tattoos* at the University of Michigan, Ann Arbor.

University of Michigan Museum of Art
Installation:
April 22, 2017 – June 1, 2018
Exhibition:
April 22, 2017 – June 1, 2018
Kelsey Museum of Archaeology
Installation:
June 2, 2017– June 1, 2018
Exhibition:
June 2 – September 15, 2017

ISBN: 978-0-990-66237-2

Published by the University of Michigan
Ann Arbor, Michigan

Credits:
Editor
Lisa Bessette
Design
Franc Nunoo-Quarcoo
Emily Schumer
Photography
David Turnley–pp. 13, 34, 144
Patrick Young–pp. 6, 11, 14, 20, 26, 31, 54–57, 72–103, 122–143, 148
James Rotz–pp. 52–53
Levi Stroud–p. 148
Jim Cogswell–p. 34
UM Map Library–pp. 2–3
Printing
University Lithoprinters, Inc.
Ann Arbor, Michigan

Source artifact photos:
Kelsey Museum of Archaeology: 1, 3, 9, 10, 12, 14-16, 19, 20, 23-25, 27, 29, 37, 41-43, 46
Jim Cogswell: 2, 11, 13, 17, 18, 21, 22, 28, 30-36, 38-40, 44, 45, 47
University of Michigan Museum of Art: 4-8, 26

Colophon:
Paper
100lb. Mohawk Superfine White Smooth Cover
100lb. Endurance Silk Text
Typefaces
Century Expanded (Roman and Italic)
Futura (Roman Bold)

Introductions

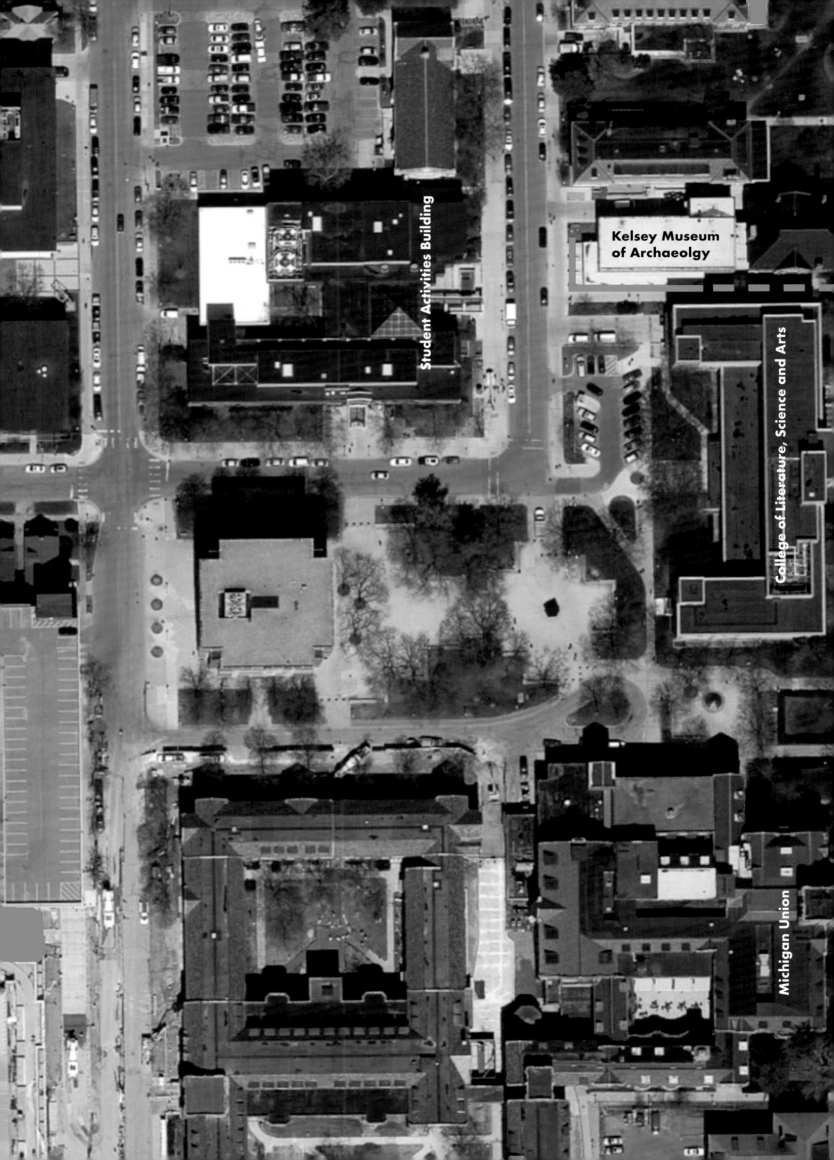

Student Activities Building

Kelsey Museum of Archaeolgy

College of Literature, Science and Arts

Michigan Union

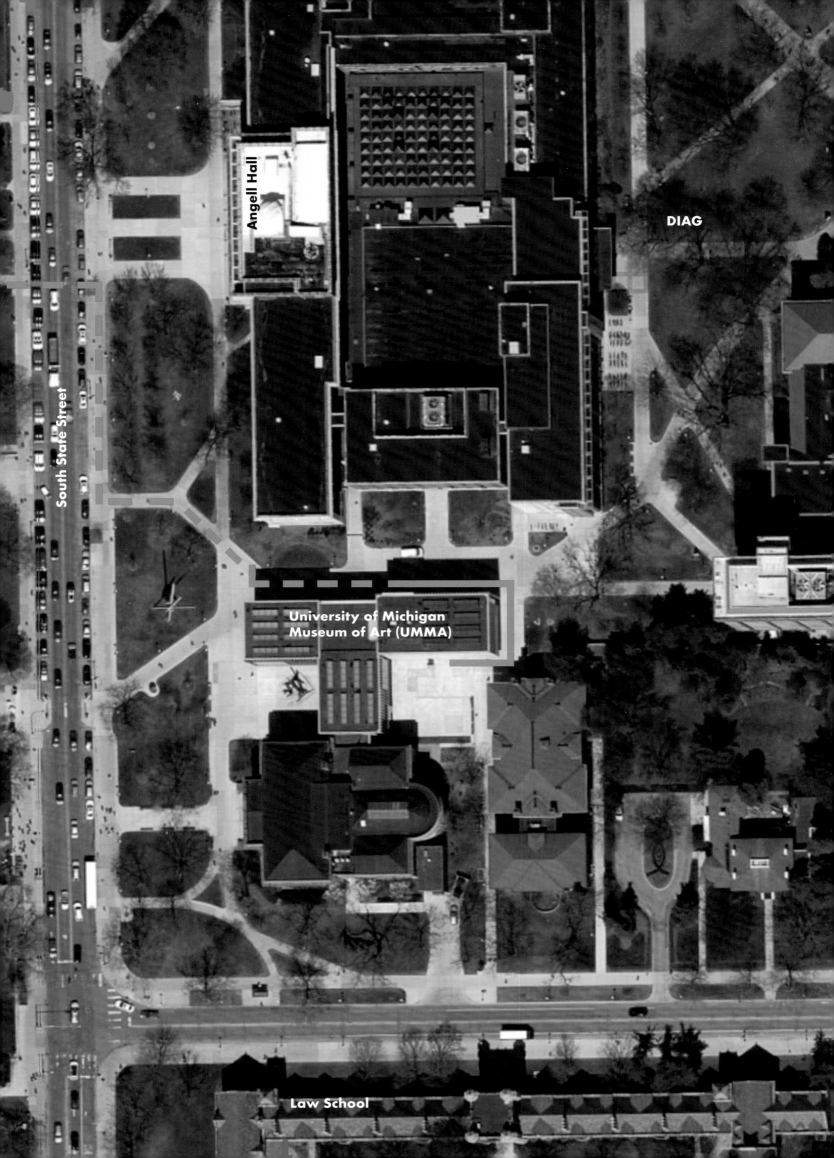

Angell Hall

DIAG

South State Street

University of Michigan
Museum of Art (UMMA)

Law School

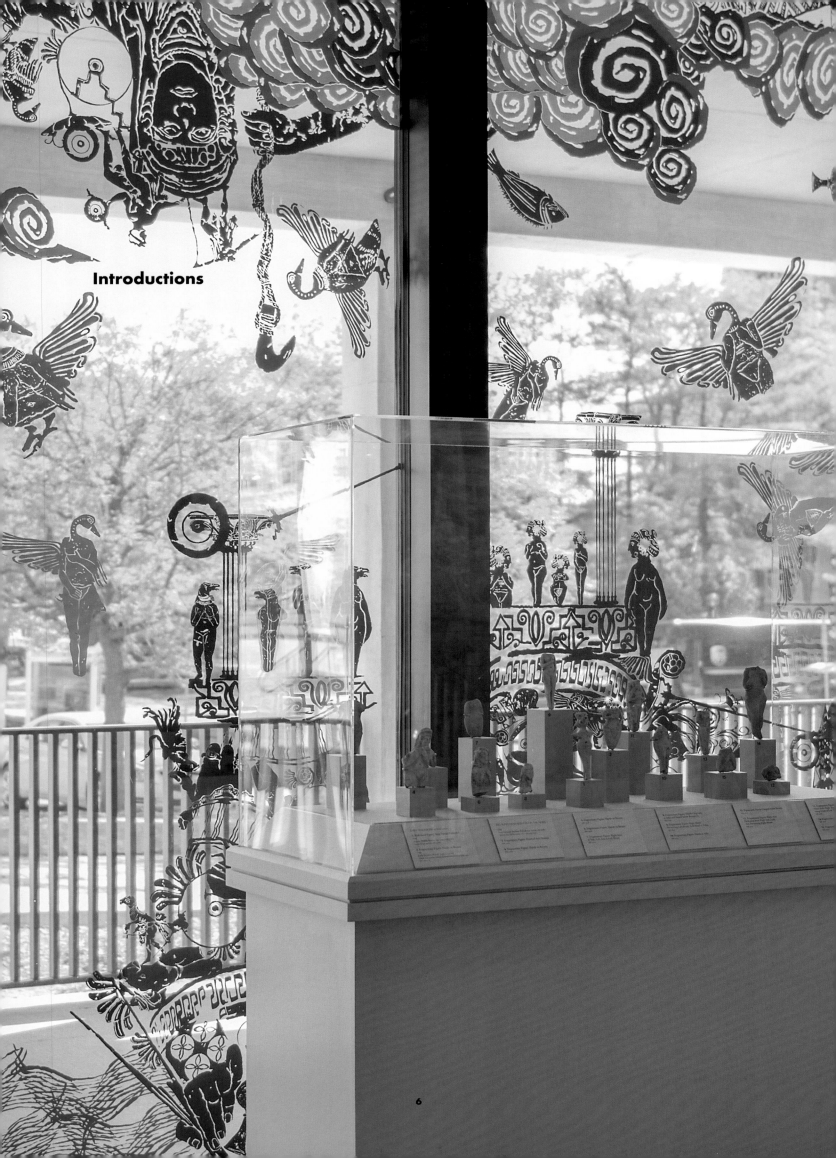

Introductions

- According to Jim Cogswell, *Cosmogonic Tattoos* is a culmination of years of extensive research and development exploring intersecting questions of architecture, material culture, and cultural memory. I would argue that it is also a coming together of several decades of his artistic investigations into the historical sedimentation, permutations, and multiple significations in/of images. Enduring questions like what is an image, and how does it come to be composed and subsequently morph over its history, as well as the role of material artifacts (including images) in constituting and rejuvenating cultural memory, have been critical to Cogswell's artistic oeuvre for many years. Thus, it gives me tremendous pleasure to introduce this catalog documenting his ambitious project.

- *Cosmogonic Tattoos* began with a careful review of and selection of artifacts and images in the Kelsey Museum of Archaeology and the University of Michigan Museum of Art, with a view to identifying some to abstract either in part or whole, to then reconstitute, repurpose, and ultimately imbue with different narratives. The result was a veritable animation that serially unfolds before us. Through Cogswell's visual manipulations, historical objects tell new stories that are both surprisingly different from their "originals," while allowing these narratives to be residually renovated. This visually stunning and immersive experience also encourages a different relationship to the architecture of the museums. The German cultural critic Walter Benjamin, in a relatively little known article, "Experience and Poverty" (1929), commented that through glass architecture, "everything comes to stand under the banner of transparency." Like Cogswell's other window installations, *Cosmogonic Tattoos* creatively mobilizes the inherent capacity of glass architectural facades to be both looked at and looked through. While one is enthralled and immersed in the stories on the facades, one cannot help but become aware of the stories that unfold beyond the glass: from inside the museums, stories of a vibrant university community as it goes about its everyday life; and from outside, a window onto the secret life of the objects within. In these simultaneous encounters of multiple narratives, the work provides a rich experience of how cultural memories are formed – i.e., in the flux that gets captured, always fleetingly but in ways that sometimes congeal, as mnemonic remainders.

- Even if this work manifests itself most visibly and viscerally as a series of architectural interventions employing the material artifacts of two museums, the project is really a deep and deliberate investigation into how cultural memories are embedded in and then elicited through material artifacts and images. And therefore it is most appropriate that it is systematically explored in a number of essays in this exquisitely illustrated catalog. I am especially proud and delighted that the catalog is a collaborative effort between two of the Stamps School's most exemplary faculty–Jim Cogswell and Franc Nunoo-Quarcoo, an internationally renowned designer and design scholar. Franc and Emily Schumer (BFA '17) immersed themselves in all aspects of this complex project in order to develop and shape a volume that conveys through word and image its process, form, and content.

- I wanted to take this opportunity to congratulate both Jim and Franc and thank all our supporters, both institutional and individual, for their help in realizing an incredible project that clearly exemplifies the collaborative and creative spirit of the University of Michigan in the year of its bicentennial celebration.

●

Gunalan Nadarajan
Dean and Professor
Penny W. Stamps School of Art & Design

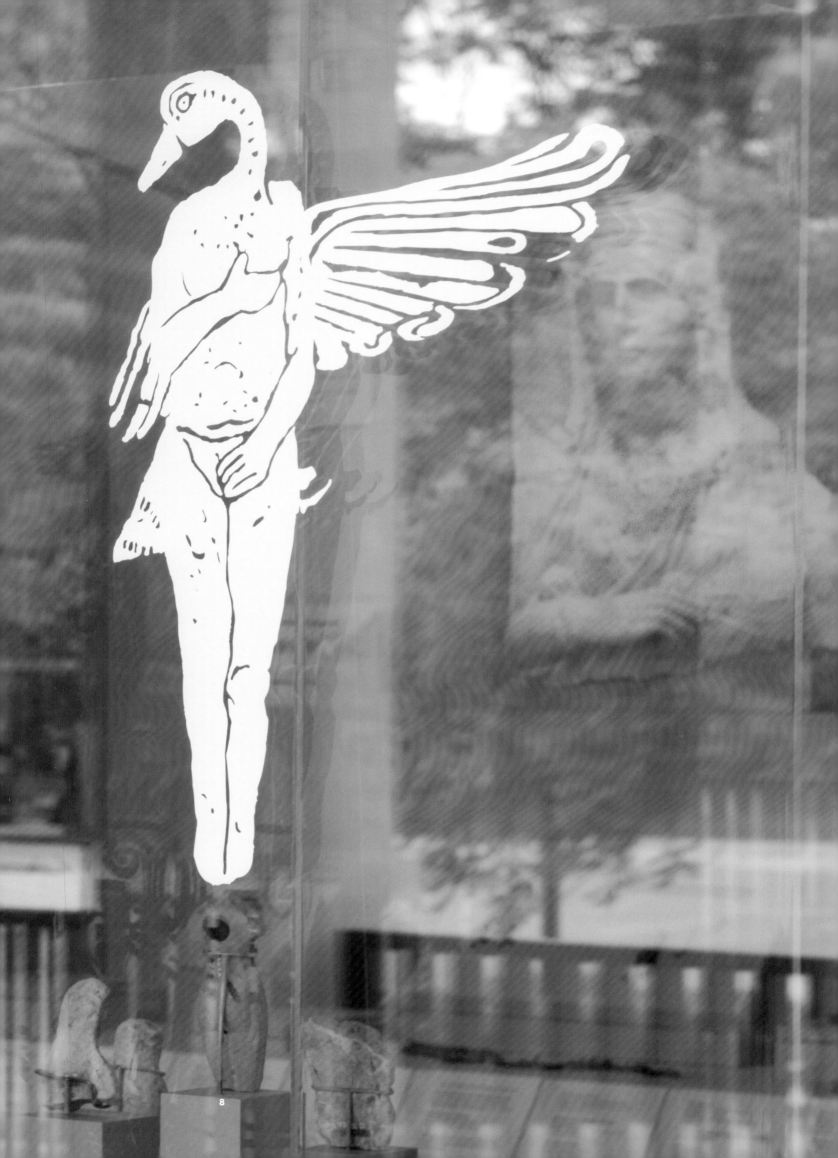

8

- As the curator responsible for a recent program of contemporary art installations and exhibitions at the Kelsey Museum of Archaeology, I have been able to work with a series of talented artists early in their careers for our "Kelsey Contemporaries" series of MFA thesis exhibitions. It was through these students that I got to know Jim Cogswell, and right away we began talking about the possibility of his doing an installation at the Kelsey Museum. We are now proud to present his *Cosmogonic Tattoos*, a work spread across windows of the Kelsey Museum and the University of Michigan Museum of Art, along with an exhibition of studies and related work and museum artifacts at the Kelsey Museum. In *Cosmogonic Tattoos*, Cogswell draws on imagery from both museums to create a completely new and original work of art that unleashes the ancient to run wild in the present.

- The opening of the new Upjohn Exhibit Wing in 2009 jump-started the Kelsey Museum's program of contemporary art installations and exhibitions. While we had shown contemporary art before, most notably the modern works reacting to the Pompeian wall paintings assembled for Elaine Gazda's *Villa of the Mysteries* exhibition, our programmatic engagement with contemporary art really began when the Upjohn wing opened. The new galleries allowed us to display many more objects than before, and the wide expanse of windows on the ground floor brought new light, in many ways, onto these artifacts. The modern space and the reinstallation of the collection attracted the attention of MFA students in the Stamps School of Art & Design, leading to a succession of thesis exhibitions featuring work with connections to the Kelsey Museum's collections. And, of course, these windows proved to be an irresistible surface to Jim Cogswell, from whom we had long hoped to commission a work that responded to the objects on display.

- Those of us who know the Kelsey Museum and its collections can take special pleasure in the redeployment of familiar objects in *Cosmogonic Tattoos*. I have already enjoyed seeing the unexpected ways in which it uses artifacts I have studied and published, but I see new things each time I look at it. And I'm already looking forward to taking students through the galleries and the installation, and seeing how they respond to the connections between them. This work is also a wonderful invitation to newcomers to the Kelsey Museum, whom I hope will be drawn inside to see the objects the windows evoke and represent.

- I would like to thank the staff of the Kelsey Museum for their hard work and creative approaches to an exhibition unlike any other we have ever done. We were assisted in meeting the unique logistical challenges posed by the installation of *Cosmogonic Tattoos* by staff from a number of U-M departments, including Plant Operations; Moving and Trucking; LSA Facilities and Operations; Environment, Health and Safety; The Sign Shop; Construction Services; Architecture, Engineering and Construction; and the Penny W. Stamps School of Art & Design. This exhibition and its related programming, like all Kelsey Museum activities, has been generously supported by the University of Michigan College of Literature, Science and the Arts, with additional support from the Bicentennial Office and the Penny W. Stamps School of Art and Design. It has been a pleasure to collaborate with the University of Michigan Museum of Art, and I would like to acknowledge the help of their staff with specific aspects of the Kelsey exhibition, as well as the overall project.

-

Terry Wilfong
Director and Curator for Graeco-Roman Egypt
Kelsey Museum of Archaeology

- Like virtually every museum where exhibition space is at a premium, the University of Michigan Museum of Art (UMMA) can display only a small percentage of its collection. The remainder is in storage, ready to be included in temporary exhibitions, to travel on loan to other museums, to be rotated into our collections galleries, or to be brought out for students to experience up close in the Museum's object and print study rooms. In 2012, Jim Cogswell, a long-standing friend, esteemed colleague, and a valued member of UMMA's Executive Committee, approached former Director Joseph Rosa with an idea to present the collection in a unique and innovative way. Drawing upon (and, quite literally, drawing) works of art both on view and in storage at UMMA and on display at the Kelsey Museum of Archaeology, Cogswell created a single, continuously unfolding mural on the exteriors of both buildings. Through a complicated process of selection, transformation, layering, and reconstituting, he imaginatively redeployed motifs from works collected all over the world, inventing hybrid creatures made up of symbols on Greek vases, Nigerian masks, and musical instruments from Thailand, that enact a sweeping narrative inviting us to look at the familiar anew.

- The vinyl-on-glass mural emerges from UMMA and crosses South State Street to the Kelsey Museum. The transmission towers broadcasting messages between the two museums celebrate their long-standing partnership, while playfully acknowledging the gap that separates them, both literally and thematically, and exposing the porous boundaries between art and artifact, art history and archaeology. At UMMA, *Cosmogonic Tattoos'* canvas is the windows facing the popular pedestrian path that connects the U-M Diag—one of the busiest sites on central campus—to State Street and is nestled within the Commons on the northeast corner of the Frankel Family wing, one of the most prominent and popular meeting spaces in the Museum. Cogswell's layers of vinyl animate the windows and activate the space in unexpected ways. Passersby, drawn to the miraculous world that he has created, may be inspired to discover what wonders can be found beyond this glass facade. For those who admire the mural from inside, an everyday environment will be transformed as weather and light change during the months, weeks, and days of the installation.

- This project coincides with the University of Michigan's bicentennial year—a moment for reflecting on the past and looking towards the future. Though primarily constructed out of historical artworks, *Cosmogonic Tattoos* conveys a very contemporary narrative of migration and displacement, one that is integral to any museum collection. People, as well as objects, have always moved through spaces and places—often forced, sometimes by choice—carrying stories and objects. For a museum and campus committed to diversity and inclusion, these stories could not be highlighted at a more crucial moment.

- It is our great pleasure to share this important commission celebrating the depth and breadth of the University of Michigan's collections. I would like to thank UMMA's staff for their contributions to making *Cosmogonic Tattoos* a reality. Our strong relationship with the Kelsey Museum was key to the success of the project. Lead support was provided by the University of Michigan Office of the Provost. Additional support was provided by the University of Michigan Bicentennial Office and the Penny W. Stamps School of Art & Design.

●

Kathryn A. Huss
Interim Director
University of Michigan Museum of Art

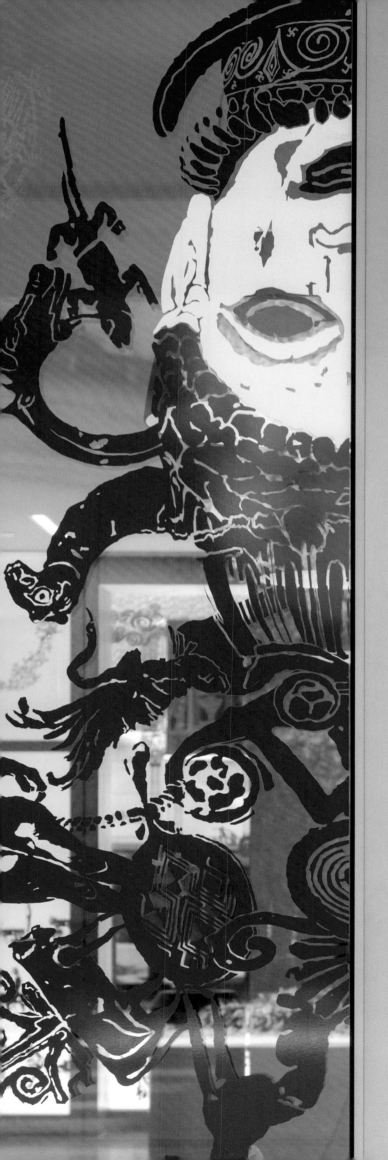
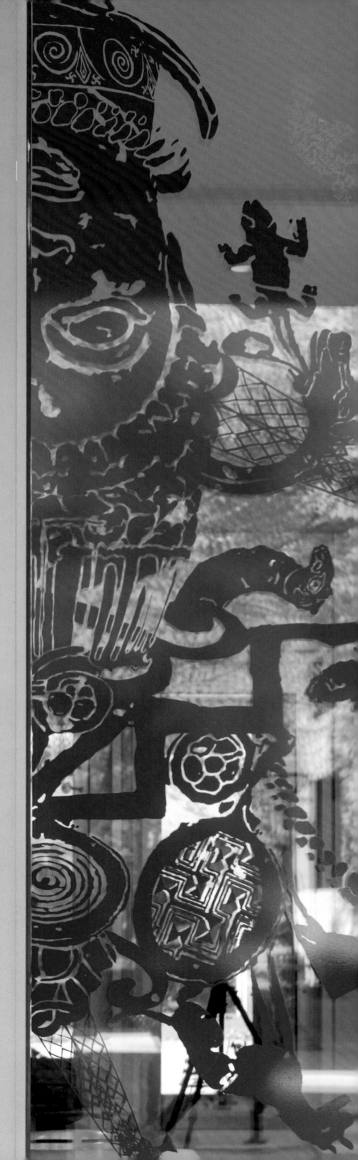

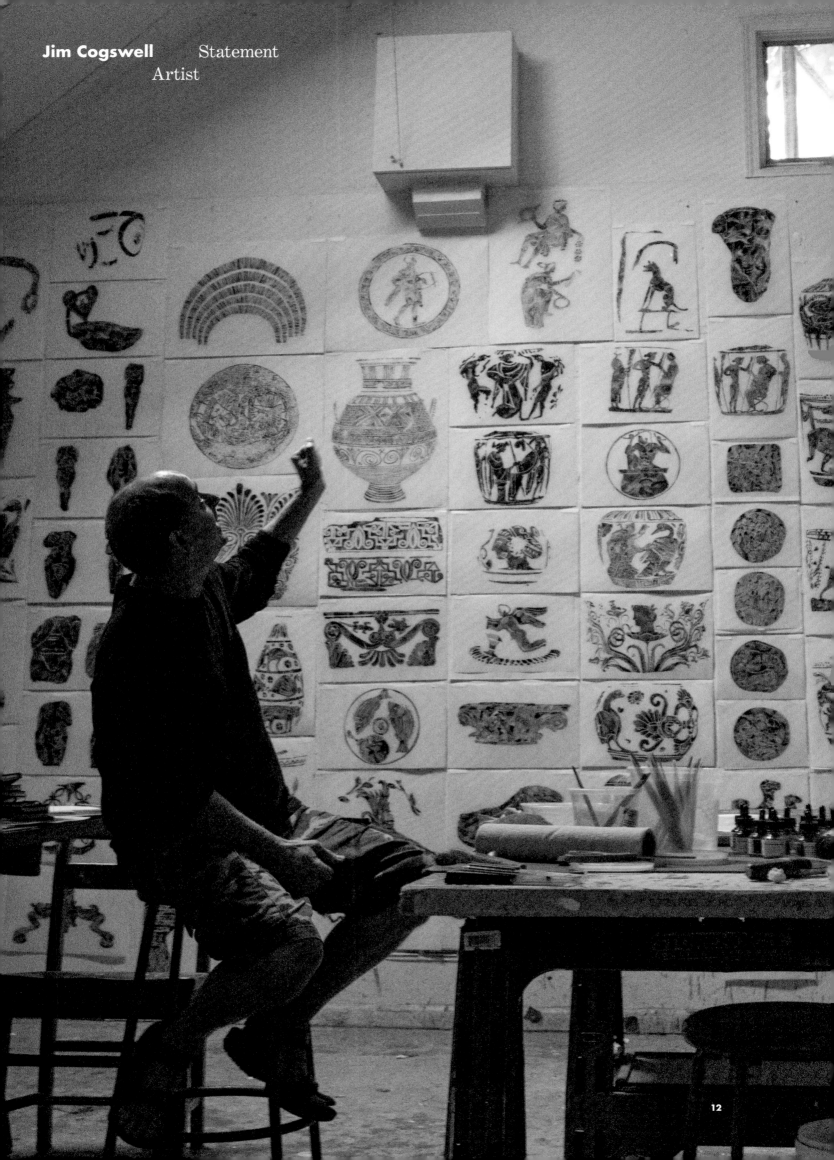

Jim Cogswell Statement
Artist

• Cosmogonies are our explanations
for how our world came to be.
They reflect our assumptions about
the fundamental nature of the universe.
They inflect our values and help
determine how we behave in the world,
how we think of who we are as a
species, as a society, as individuals.
Through collection, curation,
and displays, our museums narrate
the objects they contain to also
make statements about how we see
ourselves. I have tattoed the exteriors
of these two museums with images
of what is found inside, reframing
the stories they tell about who we
are and how we came to be who
we are. In doing so, I am calling
attention to the mutability of the
objects within—across time and
space, between materials, geographies,
and institutions. I am proposing
the museum as a fictive space built
on coincidence and personal narrative,
the chance layering of objects and
representations subject to the reflections
and curiosities of viewers as well as the
obsessions of our current predicaments.

• The story of the objects gathered
in these and all museums is a
story not only of displaced things,
but also of displaced peoples.
The installation at the Kelsey
Museum of Archaeology and the
University of Michigan Museum
of Art is intended as a single
continuously unfolding narrative
that includes the gap between
the two buildings, a gap evoked
by my series of transmission towers
and the march of refugees between.
I want that distance to speak to us—
about migration and exile, loss
and longing; about objects that were
looted, exchanged, and destroyed
in the movement of peoples through
history; about sagas of trade,
conquest, appropriation, and plunder.
Hands changing hands, shaping
histories we tell ourselves in order
to somehow comprehend it all.

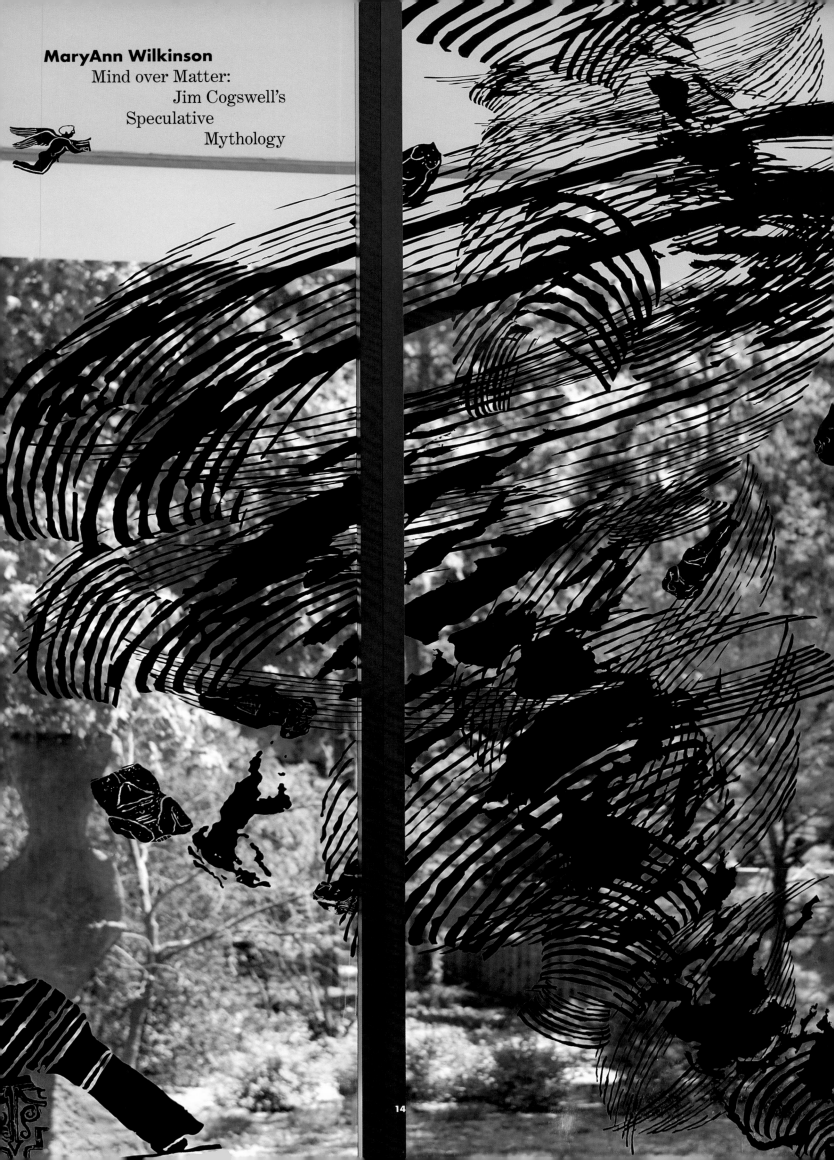

MaryAnn Wilkinson
Mind over Matter:
 Jim Cogswell's
Speculative
 Mythology

- A goddess taking a shower. A wild whirling tornado. Transmission towers blasting out indecipherable messages. Hands everywhere. A marvelous transformation enlivens the windows of the Kelsey Museum of Archaeology and the University of Michigan Museum of Art, making visitors stop, look, puzzle, and think. In *Cosmogonic Tattoos*, Jim Cogswell remixes and reinterprets imagery from across cultures and periods into an exuberant and irreverent saga of cultural transference. An aesthetic Big Bang Theory, *Cosmogonic Tattoos* encourages speculation on the ways that art and culture shape the history of our world and how human intervention drives cultural transmission. Drawing upon the movement of people, their beliefs, and their belongings across boundaries and the effects of loss, disaster, and subsequent rebuilding, Cogswell creates a richly detailed meditation on art, life, and how the world works. Like so many theories, it invites a personal reinterpretation of the history of the world through a mash-up of images, objects, memories, beliefs, and attitudes.

- Developed as a University of Michigan Bicentennial project, *Cosmogonic Tattoos* unites the two campus institutions through an epic mural that attempts to bridge both time and space. A short walk, perhaps the length of a city block, separates the two buildings. Each has a recent addition that is constructed at least in part of floor-to-ceiling glass paneled walls. Imagery cut from brilliantly colored adhesive vinyl is applied to these glassed-in areas, creating a disjointed narrative that unfolds with the help of the viewer's imagination. Cogswell began the project by carefully studying the collections of both museums—one devoted to classical archeology and the other an encyclopedic collection of art from many cultures—and excerpting images, shapes, and details from more than 250 objects. (The window installation is accompanied by an exhibition of hundreds of Cogswell's preparatory drawings, paintings, and photographs at the Kelsey Museum, which stand on their own as contemporary responses to historical objects.) Divorced from their museum context, the images were then open to reinterpretation and recombination into unlikely, often surprising, juxtapositions. The resulting array of images is a dense and colorful trail of visual breadcrumbs, leading the viewer to consider larger questions about cultural myth-making and the implications of cultural movement.

- Astonishingly intricate, the mural is a loosely formed fictional narrative that posits the formation of the universe—the cosmogony of the title—and the spread of cultures and peoples across our world. Cogswell imagines a series of disasters—wind, water, invasion— that force a migration. The refugees wander along a route guided by "transmission towers" and marked by "traffic cones," carrying with them objects that evince their values and ideas. The saga begins on the south face of UMMA, wraps around the building, and leaps over the great divide that is State Street, where it is picked up again on the south and west sides of the Kelsey Museum. Often represented only by hands, that most human of appendages, the movement of figures around the windows of each building mirrors the displacement and recontextualization of cultural objects and mores that has happened throughout history. Viewers may find it difficult to discern a story amid the cacophony of images, color, and movement, but the artist has embedded clues and signposts that suggest his thinking, as well as allowing for the construction of alternative narratives.

- The complex images are cut from adhesive vinyl— a sort of grown-up version of the Colorforms toys that were invented and popularized in the 1950s—and each shape is applied directly to the glass in a collage of colored fragments. The colors, which are cast, not printed, so that they permeate the vinyl and are equally vibrant on both sides, respond to the incidence and intensity of light, influenced by the weather and the hour. Seen from the outside, color and shape are paramount, acting together with the environment in a constantly shifting panorama of light and movement that dissolves the glass, though at certain times of day the glare of light reaffirms the support's solidity and the glass, no longer a void, becomes a rigid, solid field for painting. When the murals are seen from the inside, the colors are muted so that the images appear merely as silhouettes, flattening the visual field and reasserting the solidity of the glass wall. This deft pairing of solid and void complicates the illusion of three-dimensional space and influences how we read the composition: separate forms on the flat plane of the glass can seem to overlap when they do not; the placement of elements implies a shifting suggestion of foreground and background; and the size and scale of the forms, particularly the human figures, leads us to construct for ourselves the relationship between them. The images seem to be in constant motion— swirling, dripping, coming down from the ceiling, coming up from the base, moving urgently to the right or left—and the intense and joyful use of color is dazzling. Indeed, the elaborate scenario that frames the images in *Cosmogonic Tattoos* may not be immediately obvious to the casual viewer, lost in sussing out and identifying its individual components.

- This project is perhaps the most ambitious to date by the protean Cogswell, whose work has incorporated disparate interests and influences over his long and varied career. Though he considers himself a painter,

he prefers to explore what the act of painting can offer when combined with other mediums. Born and raised in Japan and educated in literature, philosophy, and religion, Cogswell draws upon a broad base of knowledge and his passionate curiosity to guide his earnest struggle to understand how to make sense of the world. He may be best known for works based in coded systems of letters or images—perhaps inspired or influenced by his early training in calligraphy— that become visual narratives. In *The Fountain* (2005), a collaboration with graphic designer Ben Van Dyck created as part of a group exhibition, *Water*, soon after Hurricane Katrina and the South Asian tsunami, Cogswell explored ideas that would inform much of his work over the next decade and a half. Based on a passage from Herman Melville's *Moby-Dick* on the uncertainty of even the most obvious things ("Can you not tell water from air? … I have ever found plain things the knottiest of all…"), it is a meditation on disaster and loss. Cogswell developed an anthropomorphic alphabet to transcribe the text, which he applied directly to the wall with rubber stamps. The rows of evanescent letters seem to dissolve into the spray of paint behind them; illegible and indistinct, they are presented as text, yet we cannot read them. A subtle dissection of the nature of perception, the challenge of reconciling what we see with what we know, parallels the wind/water conundrum in the Melville text. In related works from this period, such as the ceramic tile installation *O Reader* (2006) or the cut-paper collage *Nothing to Say* (2007), his anthropomorphic alphabet retains its original function as familiar symbol, while at the same time reading as something else. In his lexicon of images for *Cosmogonic Tattoos*, Cogswell uses a similar approach: the "traffic cones" that guide his wanderers, for example, look like those we see on contemporary streets, but their original source, a decorative motif on Roman glass, is also recognizable.

- The precision of calligraphy and its emphasis on letters and works is often investigated on a large scale in Cogswell's work, transforming an intimate gesture into a bold statement. He was encouraged to go big by earlier examples of mural-sized paintings, from historical to Pop art. James Rosenquist's immersive 86-foot-long painting *F-111* (1964) was an important influence. Rosenquist, a former billboard painter, commented on contemporary American life in his large-scale canvases. Looking for the most direct way to communicate, he incorporated jumps of scale, flattened forms, and a collage-like juxtaposition of fragments of imagery. Cogswell, too, uses the act of looking—following the rhythms of colors, the sweep of voids, and the recognition of single elements—to make the viewer a participant in decoding the subject. In *Silence* (2009), an important large-scale collage

painting inspired by Rosenquist's formal approach to imagery and narrative, a complex web of images is structured around the gores of a flattened-out map of the universe. Embedded within these ovoid shapes are the seven letters of the word "silence," a reference to a quote from Blaise Pascal's *Pensées*: " Le silence éternal de ces espaces infinis m'effraie" ("the eternal silence of these infinite spaces fills me with dread"). A mathematician, scientist, and philosopher, Pascal proved the existence of vacuums, countering the Aristotelian notion that creation was a thing of substance, whether visible or invisible. The absence of substance suggests that the mysteries of the universe are unknowable, that one can never fully understand the scope, much less the purpose, of existence.

- Infinite spaces and their accompanying uncertainties would become an increasing part of Cogswell's repertoire. He admits to a fascination with the unknown and even the unknowable. Its strong pull on his imagination has resulted in major works such as *Jeweled Net of the Vast Invisible* (2014), a multimedia experience of the composition of the universe. A collaboration with two cosmologists and a musician, *Jeweled Net* is a visualization of the distribution of dark matter in the universe, based on data from the massive billion-particle Millennium Simulation. The installation sought to reveal the invisible net of structures, halos, voids, and filaments that captured the matter that made up the first stars, galaxies, and galaxy clusters—the "jewels" of the universe. Unknowable and impossible to see, the existence of this dark matter can only be inferred by studying the galaxies and stars. The installation immersed viewers in the "jeweled" spaces derived from the data points, a visualization of leaving the earth and flying through the vast distances of space. In *Cosmogonic Tattoos* the forces of nature, unleashed, are similarly overwhelming, often inexplicable, and sometimes frightening. The wide-eyed awe with which we experience the vastness of the universe has given way to a dogged journey to try to make sense of the world.

- Cogswell's love of spatial ambiguity and open-ended narrative finds a natural home on glass panels. His collages on glass began in 2005 with a temporary installation at the Tabor Hill Gallery in Ann Arbor, in which vinyl shapes were applied to the gallery windows. Subsequent works have become increasingly elaborate and colorful, ranging from the outlined forms of the night sky and star-gazing tools in *Meanwhile, More Light* (2008), an installation on the windows of Dennison Hall, the home of the U-M Department of Astronomy, to the combination of words and pictures of *Poems Open* (2015), a collaborative work on the windows of the Kerrytown Market and Shops in downtown Ann Arbor. One of the most beautiful of his

window installations, *River Tattoo* (2014), created at the Eberhard Center in Grand Rapids for ArtPrize 2014, was inspired by the nearby Grand River. The vinyl images suggest the echo of the movement of water and overhead clouds, as well as flora and fauna, both real and imagined, while the transparent areas of glass stand in for both river and sky. *Enchanted Beanstalk*, a permanent installation on the eight stories of windows of the C. S. Mott Children's Hospital and Von Voigtlander Women's Hospital at the University of Michigan Medical Center in Ann Arbor, conveys the familiar tale of Jack and the Beanstalk. From the outside, the whimsical, rhythmic shapes read as a continuous design, but inside, each floor is episodic; visual themes unique to each guide viewers along the corridors beside the windows, becoming more elaborate in waiting areas. It is a sort of "Where's Waldo?" puzzle, from which viewers must reassemble the story using clues in the fanciful vinyl shapes. The multiple elements silhouetted against the Ann Arbor skyline layer an imaginary world atop a real one; the shadows they cast in the late afternoon sun on the painted wall behind the windows lend a ghostly presence.

- Images in silhouette, or solid shapes that rely on a detailed outer edge for definition and identification, are thought to have been in use in art since Greek black-figure painting (7th–5th century BCE), especially for portraiture. Their straightforward outline eliminates extraneous detail, so that the image may be read and understood at a glance. The quick recognition of forms and identities they allow has encouraged their use in moving images, such as traditional Indonesian shadow theater. Both silhouette and shadow, its more elusive counterpart, are important elements in *Cosmogonic Tattoos*, where images are repeated in the shifting shadows cast on the interior floors of the two museums and the objects on display, adding to the complexity of the visual field. Though silhouettes may evoke genteel, old-fashioned, often intimate, portraiture, contemporary artists such as Kara Walker have revived the practice with entirely different goals. Cogswell's monumental silhouettes are based on objects detached from their original context, reimagined as part of an epic narrative that becomes more and more dystopian the closer one looks. And yet it is in turn comic, something like the over-the-top, kitschy tragedy of 1980s disaster movies. His scenes suggest powerful movement in a remarkable, often unsettling, way. Indeed the mullions that separate the glass panels seem to act as a counterpoint to the unfolding story, much as the frames in films and comic strips. The flat images on the glass, seen against a three-dimensional background that is often in motion, feel a little like the push and pull of the speech bubbles and the active, often distorted, background of the frames of a graphic novel. But this is no gloom-and-doom scenario.

In disaster movies and in many graphic novels, the world is saved by the best parts of humanity—sacrifice, courage, wisdom—coming to the fore when the going gets tough. Here, culture is saved by the fortitude of people transporting meaningful objects to a place of safety.

- Through the scale and scope of his window installations, Cogswell makes clear his debt to other great murals and mural painters, but his innovative approach has expanded the possibilities of the genre. The twentieth-century Mexican muralist Diego Rivera, for example, in his mural cycle *Detroit Industry* (1931–33, The Detroit Institute of Arts) created an immersive, narrative environment of painted frescoes that is decorative, didactic, and often slyly irreverent. Cogswell's collage murals also transform the architectural environment, and they share Rivera's love of storytelling and subversive sense of humor. But unlike Rivera, who relied upon his gifts as a painter to create the illusion of three-dimensional space on a flat surface, Cogswell uses both the two-dimensional plane of the glass and its transparency and reflectivity to help him create literal and perceived depth of field. By applying images to both the inside and the outside of the glass walls, he is able to take advantage of a subtle physical shift in depth perception and overlap of images, further complicating the visual shifts between two-dimensional images and three-dimensional spaces. The large glass windows of modernist architecture visually open up a building's spaces, lightening mass and inviting a relationship with the outside world. By placing "tattoos" on the transparent "skins" of buildings, Cogswell is able to incorporate the interior and exterior environments into his work, fashioning a world of the imagination that invites the viewer to literally enter.

- Paradoxically perhaps, Cogswell's window installations are architectural interventions that challenge the very aspect of architecture that makes them possible: the large expanses of glass on modernist buildings. Modern, and to a somewhat lesser degree, contemporary architectural styles made a radical break from overt ornament, which was seen by some architects and designers as anathema, unmanly, inartistic, and retardataire. Above all, ornament spoiled the looks of a building by not emphasizing its function, by drawing too much attention to itself. In his 1953 book *Art and Industry*, the art critic Herbert Read asserted, "All ornament must be treated as suspect. I feel that a really civilized person would as soon tattoo his body as cover the form of a good work of art with meaningless ornament. Legitimate ornament [is] something applied with discretion to make more precise the outlines of an already existing beauty."* While today both tattoos and architectural ornament are more widely accepted, it is still a surprise

to see Cogswell's window installations. Their playful, decorative nature relies on the lure of color and the pleasure of rhythmic patterning; Cogswell cites the Pattern and Decoration movement of the late 1970s as an influence. Running counter to the aesthetic austerity of Modernism, P&D artists, particularly the feminist artists Joyce Kozloff and Miriam Shapiro, sought to bring softness, pattern, sensuality, beauty, and ornament to works of art, qualities often associated with "low art" such as textile design, or with non-Western traditions. While decorative and beautiful, Cogswell's architectural tattoos perhaps are closer in spirit to the work of feminist artist Nancy Spero, who became fascinated by the format, style, and mood of Etruscan and Roman frescoes and sarcophagi and used redrawn forms of images from antique sources throughout her career. Although her early work was hard-hitting and political, her later work was characterized by an exuberant and joyful playfulness that included a lexicon of classically-derived figures and shapes cavorting across her painting fields. Both artists reach across centuries and cultures to construct a visual language that suggests that the world we inhabit and struggle with and against in our daily lives is, simultaneously, a world of myth, belief, and history.

- The window installations of *Cosmogonic Tattoos* are ephemeral. For the few months that the work is installed, viewers will be able to lose themselves in its vast array of images, seek out the original sources in the two museums involved, and delight in the play of solid and void, shadow and light. In the web series *The Dictionary of Obscure Sorrows*, author John Koening posits a neologism, "dés vu," a pseudo-French phrase that describes the recognition that the present immediately turns into a memory, and that we are constantly trying to describe our present as it slips into our past.** We are time travelers, constructing a future by remembering and reordering our histories. Even before this installation becomes part of our individual and collective memories, its deep roots in the cultural history of human life will affect our thinking about the past as well as our imaginings of the future.

·

MaryAnn Wilkinson is Exhibitions Director at Taubman College of Architecture and Urban Planning and Adjunct Curator of Modern Art, University of Michigan Museum of Art (UMMA). At Taubman College she develops an exhibition program for the College's North Campus and downtown Ann Arbor galleries, organizing more than ten exhibitions a year on subjects ranging from architecture methodology to the blurry distinction between architecture and sculpture. She advises UMMA on acquisitions for the modern art collection and recently organized its exhibition celebrating the 30th anniversary of the Heidelberg Project.

* Herbert Read, *Art and Industry: The Principles of Industrial Design* (New York, 1961), 23.
** John Koenig, "Dés Vu: The Awareness That This Will Become a Memory," in *The Dictionary of Obscure Sorrows*, YouTube video, August 29, 2015.

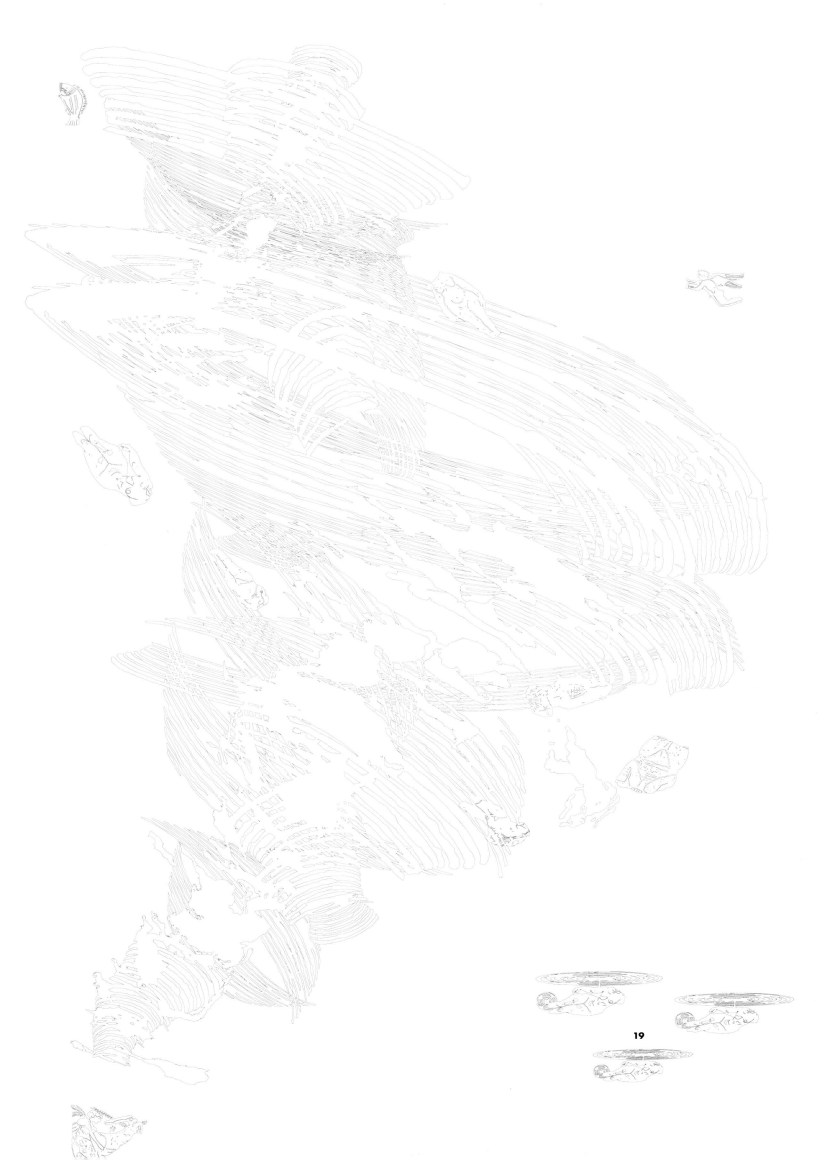

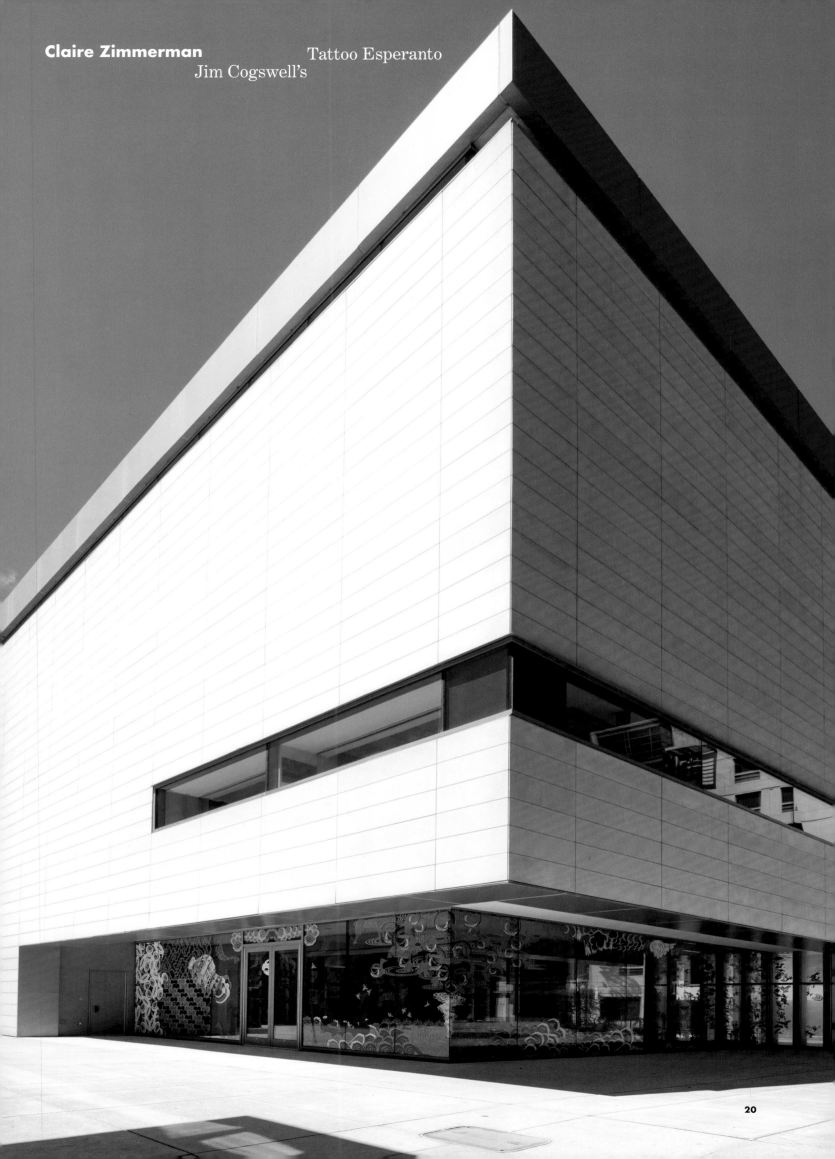

Claire Zimmerman Tattoo Esperanto
 Jim Cogswell's

- *Approaching the University of Michigan Museum of Art on a cold, blustery day in April, I find the glass walls of the ground floor Commons shrouded in white sheets of paper. In the midst of this ghosted version of a familiar place, a man is doing something to the walls. As he works, the white sheets are sloughed away, papering the concrete apron below. A constellation of images begins to appear.*

- In the fall of 2016, The University of Michigan commissioned Jim Cogswell to produce a site-specific installation to celebrate the University's two hundred years of operation. In response, Cogswell decided to repurpose and reframe two University museum collections, a venture that became *Cosmogonic Tattoos*. For this project, he designed a complex array of hybridized vinyl tattoos that could be applied to the glass surfaces of the Kelsey Museum of Archaeology and the University of Michigan Museum of Art (UMMA). Cogswell went into the museums to record objects from their collections. He came out with sketches and paintings that were then digitally scanned, dismembered, catalogued, and recombined. Using a singular approach to ornamentation and architecture, new compositions were produced, resulting in a series of vinyl mash-ups that were further recomposed by the artist. These "tattoos" were then installed on the museums.

- The iconography of this surface ornament derives from the contents of the buildings, both the objects in their collections and the rhetorical spaces of their galleries. Highly valued holdings leach through to building surfaces in improbable scalar and iconographic combinations that hybridize divergent artistic traditions and distant places. The images recall the iconic *Yellow Submarine* album cover (and movie), as much as they recall the monuments that objects of Western antiquity have become in the years since archaeologists rediscovered them, sanctified by dirt and time. By grafting Peter Max onto ancient culture, Cogswell combines analog and digital processes to deconstruct and reconstruct Western institutions. He also upends received notions of the relationship between architecture and ornament.

- *Out of the white sheets, a blue-green spiral-whirlpool has emerged in the midst of a sea of choppy yet wispy waves of clustered, nested lines. From the center of the whirlpool, a white plume of hairy smoke or water also spirals upward, growing larger in circumference as it rises. This plume supports another spiral that is as flat as a sheet of paper, flatter even than the glass on which both geyser and spiral are mounted. This razor thin oblique spiral is white and sea green.*

- Cogswell maintains that *Cosmogonic Tattoos* explores how objects and experiences change radically according to context.*Cultures thrive on borrowing; borrowed object and borrower are altered in cultural transactions like those that result in museum collections. The objects thus gathered, and the ornaments on their surfaces, narrate not only displaced things, but also displaced peoples. Through collection, curation, and display of objects (including things like painting and graphic art), our museums concretize cultural identities—those of the collector as well as the collected. The Western "canon" was formed as European and North American institutions configured their contacts with other societies, absorbing and transforming multiple traditions and modes of artistic communication and proliferating these hybridized complexes across time and space. When examining the canon represented in these two institutions, Cogswell

•

Claire Zimmerman is Associate Professor of History of Art and the Director of Doctoral Studies in Architecture at the Taubman College of the University of Michigan. She teaches courses on nineteenth- and twentieth-century architecture with research emphases on architectural media, Weimar Germany, the United States, and the United Kingdom. Current research interests include architecture culture as it interacts with commerce and industry, and the infrastructures of globalization that underpinned the spread of modern architecture throughout the twentieth century. She co-curated with Victoria Walsh *New Brutalist Image 1949-1955: Hunstanton School and the Photography of Life and Art*, Royal College of Art, London (2015) and is the author of *Photographic Architecture in the Twentieth Century* (2014).

• *Above the white plume and the planar oblique bicolored spiral, a field of bird-hands emerges, livid orange and interspersed with more sea-green flattened spiral forms that look as if they have floated up through the white smoke plume from the original whirlpool below. There are no birds, just hands and arms that look like birds in a flock. The hands and arms are attached to rondels centered on purple-blue Egyptian eyes from which floods of white tears pour from orange irises. The rondels rock back and forth across the spiral field. The hands point, chop, gesture, hold, gesticulate, and indicate.*

saw the hybridities and combinations more than the objective records of past lives.

• The gathering of images onto the windows of institutions endows both with new meaning as it subtly destabilizes them. For Cogswell, views through and reflections on the glass on which the vinyl images are mounted, visual relationships that metamorphose as viewers walk by and light shifts, the framing and echoing of objects on display nearby, and interaction with the architectural context are all part of the content of the work. This strategy of contingent composition is important to him—providing the opportunity for one sort of meaning to be replaced with quite another. Cogswell won't lock that down as a single goal for his work, but we might talk here about inversion—the replacement of canon status with something quite opposite: the status of contingency.

• By ornamenting museum exteriors with pictographs of what can be found inside, Cogswell reframes cultural narratives. By activating viewers' perceptions of artistic production and cultural exchange, he seeks to extend into contemporary materials and technologies the ancient practice of repurposing spolia. Here, however, building stone and ornamental sculpture are reconfigured into new "constructions" that exist only in vinyl images, and the ornamentation that adorns those constructions is now indistinguishable from them. A fundamental transposition has occurred, literally and in terms of media and representation as well, in which object, ornament, and substrate (glass walls) are equal partners in a project meant to confront us with the myths we have constructed in the form of a canon. Perhaps more significantly, Cogswell's combinations enlist some of the subversive strategies of Dada through bald and sometimes biting humor. We can't see the funny side without also feeling a sting.

• In architectural history, tattoos call to mind famous nineteenth-century debates about industrialization and modernization. The German theorist Gottfried Semper, preoccupied with the relationship between architecture and ornament, made tattoos famous by illustrating Maori facial ornament in the first volume of his unfinished work *Der Stil* (1878), and decoding the ways in which applied ornament narrated both history and form. Similarly, tattoos conveying "a complete theory of the heavens and the earth, and a mystical treatise on the art of attaining truth" on the body of the mysterious Queequeg (whom Cogswell celebrates in the title of this project) were memorably described in Herman Melville's *Moby Dick* (1851).**In "Ornament and Crime" (1908), Adolf Loos took Semper's image (or Melville's), to mean that tattooing was a "symptom of degeneracy in the modern adult," and that ornament should therefore be

removed from architecture and objects of industrial design.***Loos's proscription is taken as a core precept of modernist practices in architecture, one that led to abstraction in reaction to the highly ornamented historicist styles of the late nineteenth century. And yet ornament was never suppressed: instead, the understanding of it shifted from something that might be applied to designed objects, to a quality intrinsic to materials. Even Loos, who rejected the application of tattoos to his buildings, used in them the most highly ornamental wood and the most vividly patterned marble that he could find. Their smooth surfaces conceal psychedelic pattern; old black and white photographs, dramatizing Loos's interiors, show that the walls themselves seem to have been tattooed. Ambivalence about the status of ornament in modernism did not result in its disappearance, but rather in strategies of encryption and camouflage.

- Cogswell's tattoos question the hierarchy between architecture (essential, structural) and ornament (inessential, supplemental) that was enshrined in modernist texts, no matter how inconsistently it was carried into building. This theoretical hierarchy has only recently been challenged—in part by the openings that digital technologies provide. Digital fabrication makes it possible to eliminate constructional priority— structure being applied before skin, skin before ornament. Now ornament and structure can be a single integrated construct. But Cogswell's operations rely on different digital tools, particularly the imaging possibilities offered by software. His complex combinations constitute a language—an idiom, really, specific to these collections and this place—that enables a new manner of tattooing that nonetheless tells stories like those found on Queequeg's skin. But Cogswell's project is also narrating something from the inside, and putting it on the outside, as if Queequeg's tattoos depicted his own organs. With this strategy, he not only rejects existing hierarchies of ornament to structure, he inverts them completely. What is a museum, after all, but its own collection?

- Conversations with Cogswell persuade me that this project is based on a formal strategy of seepage. He talks about objects from the museums seeping out onto the walls of the buildings that house them. At UMMA, the icons of things held inside migrate down from the galleries above to land on glass walls at street level. At the Kelsey Museum, they seep out through the walls of the building onto the walls that flank the entry. For Cogswell, the cognitive operation here is crucial—the center is migrating to the periphery, to the public face of the institution. This is also purely a cognitive operation—or more straightforwardly, a cool idea.

- *Flanking the V of the whirlpool, its smoke plume, the spirals emitted from the plume, and the eye-rondel-hand combinations, other things are happening on the surface of the UMMA Commons. The sea-green hairy wave configurations that hold the original whirlpool-spiral are in turn enclosed by a different sort of wave— big chunky spirals turned upright to face the viewer in two shades of purple and two of green. These waves support a harp-ship, and in it is a family of hands, or a single hand caught in stop-motion, playing the harp sails of the boat. Recalling the fabled owl and pussycat, the hands are as expressive as words, or as images of something completely different.*

- Cogswell is, in fact, "mapping" a building's contents onto its exterior walls in a purely applied manner, but in close relationship to particular aspects of the buildings' architecture. The project joins together architectural program—what a building is made for—and formal address—its appearance to users. Such a statement seems fairly unobjectionable— many buildings are made with their program in mind. What makes this project unprecedented in terms of its architectural proposition is the temporal inversion, whereby architectural ornamentation emerges from a building's use over time, and the particular sociocultural terrain that it stakes out. Turning the buildings' contents into signage—into signs of what's inside—may be a good thing to do. But what makes Cogswell's appliqué so compelling is not that we see museum objects presented as signs of the museum. What makes it compelling is what Cogswell does with the objects as he flattens them, cuts them apart, and makes them into something you couldn't possibly imagine, even if someone told you about it. His point, or one of them: that this is exactly what the Western canon is: a fantastical story too good to be true, but worth a generous, if clear-eyed, reception.

- *On the other side of the image field—five panes of floor-to-ceiling glass on the backside of the UMMA Commons facing Tappan Hall—more icons appear. These are small and blue. In addition to a series of clustered, flock-like lines that waft throughout the entire five panes, a trio of three helicopters flank a complex structure topped with two classical columns. These columns top a complex, layered construction of objects interspersed with nothing but air. The helicopters are, in fact, caryatids with spirals where their heads might have, possibly, appeared.*

- By calling attention to museum display as a picture plane through which we view history panoramically, Cogswell uses *Cosmogonic Tattoos* to recast the museum as a fictive space built on coincidences and personal narratives, the chance layering of objects and representations subject to the reflections and curiosities of viewers, and short-lived obsessions created at the time of collection or commission. In rendering the Western canon as a contingent projection, the installation does important political work; it is a small step from viewing Cogswell's tattoos to understanding museum collections as sites where cultural hierarchies are enacted through repression, discrimination, and prejudice as much as endorsement. Cogswell claims that his installation is as much about migration and exile, loss and longing, as it is about objects that were plundered, exchanged, and destroyed in the movement of peoples through history. And you can quote him on that.

* Conversation with the artist, April 2017.

** H. Melville, *Moby Dick* (1851), ch. 110.

*** A. Loos, "Ornament and Crime," in *Programs and Manifestoes on 20th-Century Architecture*, ed. U. Conrads (Cambridge, 1971), 19–24, 20.

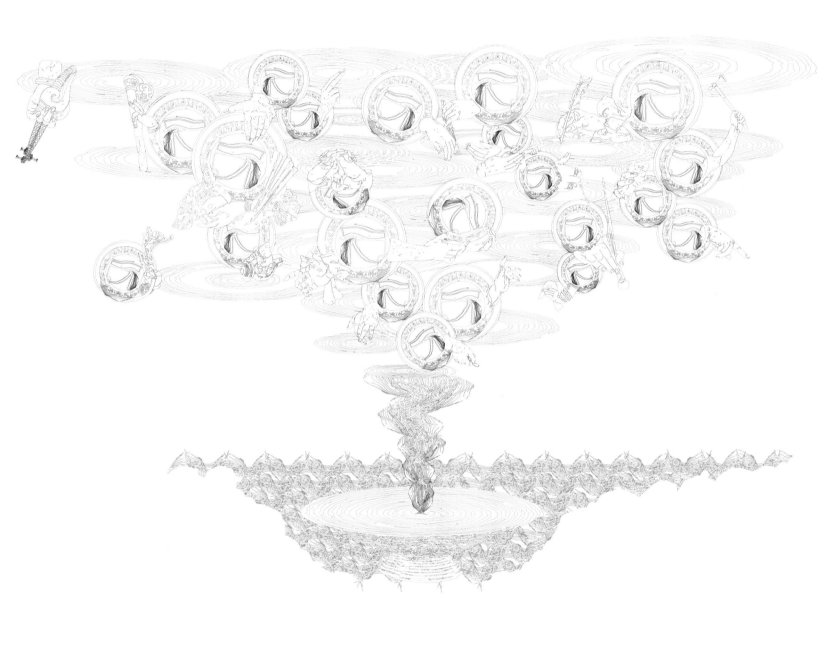

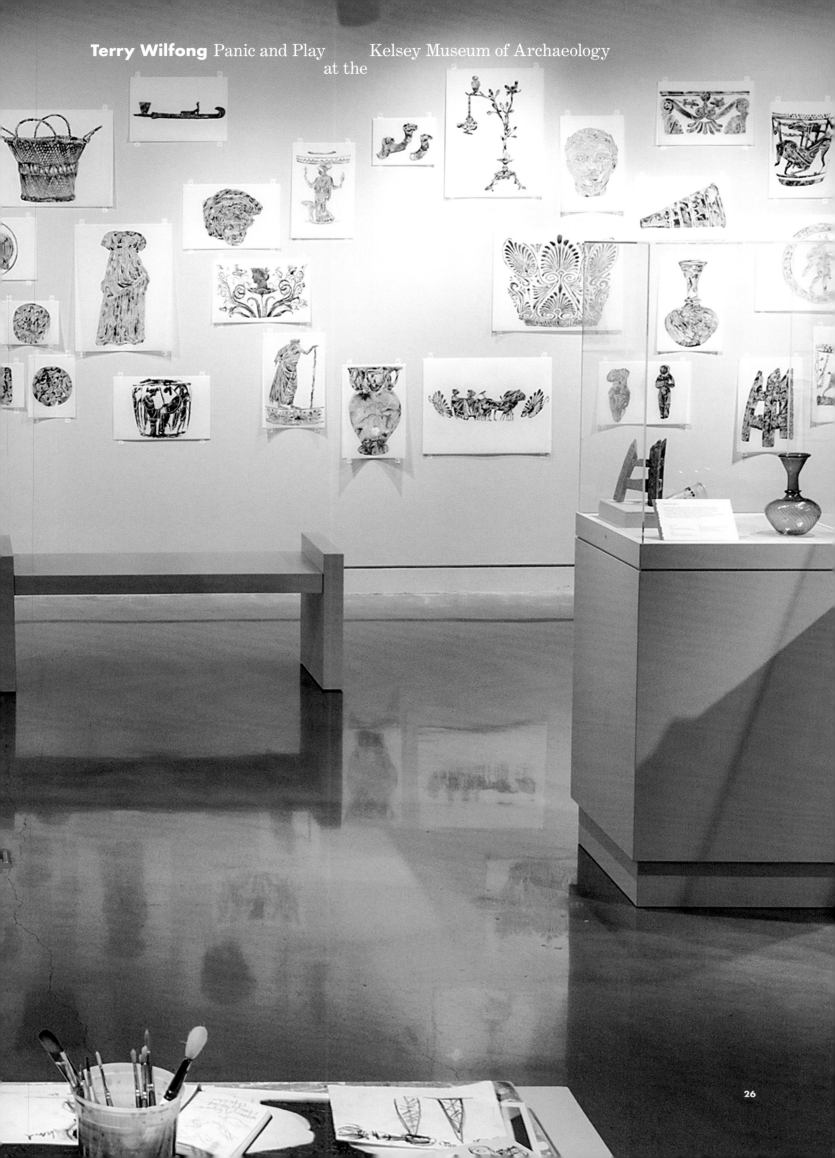

- *Cosmogonic Tattoos* is being presented on the occasion of the University of Michigan's bicentennial as a celebration and exploration of the collections of the Kelsey Museum of Archaeology and the University of Michigan Museum of Art. I've been in on this project since the beginning, nearly five years ago. I met Jim Cogswell through our mutual student John Kannenberg, whose MFA thesis exhibition and performance was presented at the Kelsey Museum. As I got to know him, I encouraged him to think about doing something for the Kelsey as well. Little did I know what amazing results that suggestion would bring. I have had the great pleasure of seeing the project grow and expand from sketches of artifacts in the Kelsey Museum galleries; to ink paintings on vellum; to the early drafts of complicated, intricate designs for the window vinyls, which evolved to include objects from the collections of the University of Michigan Museum of Art; to their final installation on the windows of the two museums. Through our regular meetings, first in the Kelsey Museum and increasingly in his studio, I had a window onto the complex processes by which the work gradually took shape. Cogswell established early on that he wanted to use objects in the Kelsey as the basis for his project, and he spent many hours at the museum, sketching and looking. Out of the 100,000 artifacts in the Kelsey Museum, he chose around 220, all on display. His choices fascinate me: try as I might, I could rarely direct him to my favorite objects, and, if I did, he used details or views I would not have expected. He focused on humble objects of daily life—a broom, a window frame—as much as on objects of fine art, and he selected details of pieces I had never noticed. I can see clusters of related objects in his choices, perhaps influenced by their installation in the museum, but they span the galleries and the different cultures and time periods they represent. As a curator of ancient art, it has been both liberating and humbling to see these objects anew, through the eyes of an artist, and I'll never look at the collections in quite the same way again.
- In Cogswell's deployment of Kelsey Museum objects, artifacts are often freed from their original use and purpose and given new roles, based on their form. Decorative motifs are liberated from the objects they adorn and reimagined as objects in themselves, while pots and jars become decorative motifs, or elements of novel composite forms. Human and animal figures merge with inanimate objects and combine into strange hybrid creatures. A window frame, turned on its side, becomes a ladder, while a glass lamp, turned upside down, becomes a traffic cone. Everything has a new purpose and a new life, and the objects' joy at their freedom is clear. They move and tumble over each other. The ladder, multiplied many times over, seems to provide an escape route. Sometimes when I look at *Cosmogonic Tattoos* I see the objects gleefully running around, freeing themselves from my curatorial oversight, thumbing their noses at my desire to categorize and tame them.
- But this freedom also brings danger. The museum's core goals are to protect and preserve its collections, as well as to interpret and display them. Cases, vitrines, mounts, and bases may be confining, but they are also protective. In Cogswell's vision, the objects may have escaped their cases to run wild, but they have also lost their protection and moorings. A sense of distress and even panic lies beneath their liberation. Waves of water threaten flood, figures move in masses, while communications towers constructed of decorative motifs send out ominous messages in an ancient pseudo-writing originally used for magical purposes.
- As an archaeological museum in the twenty-first century, the Kelsey must acknowledge and make sense of the complicated processes by which objects reach us from the ancient past. Nothing from antiquity comes direct from its original maker and owner: what survives to the present is often a result of an adventure that can involve looting, plunder, abandonment, destruction, and desolation. Each artifact in the Kelsey Museum came to Ann Arbor through some mechanics of loss, deliberate or accidental, particularly those that were purchased or donated—indeed the tumult of *Cosmogonic Tattoos* is a good metaphor for the antiquities market and its vicissitudes.
- Of course, the majority of artifacts in the Kelsey Museum's collection (and many featured in the project) come from controlled archaeological excavations— a fact we take pride in and something that adds value by providing context and secure provenance. But the process by which these excavated pieces came to Ann Arbor was itself a result of Western colonial practice. The "division of finds," according to which some artifacts went to the foreign excavators, meant objects were removed from the places they were made and used. And the archaeological context itself is the residue of processes of loss, destruction, and abandonment. For example, the glass vessels and lamps in *Cosmogonic Tattoos* are often beautifully preserved because they were carefully hidden by their owners, who were unable, for whatever reasons, to retrieve them. Bronze figures of gods dedicated as temple offerings by grateful devotees were swept into a pit once the altars were full; caches of such temple surplus

are our primary source for them and often account for their excellent preservation. The window frame that became a ladder in Jim's vision was removed, in 1928, from a mud-brick house that had stood for nearly 2,000 years—a reminder that excavation can sometimes involve destruction. Part of what makes *Cosmogonic Tattoos* so appropriate for the Kelsey Museum is that it evokes our objects' tumultuous pasts.

• I am aware that someone might ask why the Kelsey Museum is hosting *Cosmogonic Tattoos*, or why we engage with contemporary art at all, and this is a fair question. I believe these exhibitions have enormous value because artists give us new ways of looking at the ancient past. Working on a daily basis with the remains of ancient cultures, I have become used to finding meaning in fragments, and, in doing so, have come to terms with the fact that there can be little absolute certainty about the past. Our evidence is incomplete: we use the scraps that survive and subject them to close reading, theoretical interpretation, and scientific analysis. But our work also requires a degree of imagination and openness to alternative possibilities. By showing our objects in panic and at play, Cogswell's project provides a fresh perspective on the ancient world, encouraging us to see new patterns, take greater risks in scholarship, and think about artifacts in the context of a twenty-first century world.

•

Terry G. Wilfong
is Director and Curator for Graeco-Roman Egypt at the Kelsey Museum of Archaeology and Professor of Egyptology in the Department of Near Eastern Studies at the University of Michigan. His research centers on aspects of gender, society, and religion in ancient Egypt. In addition to curating several exhibitions of ancient Egyptian artifacts for the Kelsey Museum, he has supervised a series of contemporary art exhibitions, installations, and performances in which artists respond to artifacts in the collection. He is currently working on a book, *Egyptian Anxieties: Living in an Age of Oracles*.

Figurines Standing on Layers of History
Walnut ink, sumi ink, and inkjet print on paper
42 x 30 in. (106.7 x 76.2 cm)
2017

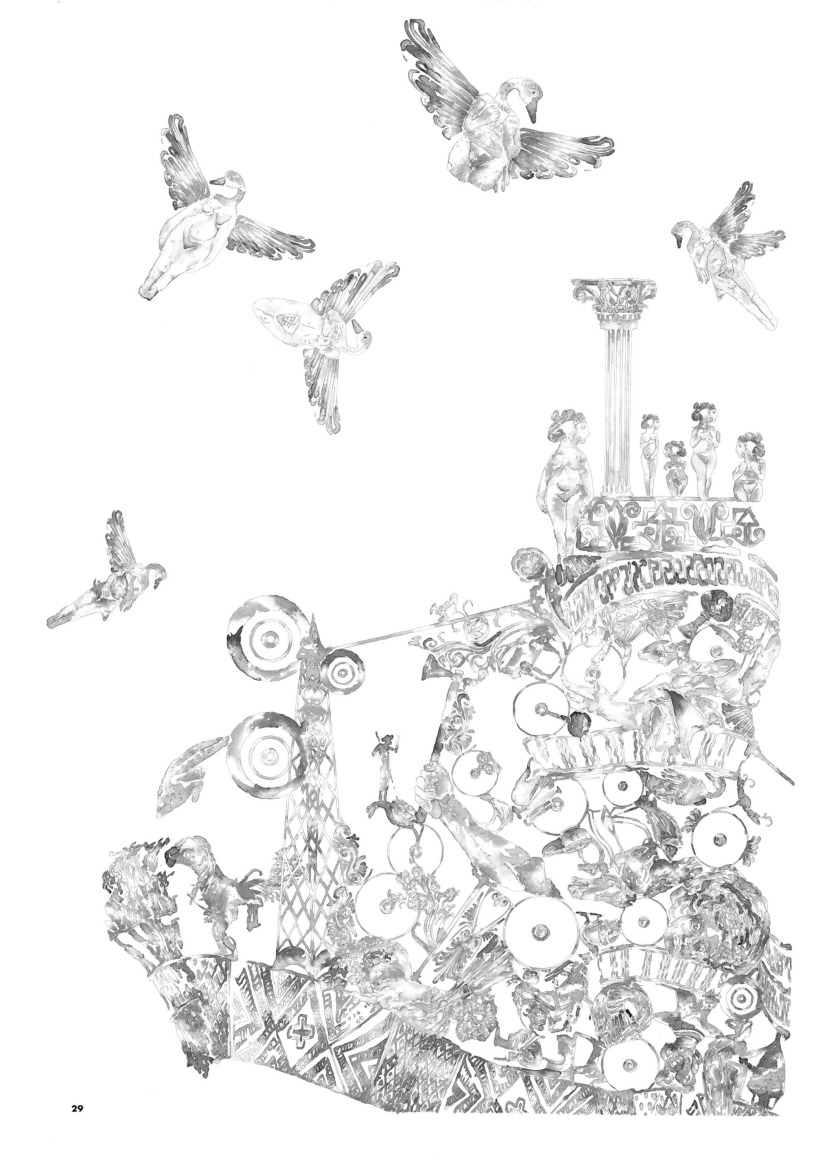

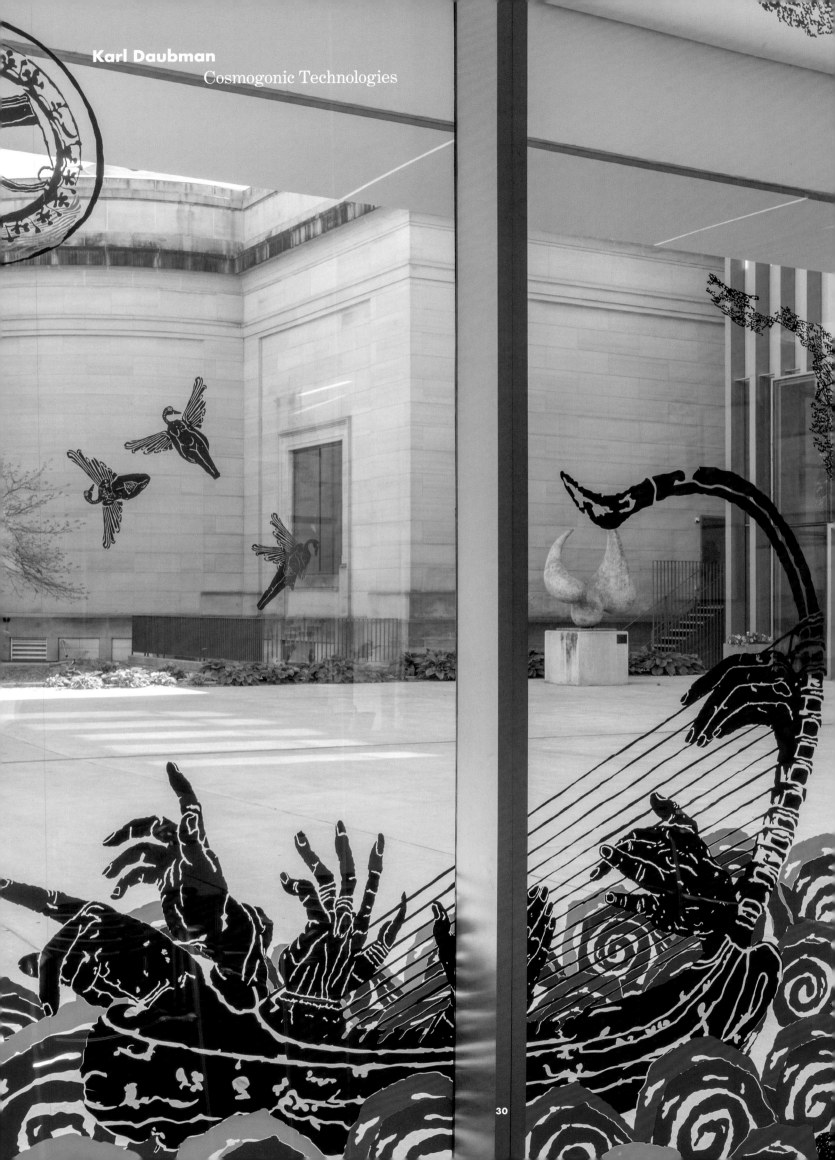

- Technology is an ever-present driver in practice, be it architectural or artistic. In architecture, the evolution of construction and manufacturing has changed the basic building blocks available to us. Innovation is now the result of the creative aggregation of a limited library of standardized industrial elements that are manufactured off site, each with its own metadata that must be controlled and managed during the design process. The architect's software has even evolved to the extent that we call it BIM—Building Information Modeling. As architects put elements together, collective systems of components take on increasingly complex relationships where the network of products transcends that of the individual parts. Different structural members get paired to create subassemblies, which are then put together to make full assemblies. The same elements deployed in different orientations or adjacencies will have performance implications— structural, acoustic, visual, or insulative impacts on the assembly. Depending on where the assemblies occur in a building or what other assemblies they are near, their function and impact changes. Their context matters.

- The digital tools that Cogswell used to construct a mythical origin narrative across the facades of the Kelsey Museum of Archaeology and the University of Michigan Museum of Art aid and transform the creative process by expanding the possibilities for combining and recombining his inventory of component parts. Each stage of his process of aggregating design elements is an extended interplay between digital control, physical slippage, and shifting contexts. He began by documenting 250 objects in the collections of the two museums in photographs. These digital images were further liberated from their original context by being translated into hand-made paintings and drawings, which were translated again into digital images. In this form, the unique, three-dimensional objects could then be more radically reinvented. Through computer-controlled production technologies, they become packets of information that could be identically replicated as independent elements. Flattened, abstracted, and broken into multiple parts, they could be readily redeployed into different orientations, combinations, and adjacencies. They could be scaled, overlapped, and trimmed. They could be dragged and layered into simulated assemblies on the screen, their function and impact changing with each variation, in a potentially infinite number of combinations.

- The ease of digital manipulation led to multiple creative associations, the elements growing together into a network of subassemblies to form collaged bodies that would eventually embark on their journey across the museums' facades. To get there, a computer file of the assembled network of parts was sent to precision cutters that directed blades to cut the sheets of vinyl adhesive material following the outlines in his digital files. The vinyl sheets were then weeded by hand to extract the negative spaces around the images and isolate the forms that would be transferred to the windows. There they became part of yet another context that altered their function and impact.

- In *Cosmogonic Tattoos*, objects from the past are reconceptualized and redeployed to suggest constantly changing connections between forms. These forms retain their original meanings while simultaneously taking on new ones. It is through their context and connection to adjacent elements that their identities change. Cogswell's associative creativity and ability to capitalize on existing forms and figures conjure up Giuseppe Arcimboldo, a sixteenth-century Italian Mannerist painter known for his portraits of human faces constructed of fruits, vegetables, flowers, and fish. Both artists are able to preserve the simultaneous reading of individual, autonomous elements and the completed, coherent assembly; the result is a work that occupies the sweet spot between the part and the whole. The sheer number of parts that get pulled into the assembly creates a graphic density that subsumes the individuality of any one element. The potential for motif emerges as we track discrete graphic icons throughout the narrative. The story builds through the repetition, disruption, and eruption of elements.

- In the way dishes, bowls, and plates are documented, abstracted, and then re-presented within the installation, I instinctively see wheels and gears, generating relationships as they turn and interlock. New meanings for ancient vessels emerge through their shifting combinations. Their forms move smoothly into configurations that churn out multiple associations across the windows. A vase becomes a transmitting device atop a tower made from a phrase of ornament. I recognize the forms as ancient artifacts in the Kelsey Museum while simultaneously seeing them as the cell phone transmission towers I encounter on my daily commute, which I have now become more attuned to noticing. Their mundane presence as instruments of communication technology has become caught up in the

gears of *Cosmogonic Tattoos*, opening them to new possibilities within their roadside environments.

- A museum collection is a record of the technologies that produced the artifacts on display, whether we notice it or not. The significance of those tools and processes for the cultures that used them is never the same as it is for us today, living within a different technological ecology. *Cosmogonic Tattoos* redeploys ancient artifacts produced by methods that have either disappeared or that we now take for granted. It is a product of new technologies, deployed to create images and metaphors of technology itself at work. Through the multiple serendipitous combinations afforded by the technology used to create it, our awareness of the role that technologies have always had in shaping the world we inhabit is heightened. Cogswell's collection of reimagined artifacts is a playground of technology, assembly, and context that provides us with opportunities to make new associations and spin new tales.

32

•

Karl Daubman
is an architect at the forefront of design and computation. He is currently Dean of the College of Architecture and Design at Lawrence Technological University and was formerly Professor of Architecture and Associate Dean for Post-Professional Degrees and Technology Engagement at the University of Michigan's Taubman College of Architecture and Urban Planning. His architectural practice is DAUB (design, architecture, urbanism, building) Research Studio, which focuses on expanding the relationship between design and technology, particularly between digital/robotic fabrication and building. From 2001–12 he was a partner of PLY Architecture, co-authoring a range of award-winning work exploring design and digital fabrication with a focus in Michigan. As the Vice President of Design and Creative Director for Blu Homes, he led a multidisciplinary team that developed green, prefab houses that fold for shipping.

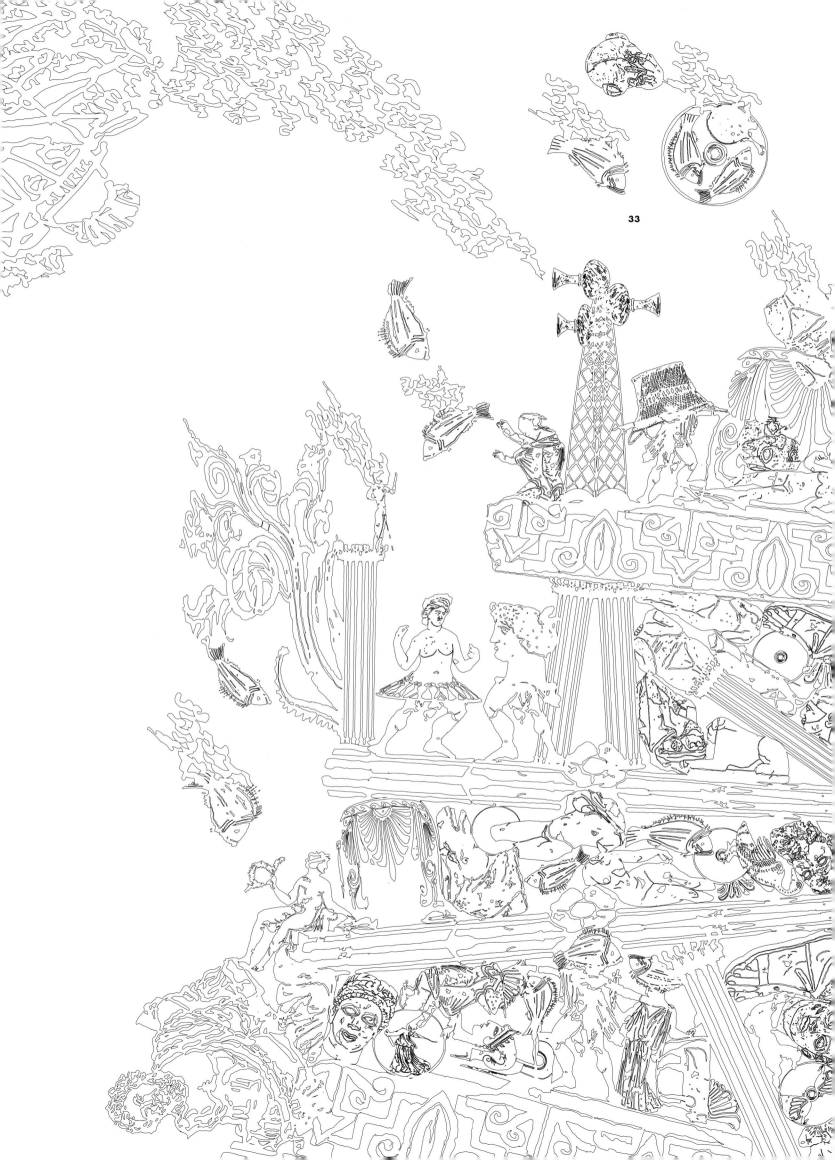

33

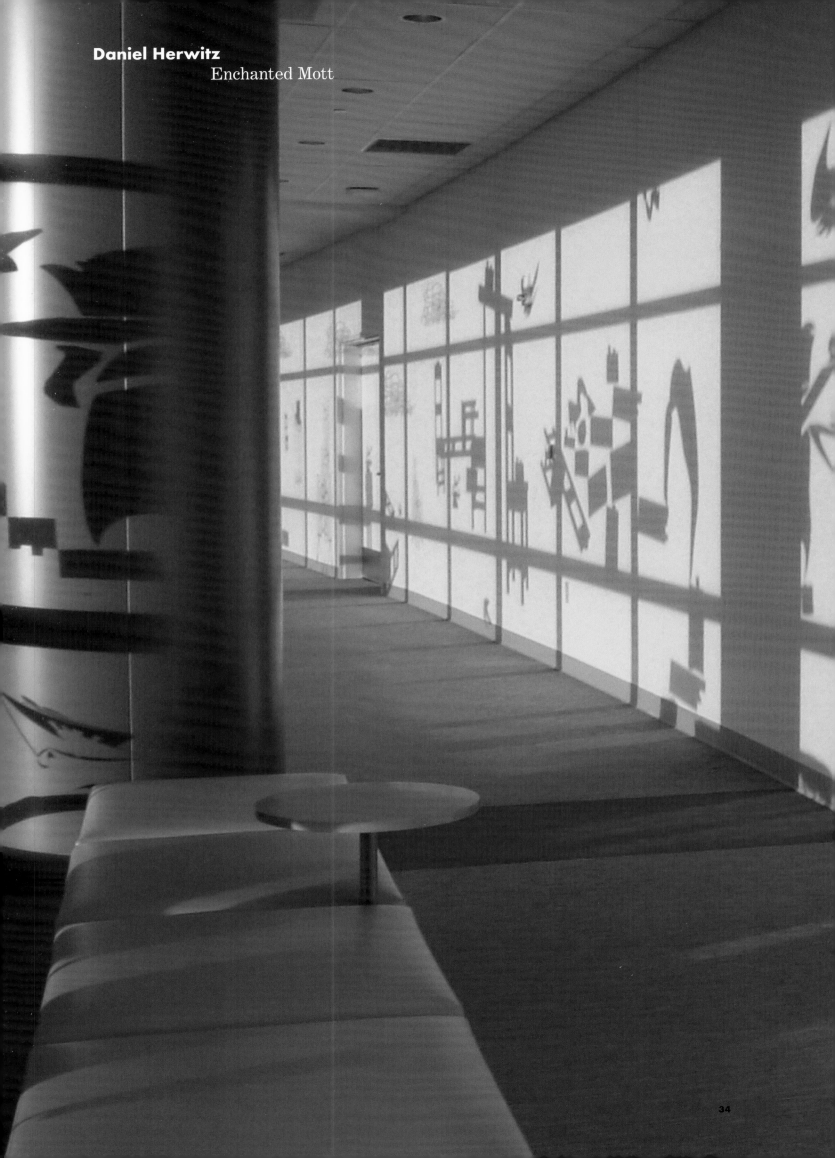

Daniel Herwitz
Enchanted Mott

In sharp August light, the yellow corridors of the University of Michigan's C. S. Mott Children's Hospital, with their cherry red carpets and gold pillars, become a theatre of shadow puppetry. The vinyl figures of Jim Cogswell's *Enchanted Beanstalk*, based on the tale of Jack and the Beanstalk, block the light of the windows on which they are pasted, creating silhouettes of black shadow on the walls. This play of black figures against yellow walls is so full of movement that one has the sense that cinema has been reinvented in all its magic and ethereal glory. Creeping through these corridors for the dreary routines of blood draw, infusion, doctor's visits, or bone marrow biopsies, one briefly floats into the artist's shadow world, as if entering a childlike vision of animated enchantment. I walked these corridors more times than I wish to remember when I underwent a blood and bone marrow transplant for a potentially devastating blood disorder. The adult transplant unit is tucked away in this building, but most of the sick here are children. They are pushed in wheelchairs, carried, or walk, hands held by mothers or fathers whose anguish is bone deep, and who, by a tremendous force of will, put their own anxieties to one side for the sake of their children. The children, with their chalk white skin, thin limbs, and wide, staring eyes, live in a world of discomfort, fatigue, and dread.

- It takes an empathetic artist to decorate such a building, to try to return joy, energy, and magic to its inhabitants. And it takes an articulate artist to do this through a mural that is only visible in fragmentary form from the inside of the building. Though it stretches over multiple windows and stories of the C. S. Mott Children's Hospital and the Van Voigtlander Women's Hospital, the mural must be legible in every one of its parts. For no one can see the whole all at once, only a shifting landscape of parts that continually surprises as one moves through the corridors of the building or studies it from various outside perspectives. Children at Mott do not play: they wait and they endure. And so the work must be an offering, a gift of the energy and pleasure they lack; it must offer the promise of a childhood to those who do not have it. Cogswell's carnival of animals and people in jazzy, whimsical, and funny designs in bold azure blue, forest green, grapefruit yellow, and elephant pink seem to jump off the page of the windows. His figures are charming, silly, adorable, and pleasantly terrifying. The scenes are not simply those of the Beanstalk story, but an extravaganza of insects, birds, beasts, and invented plants that make traversing the corridors of Mott like wandering in a garden of fairy tales.

It is enlivening even when one is tired and wearing a protective mask. In such circumstances one craves something non-institutional: colors contrasting to the usual lime green hospital walls. One craves adventure, because one is confined. One craves animation, because one is fatigued. One craves freedom above all. If the mural cannot actually offer a magic carpet to whisk the patient to another, better life, it does at least offer such a carpet to the eye and the imagination, which is a heady consolation.

- Cogswell's process began with a study of the building's plans and elevations, and repeated visits to the building while it was under construction. The designs originated as hand-cut paper collages that were then transposed into digital format and scaled to the building's dimensions. The vinyl was made by a local graphics shop in Michigan and personally installed by the artist onto the interior windows. The installation was completed in 2011. I had my autologous stem cell transplant in September 2012, but I had known Cogswell's murals since 2007, when I commissioned him to do a two-story mural to honor the twentieth anniversary of the University of Michigan's Institute for the Humanities, which I then directed. The materials for *Nothing to Say* were hand-cut adhesive shelf paper from the hardware store, a precursor to the vinyl of *Enchanted Beanstalk*, and the detritus from that project was collaged and digitized into some of its imagery. Cogswell's creation for the Institute was nothing short of stupendous, a Hollywood/Las Vegas extravaganza of abstract and modernist shapes, as if the entire history of European and American art had been put through a Cuisinart until a thousand fragmented shapes emerged, each brash and glorious. These were then composed into an elaborate collage containing a hidden text that one had to work hard to read: "Nothing to say." To a seasoned ear like my own, this quip recalled the statement by avant-garde composer John Cage, who famously wrote: "I've nothing to say and I'm saying it." This paradox of taking the liberty of saying nothing and saying it loudly rings with distinctly American brashness and hilarity, but also has a purpose somewhere between Buddhism and the project of abstraction, which is to invent an art that floats above meaning in the manner of a transcendent planet or galaxy. This creation of a thing whose color blows the mind, whose shape is virtuosic, and whose purpose is the celebration of a state catalyzed by the magic of art was, I now realize, what prepared him to do *Enchanted Beanstalk*, which also says nothing and says it beautifully. After all what

Enchanted Beanstalk (2011),
interior views
Adhesive vinyl on glass,
C.S. Mott Children's
and Von Voightlander
Women's Hospital,
University of Michigan
Medical Center,
Ann Arbor

could be said by a mural composed for drastically ill children (and a few adults)? Some kind of platitude about the meaning of life, about fortitude and bravery under adversity, about how sad it is what children have to endure, some drivel about being victorious when children routinely die there? Such words would be condescending, or worse.

- The key is not to speak, but to elevate, which is the point of the Jack and the Beanstalk story. Remember that story: Jack exchanges (to his poor mother's consternation) the family's only cow for magic beans when he was meant to sell it for money. He tosses these beans to the ground and out shoot enormous beanstalks. The fearless Jack climbs all the way up one to an enchanted castle, where he must avoid the notice of a giant fond of eating the flesh of children, who utters the famous, terrifying line: "Fee fie fo fum, I smell the blood of an Englishman." Jack steals the giant's golden-egg laying hen and escapes down the beanstalk to his mother, cutting it down to kill the giant pursuing him. This is a fairy tale about adventure, risk, reward, and stealing life from the clutches of death by cunning. I remembered the story when I lay close to death in the transplant unit on the eighth floor of C. S. Mott. For a transplant is a way of outwitting death. In the course of an autologous stem cell transplant, one's bone marrow is totally destroyed and replaced either by one's own stem cells, harvested earlier, or a donor's. The amazing thing is that these stem cells, once inserted into one's blood, find their way to exactly the right place in the body, to the bone marrow where they graft and regenerate blood and life. These tiny cellular miracles never get waylaid, never attach instead to stomach, liver, heart, brain, or left toe. Nature is magic, the stuff of fairy tales.

- Jack and the Beanstalk is the right story for Mott, where blood and bone marrow transplantation is routine for both children and adults. It is a diversion, an allegory, and a prayer. In 2012 I was lucky to cheat death and its lust for the blood of the Englishman. I now occupy the dancing shadow-world of Jim Cogswell's figures. It is called life.

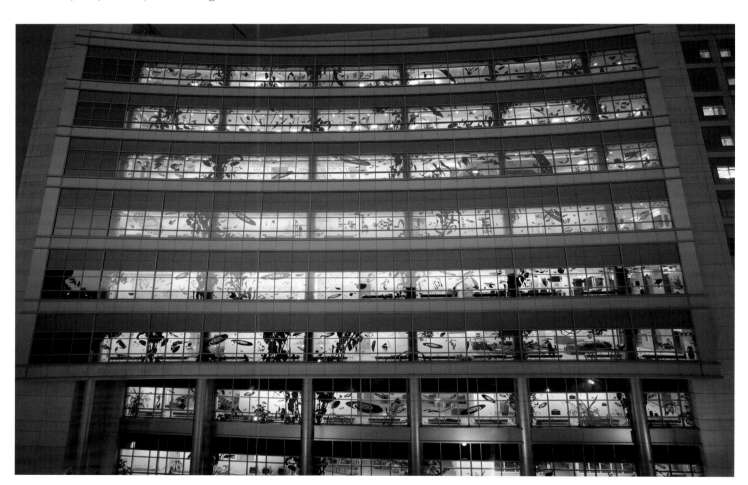

•
Daniel Herwitz
is Fredric Huetwell Professor of Comparative Literature, Philosophy, and History of Art at the University of Michigan, where for a decade he directed the Institute for the Humanities. He was Chair in Philosophy at the University of Natal, Durban from 1996 to 2002; this moment of democratic transition in South Africa inspired his books *Race and Reconciliation* (2003) and *Heritage, Culture, and Politics in the Postcolony* (2012). He has published ten books including the award winning *Star as Icon* (2008), and *Husain* (1988), on the modern painter M.F. Husain, which won a National Book Award in India. His most recent book is *Aesthetics, Music, and Politics in a Global Age* (2017). Herwitz frequently writes about art for galleries and publications in New York, London, and Cape Town.

Enchanted Beanstalk (2011), exterior views

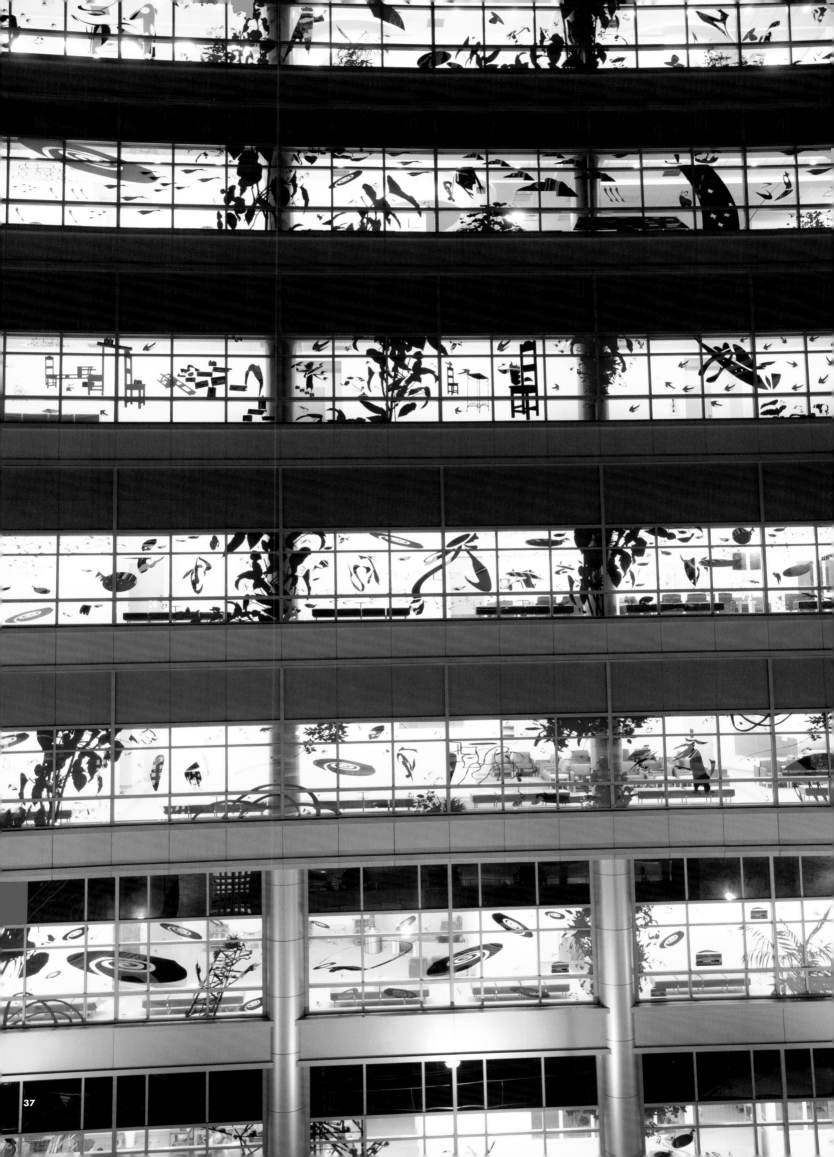

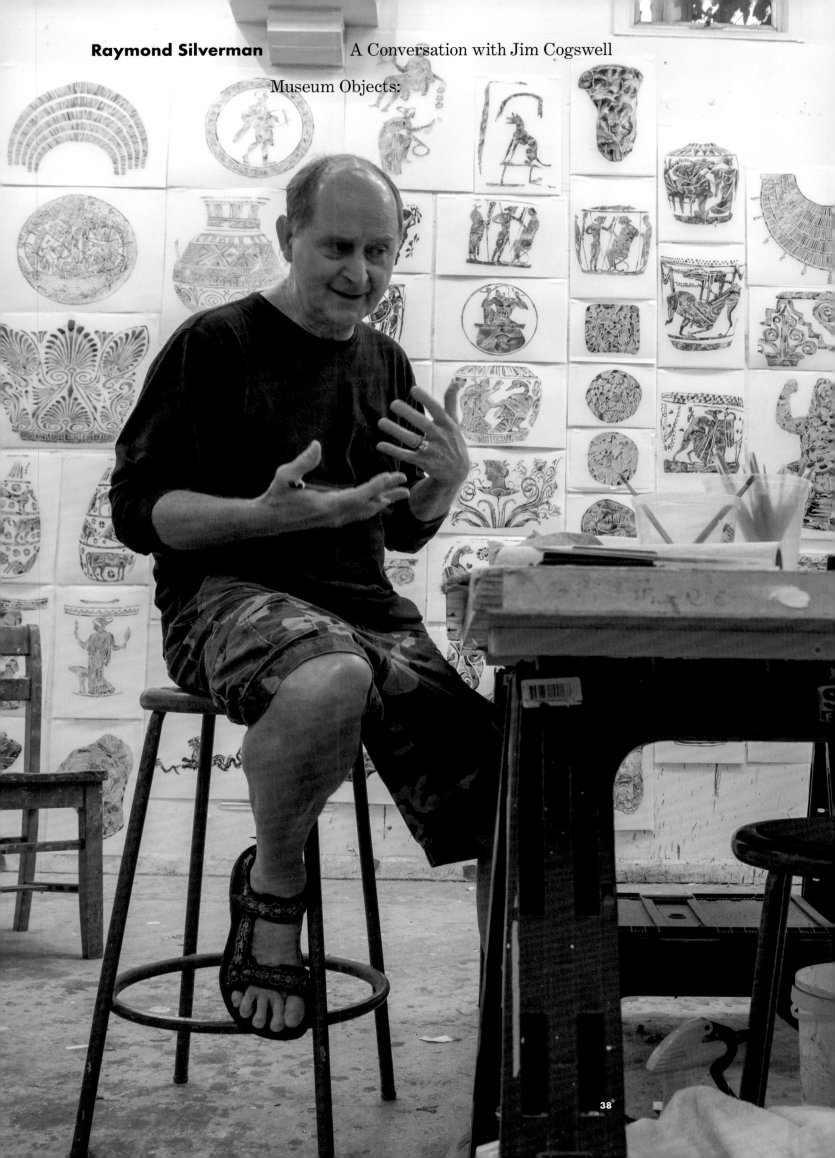

Raymond Silverman A Conversation with Jim Cogswell

Museum Objects:

The following conversation between Jim Cogswell and Ray Silverman, the founder and former Director of the University of Michigan's Museum Studies Program, took place in Cogswell's studio in February 2017, just before the installation of *Cosmogonic Tattoos*. In this edited excerpt they discuss the project in the context of current thinking about how and why museums collect and exhibit.

Raymond Silverman **• Jim Cogswell**

Where to begin? Let's start with the title of your installation. You have called the vinyl images that you applied to the windows of the Kelsey Museum of Archaeology and the University of Michigan Museum of Art (UMMA) "cosmogonic tattoos." What is it you are referencing here?

- By calling my piece a tattoo, I am invoking human skin and, metaphorically, the skin of the building. Skin suggests a dynamic exchange that is part of the vitality of life. Suggesting that the building has a skin might provoke a sense that the museum is alive as an institution.

- I am also invoking traditions of ornament. Part of my experience in the Kelsey Museum was being confronted with traditions of ornamentation in premodern societies, something markedly different from the world we live in now. I became curious about the compulsion to ornament. I imagine that early humans decorated their bodies even before they decorated what they wore.

Yes, there is also an important social dimension to tattoo. A tattoo is a mark that often can be read. As such it offers a visual strategy for articulating one's social identity. They can be public, but also very personal, perhaps signaling a moment of transition in one's life. Along these lines, was there any sort of thinking on your part about using the tattoos you have created as a means for defining or perhaps redefining the identities of UMMA and the Kelsey?

- The vinyl installation comes at the end of a long process of social negotiations. It goes on a permanent architectural surface. The building it is on represents the identity of a place, the institution that owns it, and the people who use it. By putting vinyl on windows I am mediating the building's public identity, if for a short time.

Why cosmogonic?

- I understand cosmogonies as the stories we tell ourselves about how the world came to be the way it is. All cultures have their own cosmogonies, whether or not they are openly articulated. They shape the values by which we function as individuals and as a society. When we talk about the Big Bang, we are not talking just about something isolated within astrophysics. This explanation for the origins of the universe has repercussions for what is significant about my relationship to you and the society I am part of. Societies with different cosmogonies are bound to have different understandings of what it means to be human.

- So with *Cosmogonic Tattoos* I am trying to keep bigger questions in mind, such as, where did we come from and how did we get here? Do I need to assume the presence of a conscious being that originated this universe in order to find meaning in it? What other forms of meaning are possible? It is related to how I find meaning in my own life and what my responsibilities are to the society in which I live.

- My title is also a tribute to Queequeg, the South Sea islander and harpoonist in Melville's *Moby-Dick*, whose tattooed body bore "a complete theory of the heavens and the earth, and a mystical treatise on the art of attaining truth." And it is a

rejoinder to Adolf Loos, the early twentieth century Viennese architect and critic who famously wanted to banish ornament from modern architecture, declaring it suitable only for the likes of children and tattooed Papuans. You can clearly see where my loyalties lie.

Yes, I can! The installation is also in part about migration, specifically the migration of objects from one place to another. While developing this project, I wonder if you were thinking at all about current world events, specifically the refugee crisis and the migration of people from Africa and the Middle East to Europe and other parts of the world?

- That crisis definitely became part of my narrative. In my working process I borrowed images of objects from one museum and put them with images of objects from the other, as if the objects themselves were being displaced from one context to the other—migrating. I then began narrating that displacement within the design I was creating. With a slight shift of focus in how I defined what I was doing, it became clear that my project was relevant to contemporary predicaments of cultural destruction and human displacement. I began this project wondering where these objects came from and how they got where they are. I soon realized that this question is part of a much larger story.

- We share a fundamental humanity with people of the past. In the Kelsey I recognize objects that would not be out of place in my own home—an ancient broom, vessels, and jewelry. But despite our kinship I have no clue why people made many of the things I am looking at. Is the maker a different kind of person than I? When I say that these are objects from societies that had fundamentally different assumptions about what it means to be human, it might make some people uncomfortable. But what I mean is that I can't presume to understand the people who made and used these objects when we are separated by such an abyss of time and space and such profound cultural differences.

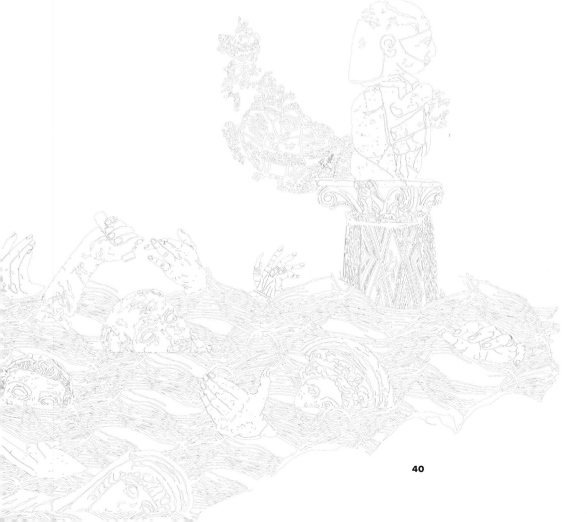

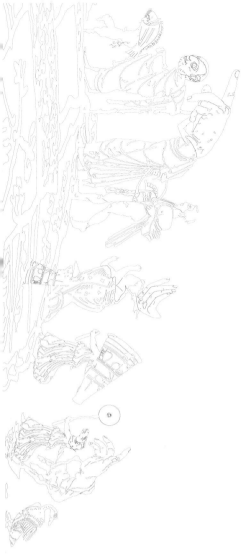

It is interesting that some people might be troubled by your being honest about that. In a way you are saying, "Okay, I've basically borrowed imagery derived from objects made in a different place and time and have made something new from them, have given them new meaning." What it boils down to is the tension that exists between people who embrace cultural relativism and those who don't—people who believe there are fundamental human beliefs or values that transcend time and space. Some folks think that the meanings they have ascribed to the objects you have "appropriated" represent fixed "truths." They fail to realize that the truths in which they are invested have emerged from the specific contexts in which they have engaged these objects, in much the same way you have created new truths—given new meaning—to these objects by setting them into a new context. The process of taking things from other times, other places, other cultures, and giving them new life, new meanings, is an issue that historians of material culture struggle with all the time. One of the things you've got going for you is that you are an artist. As such you occupy a particular social space in our society. You have "artistic license," the freedom to basically take stuff and pretty much do whatever you want with it to create new stuff.

- Being an artist is a privilege. But when I realize that I have been given this exceptional space to work within, it makes me a little nervous. I would rather understand the ways in which being an artist is not exceptional. Being exceptional means that what I do as an artist occupies a separate category from what other people do, and that isolates what I do within a so-called aesthetic category of experience.

But what you do requires a certain level of aesthetic or visual literacy.

- I believe in visual literacy. Like any kind of knowledge, it is acquired through experience and attentiveness. And you can't be lazy about it. But I don't want artistic experience to be in a separate category from the rest of life.

I understand. Sadly, one of the shortcomings of our society is that art is all too often seen as exceptional. For some people it is a good thing, something wonderful, something that is highly valued, but still something that is different. Separate. When it comes to folks who don't value art, its exceptional nature translates into its being unessential, irrelevant, something that is expendable. A lot of people are driven by this issue of relevance. But what does it mean to be relevant? An initial response to your work might be visceral—for instance one might find your tattoos whimsical. But spend a little time looking and it is profoundly cerebral. It gets inside your head and it gets you to think. People are drawn to your work and engage it in different ways. It is going to evoke personal responses. But the public nature of Cosmogonic Tattoos *encourages social interaction, prompting conversations about what is going on in your work. In effect it is opening a space of dialogue about a host of relevant issues—some anticipated, others not.*

- That is important to me. I want people to have an experience. Embodied experience. Embodied knowledge. I have a passion for making things. I am compelled to wrestle with physically putting things together. I'm not happy with just making a reference to something. I want to shape something. Shaping it is what gives it meaning. Not pointing a finger, and saying, "Hey, look over there."
- You say that the work is cerebral. I have invested a lot of cognitive energy in it, but I don't want it to be hermetic. No one ever needs to know about the layers and layers of thoughts and associations unearthed in the process. They are what compel me to make something, and whether the viewer is conscious of them are not, they shape what they are experiencing.

*My suggesting that your work is cerebral derives from what
I personally bring to looking at it. If your work operates on
different planes for different viewers and evokes a wide range
of significance and meaning, bravo!*

• As far as I am concerned, the work does not exist until
somebody engages it. As a viewer, you must create
the experience for yourself. It is your responsibility.
Otherwise it won't mean anything to you.

*There is an interesting manifestation of the idea of experience
in current thinking in and about museums. It has to do with the
process of "meaning making" that goes on, not only in museums,
but in all aspects of life—the recognition that everyone brings
a unique set of past experiences to each new experience, and
that it is from this meeting of past and present experience that
personal meaning is derived. So while one may speak of shared
experience, the meanings people ascribe to experience are
idiosyncratic.*

• When you gather objects in museums, you are offering them
up to people, but at the same time you are creating a structure
for them to slot their experience into. Therein lies all the
conflicts and tensions that make museum collections fascinating
and problematic at the same time. The question is how to open
these objects up to our imagination. I know in your field you
wrestle with that. I am deeply grateful to museums. They have
introduced me to thrilling experiences. I didn't grow up visiting
museums, so when I first encountered the critique of museums,
it didn't mean a lot to me. I was just so grateful to be drinking
at the well. While this project is not a critique of museums, it has
made the critique of museums more meaningful to me because
it has foregrounded the problem of how objects get organized,
whose story is being told, and from what perspective.

*Exactly. Your installation is about pulling objects out of
particular museum environments and reconfiguring them,
which makes it possible for people to apprehend them in different
ways, which inevitably will force them to think about their
original context in different ways. So, what we are talking about
here is the discursive nature of objects. This is another subject
that many people in the museum field think about. Not too long
ago, a curator believed that her or his sole responsibility was to
work with what we might refer to as objects of knowledge that
possess specific meanings, specific truths. Curators interpreted
or translated the knowledge derived from the object and, in
exhibitions, shared this knowledge with the museum visitor, who
would leave the museum having assimilated that knowledge.*

• As if it could be poured from one vessel into another.

Right. Pretty straightforward.

*However, we now recognize that things are a bit more
complicated. Engaging with the knowledge that a curator offers
is only one element in a complex encounter between the visitor
and the museum. Curators today are thinking more holistically
about what happens when someone enters a museum, thinking
about visitors engaging not only the single object, but a group of
objects set in a specific context.*

• Is this what you mean when you talk about material discourse?

*Yes, we are acknowledging that museum objects have multiple
layers of meaning. That things move through time and space,
acquiring meanings depending on the contexts in which
they are used. They are material sites that prompt multiple
interpretations. They engender discourses that sometimes
affirm and at times challenge the ideas that circulate around
them. These objects are not static. They do not possess a single
fixed meaning. As they move in time and space their significance
is in a constant state of flux. Recognizing the discursive nature
of things acknowledges the power that objects possess to move
people to think and act.*

One of the things I find so exciting about your project is that you have turned the museum inside out. You have recontextualized objects that people see in museums, institutions that protect and display things. You have taken these things out of the museum and put them in a very different setting. Literally thousands of people—primarily students—walk past UMMA every day, so in re-siting these objects, you have created an opportunity for many more people to engage them.

- More people, but also with a different set of expectations. When you go into a gallery or a museum, when you enter the white cube, you switch to your, "now I'm looking at art" cognitive apparatus. What I enjoy about working in vinyl is that you can subvert that mindset, make something that people may not think to call art. I am using exactly the same material you would find in the window of a restaurant or a hardware store.

Can you say a bit more about this strategy in Cosmogonic Tattoos?

- At the outset, I created a constraint for myself—all the images on the windows would come from objects inside the two museums. I wanted the viewer to sense that these images had their own histories separate from my using them. And I didn't want those histories to be obliterated by my manipulations. So when the people who know these collections really well see my images, they have a double picture in their mind. They have the picture of the object the image came from because they know the object, but they also see how it has been transformed and connected to unlike objects. This produces a moment of friction. They recognize that the thing they thought they knew has become strange to them. That delights me.
- You have touched on the issue of what happens when an object that was personal to someone is depersonalized by being put in a spotlight, frozen in time, preserved in a collection. In a sense it has been made special. At the same time, it is deprived of its original uniqueness in relation to its place in someone's life. In my project, I am reappropriating those objects. I don't know if my process is a naive extension of the way that museum collections appropriate objects for their own purposes or a critique of that practice. I'm not sure I know how to make the distinction.

The simple answer is that there really is no difference unless you are familiar with the history, familiar with the object's original context, unless, of course, you think about the circumstances in which the object may have been acquired from its owner. The fact is we seldom know anything about such circumstances.

- The collecting of objects from other societies has a troubling history. I began painting the African objects in the UMMA collection because they were compelling to me. I don't know why, but the headrests in particular appealed to me. They had a structural clarity and a presence that I wanted for my windows. After I started making images with them, I realized that I was not quite as comfortable freely manipulating them as I was with objects from, say, the ancient Mediterranean. I took enormous liberties in my translation of the Yoruba Egúngún mask, reconstructing it using objects from the Kelsey. In the end I used those translations, but only after working it through with you and with Laura De Becker, the Associate Curator of African Art at UMMA.

*Your uneasiness regarding the African material comes
from your being aware of the violence that was brought upon
the continent in the context of colonialism, and even now.
I think the most significant difference between these two types
of objects—the ancient Mediterranean artifact and these
more recent "ethnographic objects" from Africa—has to do
with temporal distance. We are much more removed from
the circumstances in which the ancient material was acquired,
and it is therefore easier to rationalize owning, and as you
put it, re-appropriating these things.*

• Yes, using the headrests implicates me as an actor in that violence. I don't feel I had any agency in the Roman destruction of ancient Seleucia, but my connection to the exploitation of Africa is too close for me to be comfortable.

*An exploitation that is still going on. So, let's return to this
term appropriation and think about how these objects were
acquired. This is something that I consider in my teaching,
pointing out to students that in most art museums that exhibit
African art, there is no reference to how the objects on display
left Africa. The biography, the provenance, of an object begins
only after it finds its way into a European or North American
private collection or museum. Most collectors prefer to remain
blissfully ignorant of the contexts in which these objects were
acquired from their original owners, because not knowing
means they do not have to grapple with the moral dilemmas
such objects raise.*

• A large part of the content of a work of art is not encompassed by a title or by a verbal narrative supplied by the artist—for example my statements about this project, which will inevitably become part of its content for viewers. The content also includes physical characteristics such as scale, material, and temporality, and it includes the history of the object itself. If I read a label that tells me where an artifact comes from and how it got here, it is not only doing justice to history, but deepening the content of the work, bringing into awareness something that might not be acknowledged because it is too uncomfortable.

*Yes, such knowledge might be characterized as an
epistemological patina. It is the intangible surface
of the object, and what lies beneath it. Apprehending the
meanings an object may have had over the course of its life,
especially those that lie beneath the surface, peeling away
the layers of meaning that have accumulated over time,
is an exciting challenge.*

• For example, the Mona Lisa will never be what it was to a viewer 400 years ago. It is tough to see past the layers of association it has acquired. In fact, impossible.

This is the nature of many objects. There is a religious institution in some rural Bamana communities in southwest Mali that utilizes a boli, *which begins as a carved wooden figure that takes the form of human being or animal. A* boli *is a material manifestation of the life force that sustains a community. It is an altar of sorts, a ritual object that receives periodic sacrifices from the men who maintain it—millet gruel, animal blood, the saliva of its custodians (thought to contain the life force of each individual), etc. Over time a thick sacrificial patina develops that almost completely obscures the original form of the wood figure. What is most important is not the wood figure but the patina. Its power resides in its patina. That is what you are talking about. What becomes most important isn't the original work but the patina. I have heard more than one person say, "You know, the Mona Lisa really isn't all that great, there are a lot of paintings out there that are much better." One could argue that it is not the painting itself but this intangible patina of meaning and value that has been ascribed to it that is most significant.*

- The cultural patina is what we see, even though we are not conscious of it because it is so integrated into our understanding of the object.

Yes, and your project can provoke those who engage it to think about the cultural patina of objects in a different way. You began with objects that we usually associate with a museum environment. Some people will have seen them in that context and what they know about them derives from that experience. You have taken these objects out of that context, remade them, transformed them into something new. Their relationship to the original museum object is apparent, but people are going to think about what they mean in this new context. It is going to be interesting to see how people deal with these objects back in the museums after experiencing what you have done.

- The vinyl is designed so that you see through the negative spaces between the forms. So at the Kelsey, artifacts in the collection will be visible both through the window and, in altered guise, in the images on the window itself. It is impossible to focus exclusively on what I have put on the window. Your focus will inevitably shift to what you see reflected in the glass or beyond it. The relationship I have orchestrated between artifact and image will also change as your body moves through space along those windows. I want my piece to provoke an awareness of the marvelously shifting relationship between all these elements. For me, that is the most significant content of the piece. Hopefully it will invite viewers to go through the museums again with different eyes, more attuned to the role of their own imaginations in understanding the artifacts there.

One of the marvelous things about this work is that it is constantly changing depending upon the light passing through the window and the angle from which you view the vinyl tattoos. The variations are infinite.

- The vinyl images are especially powerful when viewed from inside the museum. They are a kind of shadow or silhouette hovering behind your experience of the objects you are looking at rather than in front of them. One of the dimensions of my piece is the museum itself as an institution, an architectural structure, and a rhetorical space. At their best, artists enable their audiences to become aware of their own perceptions. Second order consciousness. Awareness of being aware.

I would imagine that matters for you in museum practice, too. You are trying to make people conscious of something more than just facts. You want them to be aware of their own perceptions.

Current thinking in the museum world suggests that rather than attribute a specific meaning to an object, the institution should provide viewers with an opportunity to participate in a process of making sense out of what that object might be about. Then it becomes more than just a visceral response. So, one of the things we talk about is the ways objects can be presented in different kinds of museums to address multiple ways of thinking about or apprehending what one encounters. The same object can be presented in an art museum or in a natural history museum or an anthropology museum, and those different environments can engender very different kinds of responses from the visitor.

- Because of different methodologies of presentation and the audience's expectations. I am concerned with how to convince viewers that the construction of meaning is their own responsibility. I am not abdicating responsibility by leaving it open, but granting them what is rightfully theirs. In fact, openness gives the work more impact, but its power originates in the perceptions of the viewer.

It is really interesting that artists come down on that issue in different places. There are artists who could not care less what people think of their work. They have a very specific narrative that they want to project onto the viewer. At the other end of the spectrum is the notion that viewers can make out of it whatever they want—I am not going to tell you what I am thinking about, as far as you are concerned, I am not really thinking about anything. And there is everything in between. What is significant about your process is that you are so interested in creating a context for dialogue. You thrive on talking to the people that engage your work.

- I do. I need them. That dialogue is essential for me. In a way that is what this entire project is about. It is not simply my methodology as an artist, but my theme: encounter, appropriation, plunder. Activities that lie at different locations on the spectrum of power relationships but are nonetheless related. How is something passed from one individual to another? From one society to another? Or in the case of the university, from one generation to another? At its core, those are the questions that we as educators must always ask.

- You have talked about the significance of objects moving through time and space. All the museum objects from which I have drawn inspiration traveled through time and space to occupy a spot in our collections. Talk to me a little bit about objects and time. You did a whole exhibition on time. Why does that interest you?

It interests me because in wanting to understand more about people who come from societies other than one's own, one quickly learns that everyone doesn't think about, or even reckon, time in the same way. Even in our own culture we have different ways of thinking about time. The exhibition you are referring to is African Art and the Shape of Time *[UMMA, August 18, 2012–February 3, 2013], in which we looked at how objects have been used to reference time in various contexts.*

One kind of time we considered was mythic time— cosmogonies. Most societies develop strategies for explaining where they came from, their traditions of origin, which are often framed as historical or quasi-historical. Another context

*for thinking about time concerns moments of encounter.
One of the most significant that we considered was when Europe
"discovered" Africa, and how that period was remembered in
each of those places. The objects that reference these moments
serve as temporal markers. Another context for thinking about
time concerns migration, moving across a landscape at a
particular moment, which also has a cosmogonic dimension.*

- Migration is represented in narratives from many cultures.
 It is also represented in our scientific narrative of the evolution
 of Homo sapiens out of Africa. I can see how the world
 shapes the narratives we create to describe it. But maybe
 our narratives also shape the way we perceive the world.
 As you were talking about time, two thoughts came to mind.
 The first concerns mortality, and related to that is the
 transience of material objects, through which we understand
 our own impermanence as individuals, as a society, and as
 a species. Just as different cultures operate with different
 senses of time, every culture has an awareness of the end
 of an individual life as a marker in time. But how it occupies
 our thinking is bound to differ.

*Much of what one encounters in the Kelsey comes from societies
that no longer exist, or have changed dramatically over the
course of millennia. Have you thought much about this?*

- One of my first impressions walking into the Kelsey Museum
 was of the presence of people long dead. After all, many of
 the objects there were preserved as parts of burial practices.
 But I also experienced the death of societies. I am fascinated
 with archeological time partly because it offers a view of
 societies that have ceased to exist. It offers a glimpse of our
 own ultimate demise as a society, which, from our limited
 perspective, appears to be permanent. It is hard to imagine
 that where we are sitting now was once under half a mile
 of ice and that one day it will be at the bottom of the ocean.
 Our imaginations balk at those changes because our point
 of view is so limited. Archaeology helps give me the long view
 of my place in the world, and helps me grasp the transient
 nature of being, the inevitable reality that nothing is forever.
- My thinking about the relative permanence of materials is
 related to this. Different societies assign different values to
 the physical longevity of man-made artifacts. Western society
 assigns great importance to the archival. Perhaps it is the status
 of objects as possessions or as commodities. Perhaps it is an
 expression of our own yearning for longevity. Our perception
 of transience and permanence is part of what engages us when
 we are in front of art objects as well as archeological artifacts.

*Yes, here again we have an opportunity to appreciate a very
different sense of what we might refer to as material time. There
are many examples of things that are produced by artists who
were not thinking about the future, about their work surviving
beyond the brief period during which it was made and presented
to the world.*

- The lack of long-term perspective on the part of an artist can
 be considered a form of innocence, ignorance, or carelessness.
 But from a different point of view, it is an acknowledgement
 of the transience of all objects, and our own impermanence.
 My awareness of the transient state of an object gives it an
 added poignancy. It touches me in a different way to be looking
 at something that I know is changing in front of my eyes,
 rather than something that will be there relatively unchanged
 long after I am gone.

Of course, Cosmogonic Tattoos *is emphemeral.*

- Yes it is. The vinyl is destroyed in the process of taking it down.
 It took me a while to get used to that, because making it is such
 an effort, installing it takes a lot of time, and it costs so much
 to produce.

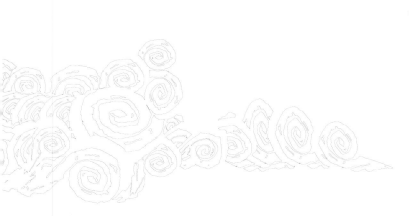

• Even the work I did in preparation for the vinyl inadvertently became ephemeral. When I first started making paintings of the objects in the museum collections, I was using materials I was not familiar with—shellac ink on mylar. Mylar is not absorbent. I was watering down the shellac ink to make it puddle in interesting ways, but in watering it down, I was altering its capacity to adhere to the mylar. After some months I started noticing flaking on some of the paintings. I was representing objects that had somehow made it through natural decay, deliberate destruction, long stretches of time, and were being held in a precarious state of preservation with great effort. And my paintings in response to them were falling apart soon after I finished them. I remember asking myself if I was willing to exhibit something I had made that was in this state of decay. When I realized that what had happened was appropriate for the archaeological context of my project, the answer became clearer for me. In a way, I became more honest about what I was doing.

Interesting. That is sometimes difficult for people to grasp, especially those who are charged with preserving things for posterity—people who work in museums! It is, in fact, a given that everything deteriorates over time. Nothing is forever. We can slow down the process of decay, but we cannot halt it. Embracing that must be liberating to a certain extent. It also gives one a sense that these objects actually are alive, that they are always changing.
You mentioned a few moments ago that the things you encounter in archaeological museums lead you to think about death. In a way, they are dead objects. Here I am thinking metaphorically: the vitrines in which these objects are displayed are hermetically sealed, devoid of any oxygen. The objects in them cannot breathe. So objects that once were alive, serving some function in the societies in which they were produced, have been "killed" or suspended in a state of stasis. As an aside, I have been intrigued with a recent trend towards repatriating museum objects to communities in which they have spiritual significance, where they are regarded as animate. In effect they have been resuscitated, meanings buried beneath the museological patina are reconstituted.

• That new life may mean that they cease to exist as we know them sooner than they would have if they had been preserved in the vitrine.

Yes, this is a cost associated with such initiatives. We once again must think about the relationship between ephemerality and permanence. • I am grateful for their preservation. It gives me access to them.

As am I. But it is important to weigh this need to preserve against the moral obligation of respecting the communities from which these objects were taken, where they still have an affective presence. Some of these objects were made to live a life, to be used, to, in effect, be consumed. There are many examples of practices that involve the production of an object that is meant to be used for a certain purpose, for a certain period of time, and then set aside and allowed to naturally deteriorate, returning to the basic state from which it originated. A wood sculpture representing an ancestor, for instance, that is supposed to naturally decay over time, to replenish the soil.

• We gain meaning from participating in or witnessing that cycle. On the other hand, we deprive those who aren't present of the opportunity to be enlarged by an experience of it. So, you have two different value systems. It is a powerful tension.

*For sure, it's complicated. It is a tension that, depending on
how you look at it, can be a positive or a negative thing.
As we noted earlier, a preoccupation with preserving things is
found in most societies, but not all. Regarding our own society,
we need to ask what it is that we have chosen to preserve.
What makes these objects exceptional, worthy of preserving?*

- Well, authorship reflects sets of values that are deeply
 embedded in the human psyche, though perhaps more central
 to some cultures than others. In our culture we all want
 to be unique. There is a lot of anonymity in archeology
 museums, which inflects the way I perceive these artifacts.
 But, whether or not I can see traces of a particular hand in the
 work, I know there is a maker on the other end. That is deeply
 moving to me. Even if we navigate the world through acts
 of empathy, there is a difference between empathizing with
 someone who is named and someone who is anonymous.
 Over time, those who are identified become elevated in stature.

*In most museums exhibiting African art, the ubiquitous tombstone
label almost always identifies the maker as anonymous, unknown,
or unrecorded. It gets one thinking, as you are suggesting, about
what anonymity means. I wonder what museum visitors think
when they encounter an entire gallery in which none of the work
can be attributed to a named individual. Does the meaning of an
object change if we know the name of its maker?*

- It changes how you perceive the object if you know nothing
 about the person who made it. If the maker is named it enhances
 the value of the object, and that somehow enhances its meaning.
 It takes on more of a personal significance. It allows me to
 empathize with both the object and its maker.

That is a beautiful way to put it.
- It is possible that other societies have ways of creating
 empathy other than focusing on an individual. Our culture
 seems obsessed with individuality and we associate names
 with individuality.

*True. We haven't talked much about your process. You spent a lot
of time studying and drawing the objects in the Kelsey and UMMA.
Can you say a bit about the various iterations this project has
been through?*

- The process began with befuddlement. I made a commitment
 to do something, I convinced others that I could do it,
 but I was full of doubt about what that something would be.
 Doubt fuels a lot of what I do. There is also a thrill that
 comes with doubt and terror. I had a difficult time immersing
 myself in the project. I thought, what have I gotten into?
 For a long time I could not get any traction. I went into
 the museum, tried to get engaged, I walked out. That made
 going back the next time harder.

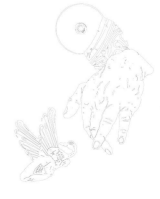

• There were two ways out of this conundrum. One was thinking about what archaeologists were doing, trying to relate to what was behind that compulsion to unearth the past. And the other was a physical engagement. I told myself just to go to the museum and do one drawing and walk out. Begin by simply doing something. Anything. It is hard to do something that you don't ascribe value to, but often you can't understand its value until you do it. The only way out of that paradox is through direct action. Just do it.

• Finally, the question of ornament became traction. I was in the Kelsey, drawing, and came across an ornament on the side of a Greek vase. I was making a mess of my drawing. Part of the problem was the visual complexity of the ornament, which had an intricate figure ground relationship that didn't lend itself to a linear sketch. The other problem was that I was focusing on a decorative detail. Right next to it were human figures. The museum label is all about the figures. There is nothing on that label about the ornamental design. I was drawing the least valued part of this object and getting frustrated with it. But then I thought more about what the situation was telling me. Looking around I saw that the place is full of ornament. I thought, how can I look at the things in this museum without an awareness of ornament? After all, my plan is to ornament the museum itself. The project was born out of that moment of frustration. It is called instructive failure.

But this project is about much more than ornament. After having established this foothold, how did the project evolve?

• That led to a series of processes with a long train of outcomes, which will be documented in an exhibit in the rotating gallery at the Kelsey that will be up from June 2 to September 15, 2017. I went from doing sketches, to taking photographs, to using the photos as the basis for 250 ink paintings on mylar. My paintings were translated into digital format, which became an archive of image fragments from which I assembled my digital designs for the windows. A graduate student in the MFA program at Stamps, Jon Verney, pointed out that the mylar paintings could be used as negatives for black and white photographs because of their transparency. We tried it in an improvised darkroom and the resulting photos were stunning, mysterious in how they evoked the original object in the painting. I followed another trail of material outcomes to make a series of ink paintings that will also be in the exhibit. The vinyl designs for the windows reside in the computer as impossibly delicate, complex lines in Adobe Illustrator, a vector program. I wanted to feature the lines themselves in some way, so I converted some of my Illustrator files to pure line then digitally printed them on quality drawing paper and painted into those using sumi and walnut inks. What those images lost in architectural scale when translated from vinyl into ink on paper, they gained in materiality, texture, and intimacy.

Do you see this work as iterations of a multifaceted process?

• Yes. The visual record of these variations is not simply about me and what I do as an artist. This constantly branching process tracks what I find compelling about the life of the objects I have encountered—their mutability, how they influence each other, and how we ascribe different kinds of meanings to them depending on where, when, and how they are perceived.

It seems that your process has been a personal quest for making sense, making meaning, for seeking the essences of what these objects mean to you.

• I don't see it as a search for essence, which I am skeptical of, so much as a kind of focus. In order to see you, my body engages in a complex set of negotiations, some of which are beyond my conscious control. Many minute muscular contractions in my eyes send a message to my brain about your position in space relative to my own. In the multiple iterations of this project, I experimented with different points of focus. The objects have taken on a different life for me since I first encountered them. Quite frankly, sometimes I go back and am surprised at what they actually look like. In my memory, they have changed. You sent me an article by Stephen Greenblatt, "Resonance and Wonder." It got me thinking about my own experience in museums. It also got me thinking about how contemporary artists take radically different approaches to making their work. As a historian and one who organizes public encounters with objects, how do you think about resonance and wonder?

Greenblatt's work got me thinking about the relationship between the visceral and the rational, between experiencing things that you don't necessarily think about but respond to in the context of wonder or awe, and things that you might think about but do not necessarily respond to viscerally. I see setting these two modalities in dialogue with one another as an exciting strategy for creating experiences for people who encounter things in a museum space. We have moved beyond designing exhibitions; we now think about creating experiences and engendering dialogue. Let me ask you a rather existential question: Do things have any intrinsic meaning or value? Can you think of any object that no matter when and where it is, it will carry the same meaning?

• No, I can't. That possibility runs counter to everything I understand about human experience. Here is an anecdote from my own past. I am a student carrying my painting across the parking lot from the studio building to my car. Somewhere in that short walk I experience a moment of profound estrangement. This thing I am carrying is evidence that somebody went to great trouble to make something. Sticks have been carefully joined in the corners so that they form right angles. Cloth has been stretched over the sticks. One side of the cloth has viscous stuff applied in blobs to it, while the other side does not. That's it. That's all I have left from my struggles. If I were an archeologist who had never encountered an oil painting I would recognize that there was enormous effort put into this object, but what that effort amounted to would remain a mystery. The thing was transportable, but its significance was not. The ease with which all the intangible meanings I had invested in that painting could be stripped from it in a moment left a lasting impression.

Indeed, it was that experience that made it what it is. We probably should be wrapping things up. I would like to circle back, if it is okay with you, to our discussion of the discursive object. In Cosmogonic Tattoos *you are taking objects that exist in a particular context—the museum's interior—and putting them in a new environment—the museum's exterior. You have manipulated these objects in certain ways, and this creative process has produced new meaning for you, and it surely is producing new meanings for the people who encounter the objects on the transparent skin—the windows—of the Kelsey Museum and UMMA. How do you anticipate other people will receive your project?*

• The work is outside the white cube and visible to people who have no intention of entering that space. It is not completely free of the institutional context associated with the display of objects,

but it is external to that context and viewers will encounter it without intending to. I like that.

- The installation will certainly alter one's perception of the buildings. We do not associate saturated color with dignified buildings on a university campus. This will cause a little friction. It will be applied to the exterior of the building, which we associate with unsanctioned acts, with defacement. Am I "tagging" the museum?

As we noted earlier, you are putting this stuff on the skin of the building.

- Viewers will be looking at windows that they have not paid much attention to. Perhaps they will become aware of the complexity of simultaneously looking at and looking through a window.

I have thought about resonance and wonder in terms of your project. I am pretty sure that when people first encounter it, it is going to bring a smile to their faces because of the whimsical nature of a lot of the imagery and how you have transformed the building. That is wonder. And it might be that they just walk by and that is their response. But if people slow down and start looking more closely at the objects and begin to recognize certain things and to see the relationships between them, resonance will kick in and, I suspect, you will begin to get that interplay between the two modalities, and this will create a context for dialogue.

- In the process of installing my vinyl projects I am often asked what the material is and how I made it. To make people curious about their constructed environment is in itself worth the effort. I also think the installation might cause a viewer to move differently in space. You are looking at something on a window you are inevitably looking through at the same time, which has also been designed to move you on to look at something else. My hope is that it pulls viewers along, that it reaches out, engaging them physically. I want the piece to interact with the bodies of the people that are physically in the space with it.
- I also want people to make up their own stories. I want them to narrate the piece to themselves. I want them to share their narratives with other people. We live in an electronic culture where people are quite comfortable sharing fleeting impressions. I want to see their smartphones out, taking pictures of themselves in front of or behind it. I want them to enter its space. I want them to be part of the work.

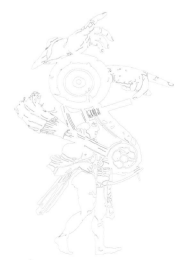

●

Raymond Silverman
is the former Director of the University of Michigan's Museum Studies Program, and serves on the faculties of the departments of Afroamerican and African Studies and History of Art. His research focuses on the visual traditions of Ethiopia and Ghana and on museum and heritage discourse in Africa, specifically how local knowledge is translated in national and community-based cultural institutions. He recently edited a collection of essays on this theme, *Museum as Process: Translating Local and Global Knowledges* (2015). He is particularly interested in the visual culture of the modern Ethiopian Orthodox Church and has published *Painting Ethiopia: The Life and Work of Qes Adamu Tesfaw* (2005) and *Ethiopia: Traditions of Creativity* (1999). His current project is a monograph titled *Icons of Devotion/Icons of Trade: Contemporary Painting and the Orthodox Church in Ethiopia*.

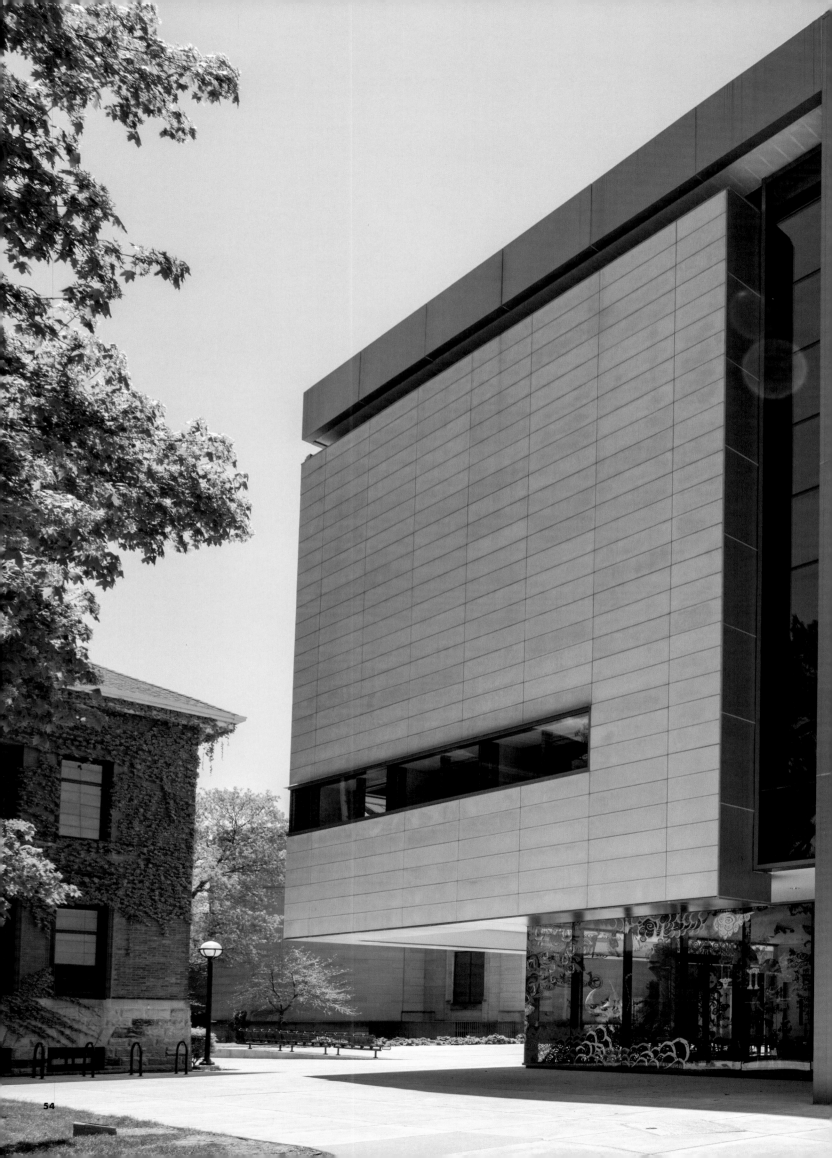

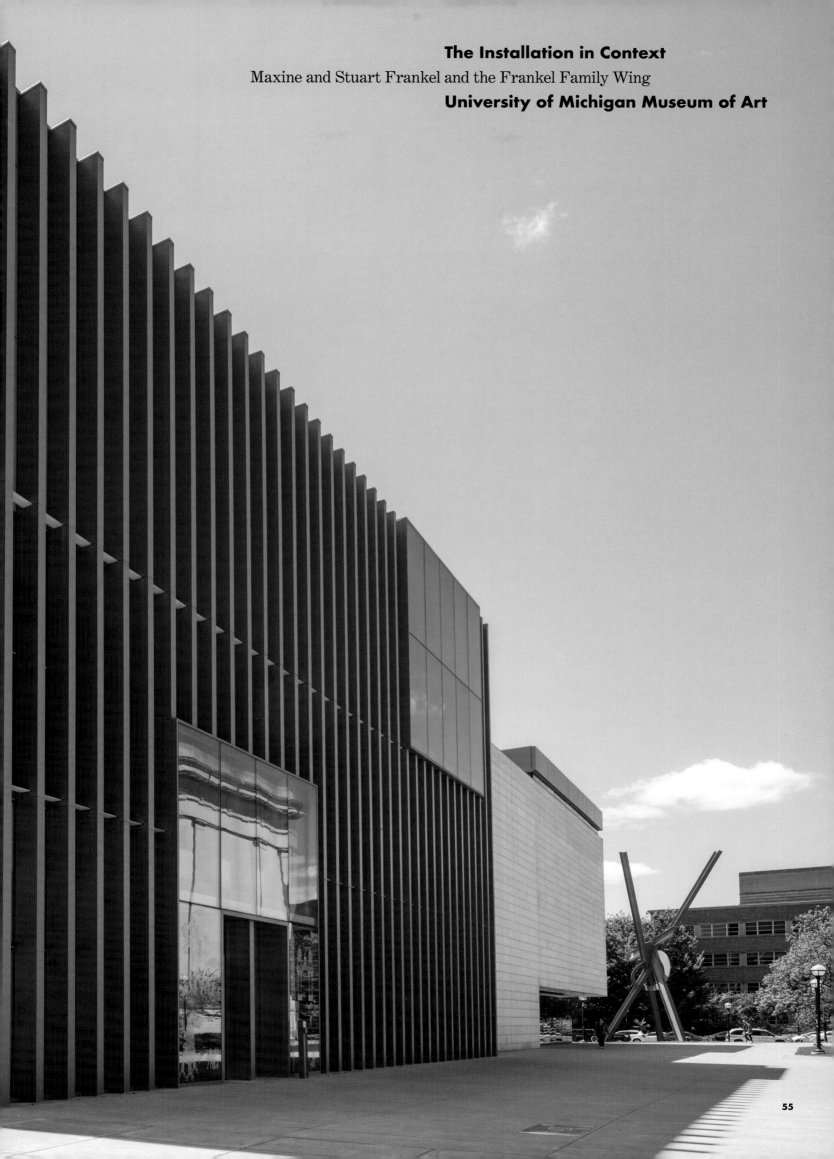

The Installation in Context
Maxine and Stuart Frankel and the Frankel Family Wing
University of Michigan Museum of Art

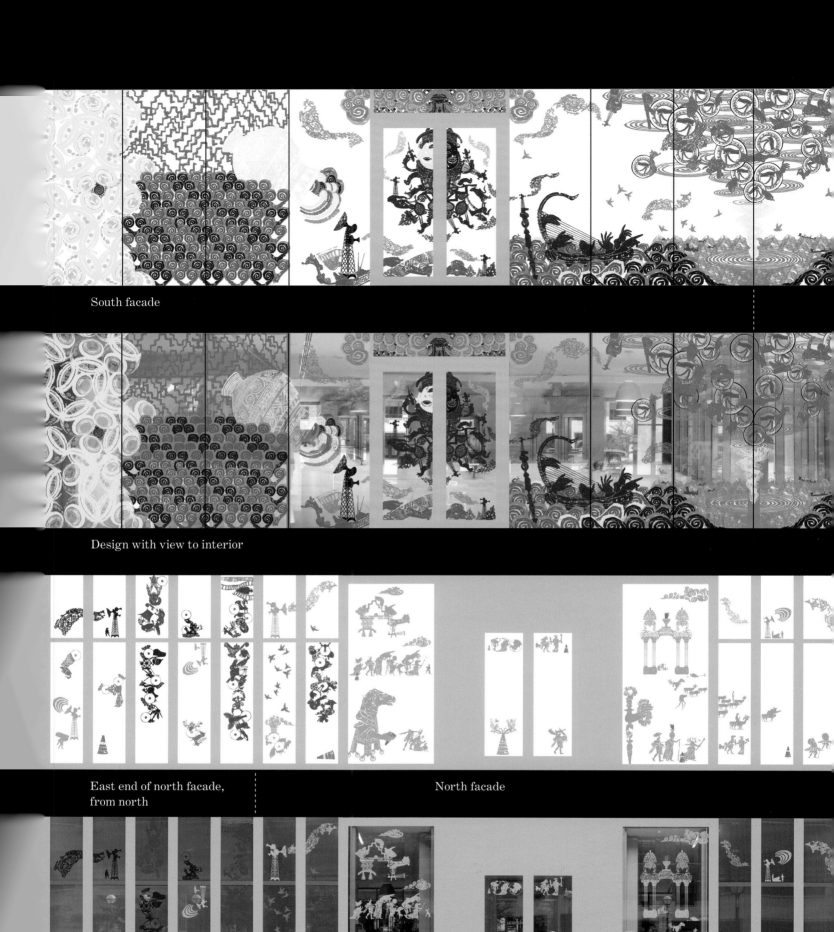

South facade

Design with view to interior

East end of north facade,
from north

North facade

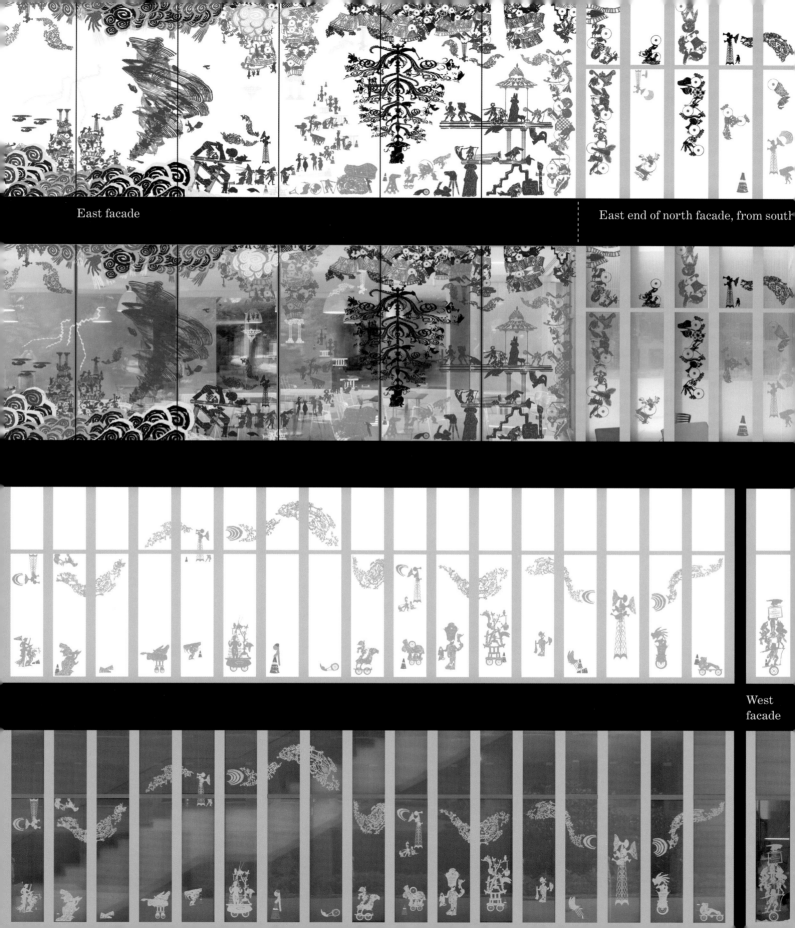

East facade

East end of north facade, from south

West facade

Maxine and Stuart Frankel and the Frankel Family Wing

Design for exterior windows with
examples of source artifacts from
the collections of the Universitty of Michigan
Museum of Art and the Kelsey Museum
of Archaeology

Text by Jim Cogswell

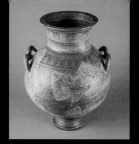

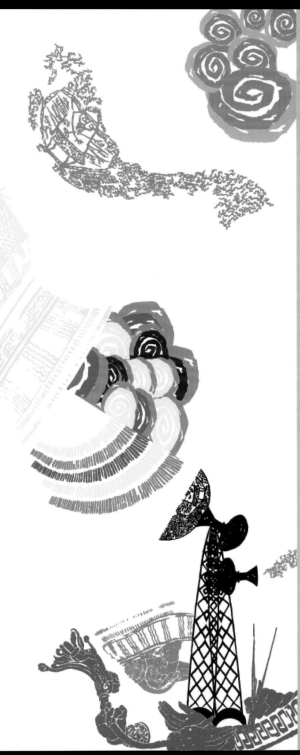
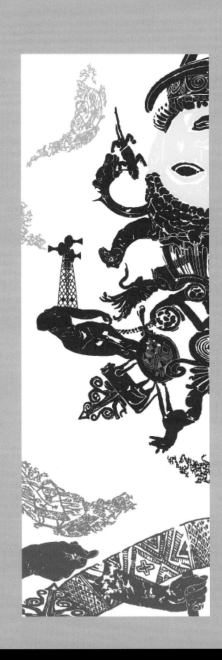
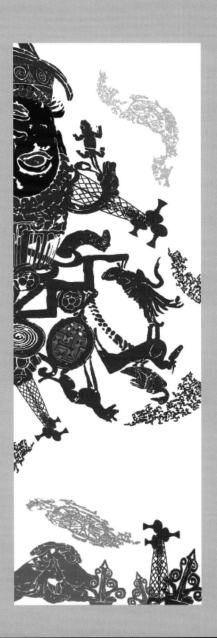

patterns on a rounded geometric vase from ancient Thebes. Beginning here, transmissions are beamed from tower to tower along the sides of the University of Michigan Museum of Art all the way to the front entrance of the Kelsey Museum of Archaeology across the street, signals in a forever foreign language, persistently visible, sensed but never fully understood.

● A colossal inverted human head straddles a doorway facing the courtyard. This forceful presence is cousin to the Yoruba mask in the museum galleries above– Egúngún, the collective voice of the ancestors. My vinyl head has been assembled using fragments from the ancient Mediterranean world. Cultural essentials scrambled. Colonization reversed. Creatures swarm in its orbit,

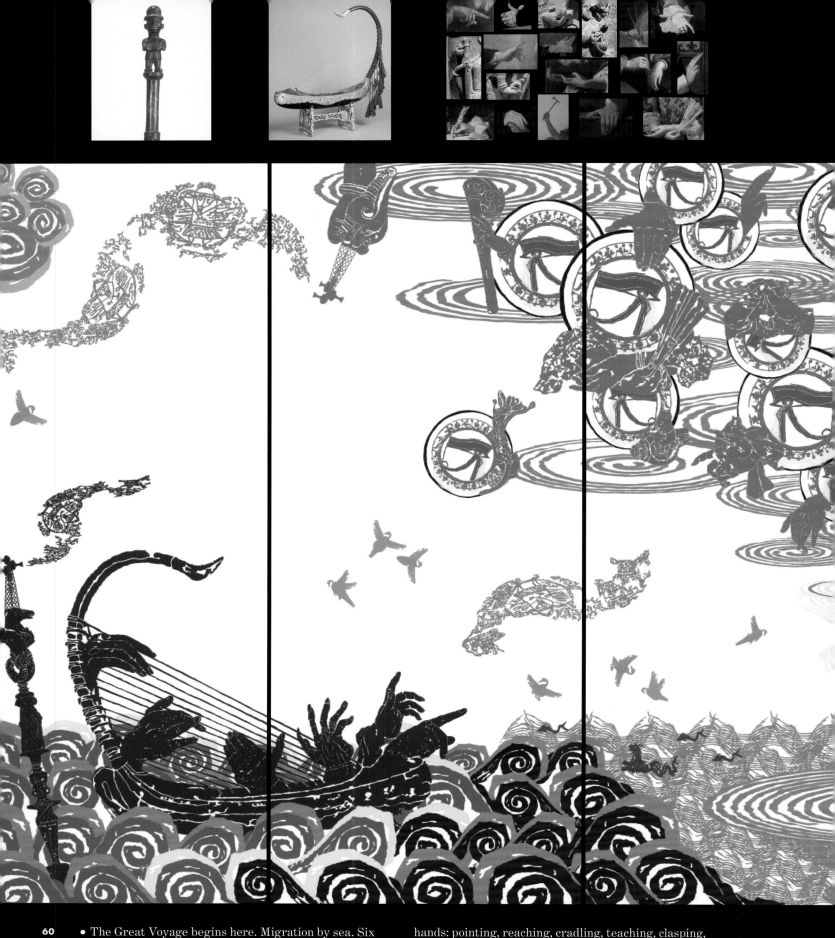

- The Great Voyage begins here. Migration by sea. Six hands from the painting galleries are setting forth on a Burmese harp. The harp navigates toward the corner of the building under a cluster of eyes that have floated free from the elaborately painted coffin of Djehutymose, priest at the temple of Horus at Edfu. Each eye is a sparkling fountain, each framed within a separate medallion, each medallion sprouting

hands: pointing, reaching, cradling, teaching, clasping, writing, lifting, grasping, offering, touching, blessing.

- The cloud of hands hovers high at the corner of the building, as if seeping onto the glass from the galleries above. A pool at the base of the building holds their accumulated sorrows. These are the tears of witnesses who know what is coming but are helpless to stop it. The hands have been plundered from the European and

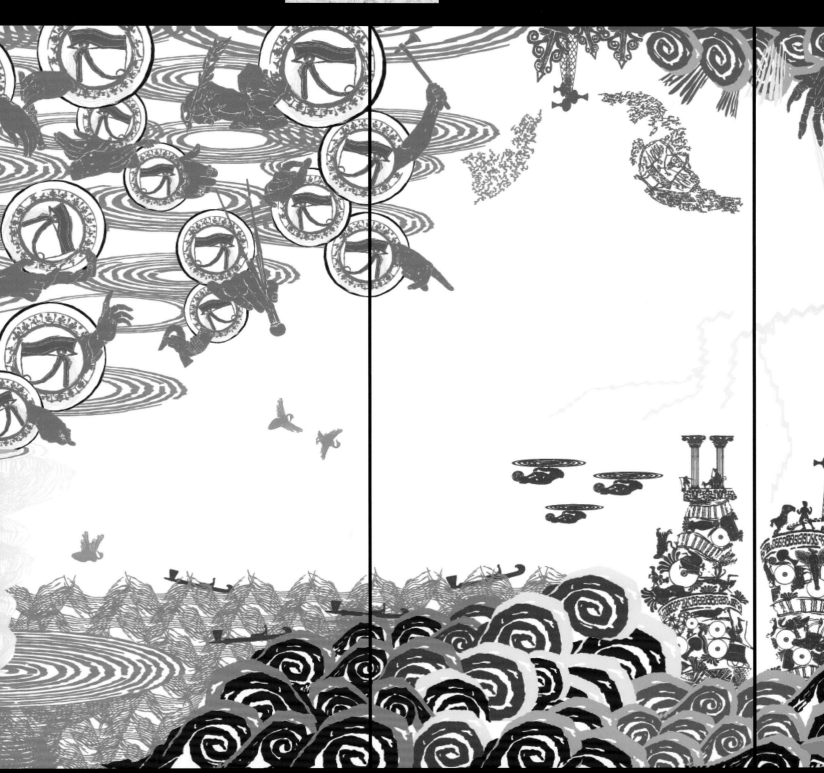

American collections inside, but also from South Asian sculptures, like the 10th-century black schist figure of Vishnu, preserver of the universe and maintainer of cosmic order, who has several extra hands to spare. Around the corner, calamity waits.

• A confluence of disasters inundates an isolated promontory: earthquake, cyclone, tsunami, invasion by incense censer and recumbent Aphrodite with whirling rotors. This was Lisbon in 1755 and Fukushima in 2010; it will be New York in 2055. Out of sight is the constant changing of the earth, plates buckling, winds shifting, water racing and gathering

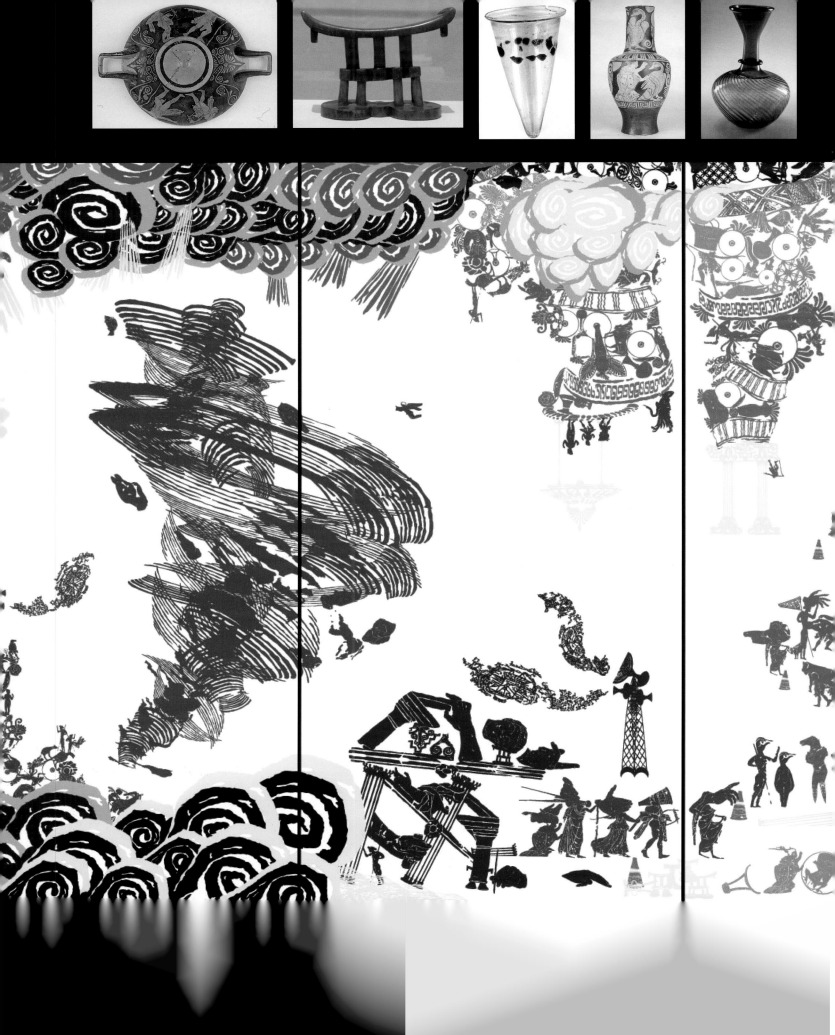

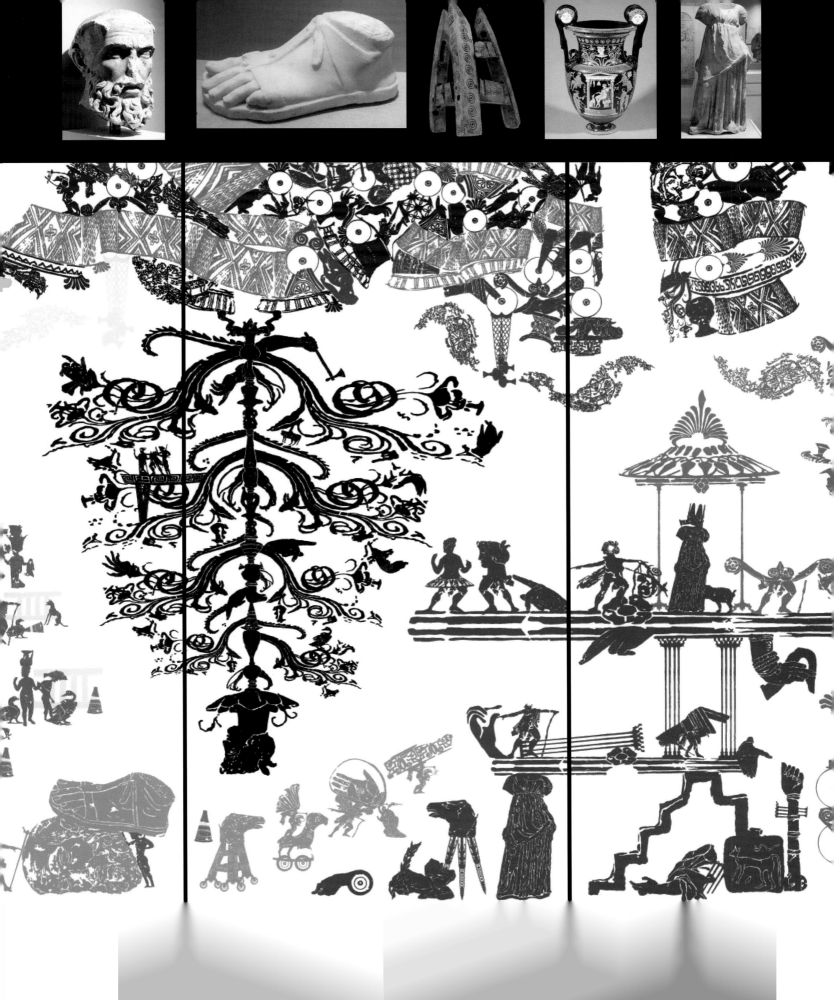

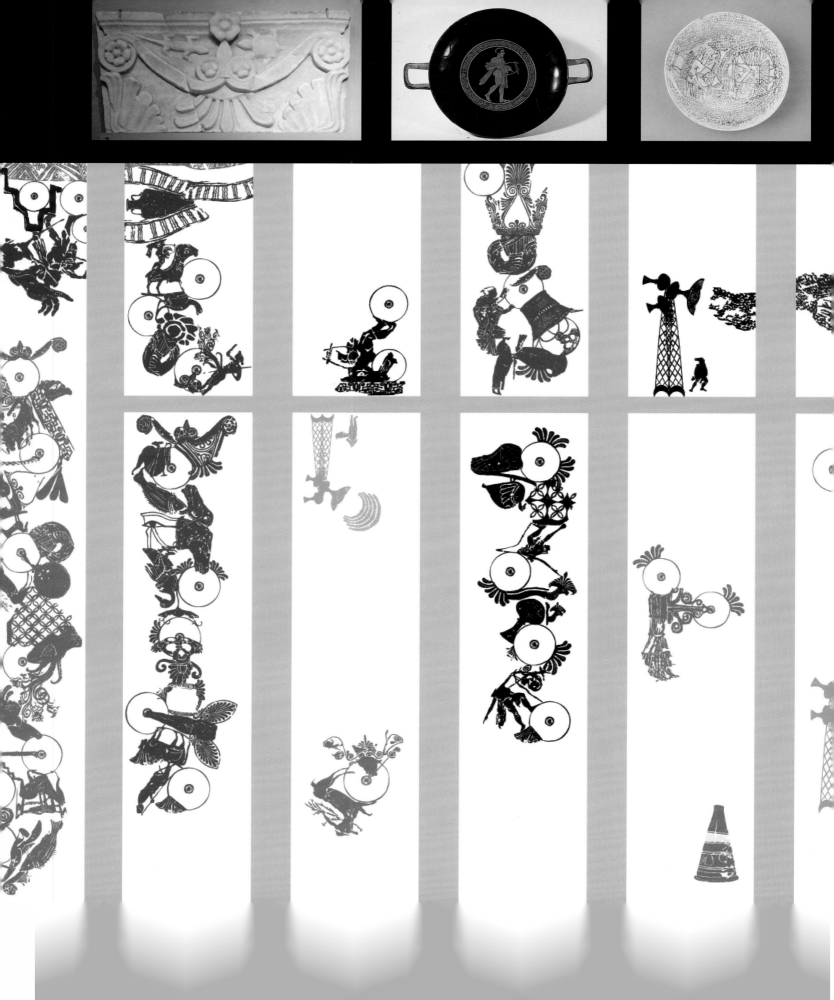

• Viewers are then guided by way of transmission
towers to the north face of the building, where they
join a procession of refugees on their journey.

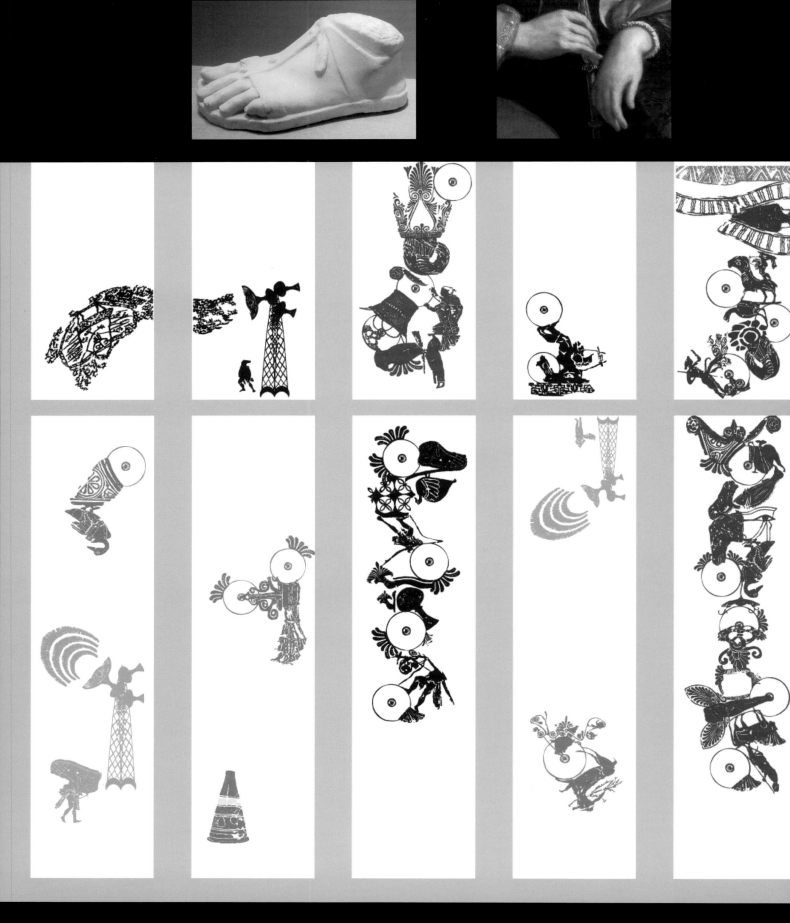

The north facing windows are set deep between prominent ribs on the side of the building, establishing a pattern of narrow niches running parallel to the movement of pedestrians along a major walkway across campus. Vertical ribbons of rhythmically fused images float within the niches at the east end, also visible from the south. Their cascading colors link the two sides, acknowledge the vertical force of the tall windows on the north face, and establish a tempo that will be released into the march of figures along the north side of the building.

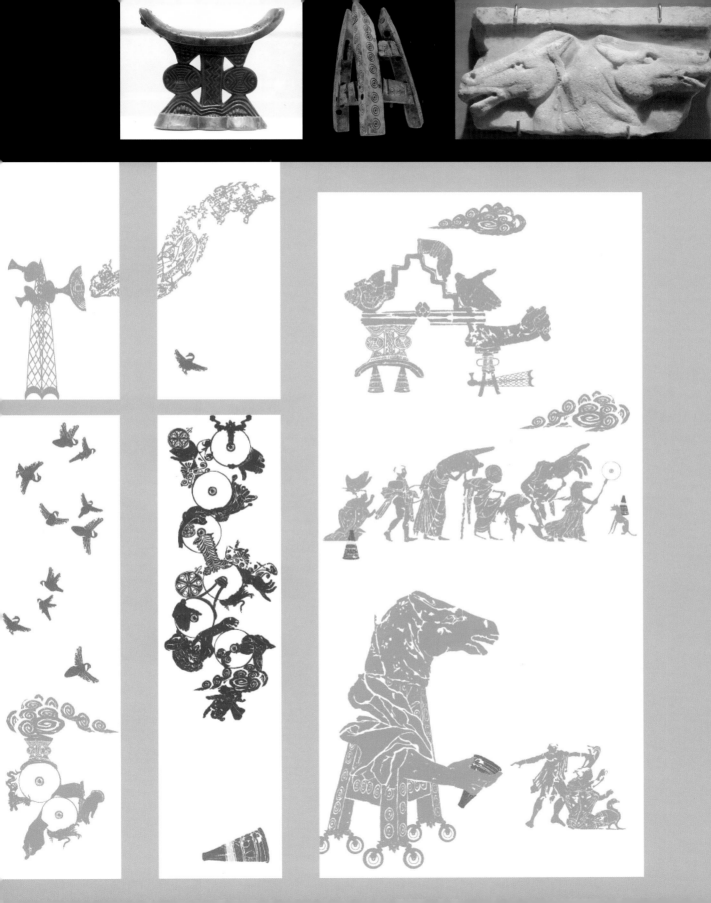

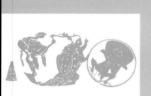
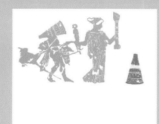

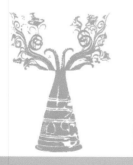
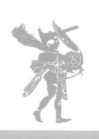

The march of figures is designed like a flip-book,
a rhythmic sequence of frames that can be experienced
in short bursts between the ribbing. The vinyl's
monochromatic palette blends with the metallic
cladding of the building, pulling viewers into the

gauzy space behind the semi-opaque windows.
A stairway landing visible through the glass offers
a platform for transmission relay. Beneath the stairs
Aphrodite showers in her mobile basin.

Approaching State Street at the front of the march is
Nydia, the blind flower girl of Pompeii. She is rolling on
a longboard, her hand cupped to her ear, guiding her
companions across the traffic towards another volcanic
eruption in progress at the Kelsey.

JIM
COGSWELL
COSMOGONIC
TATTOOS

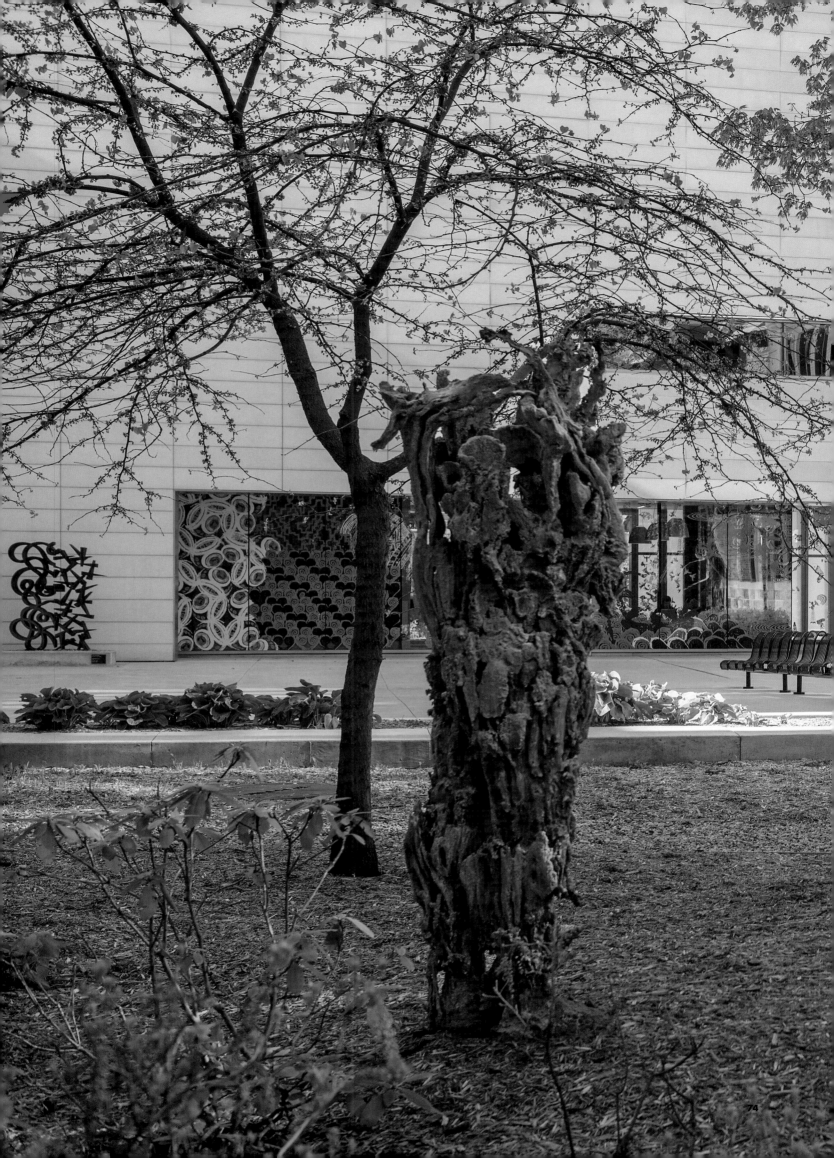

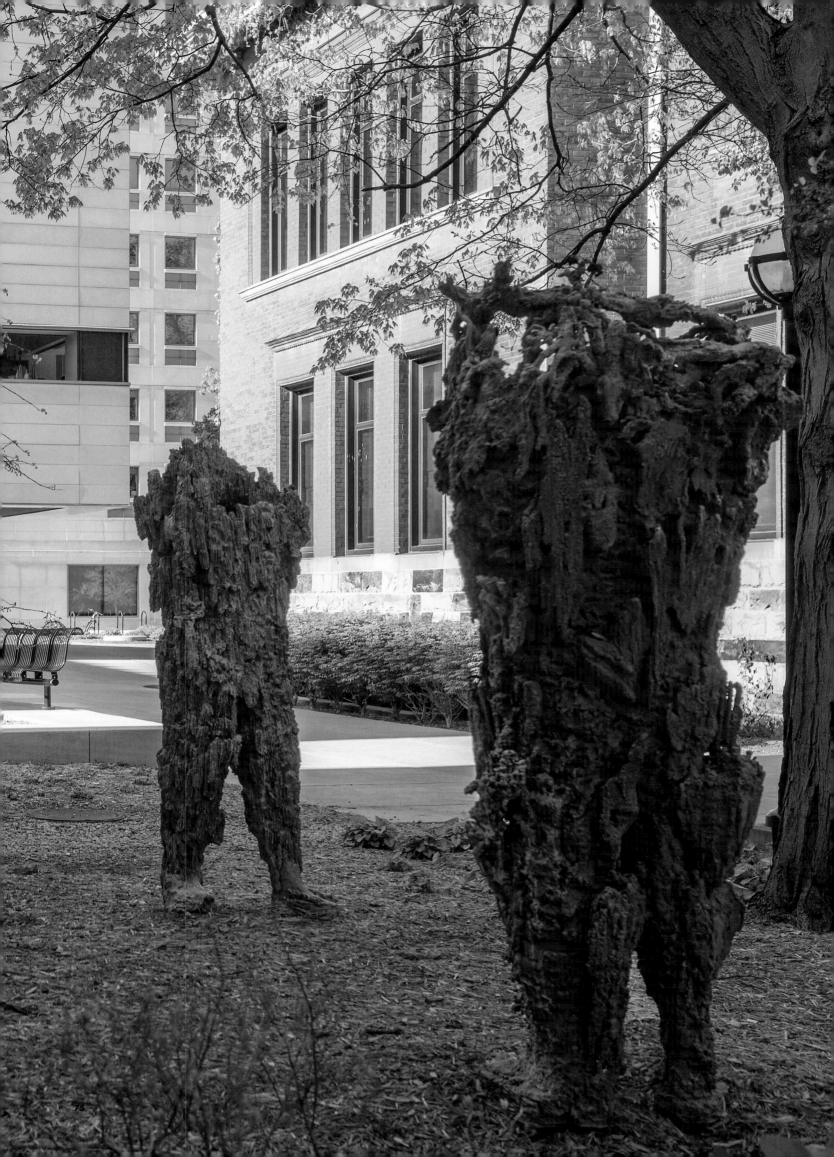

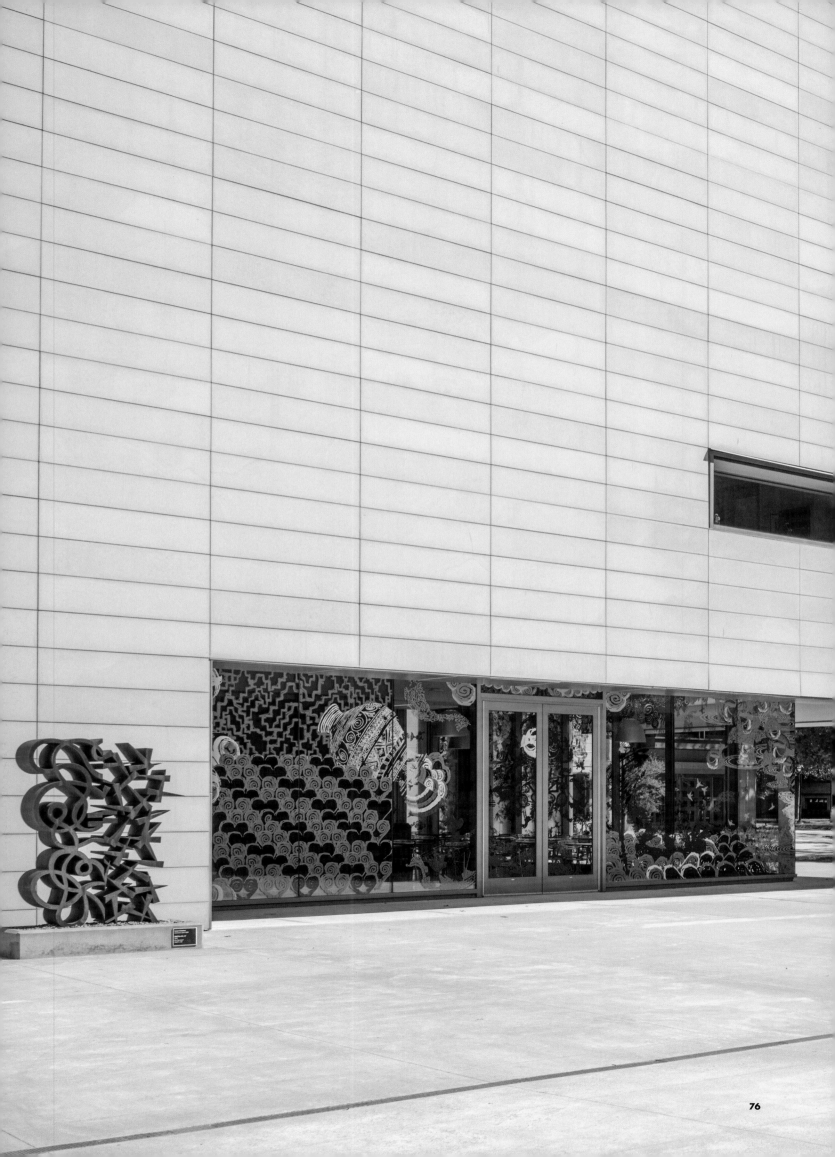

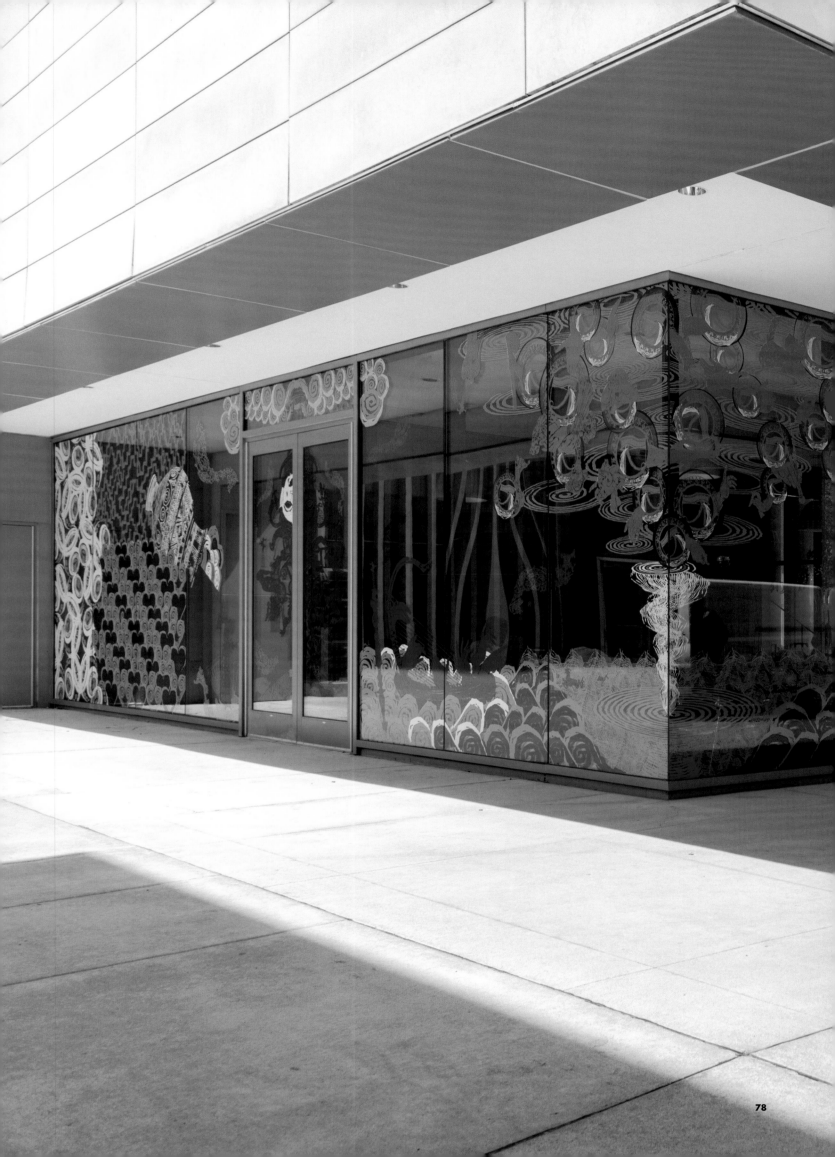

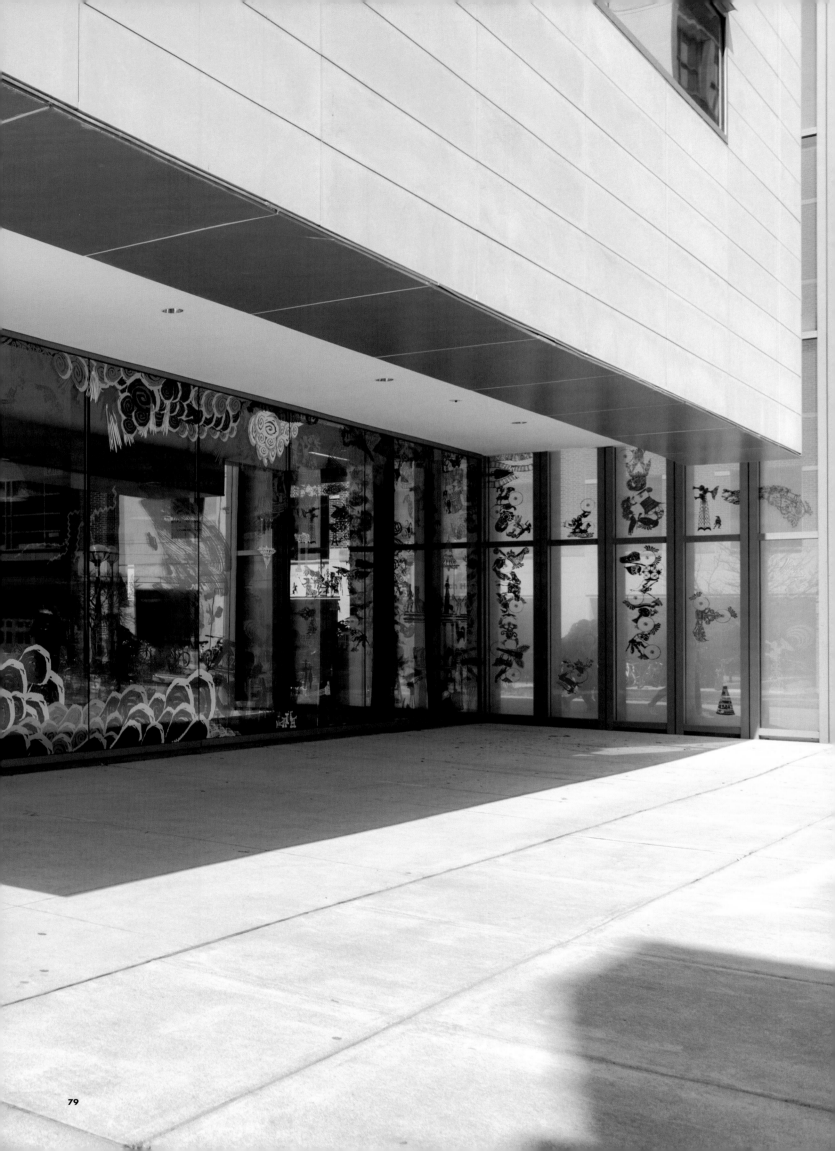

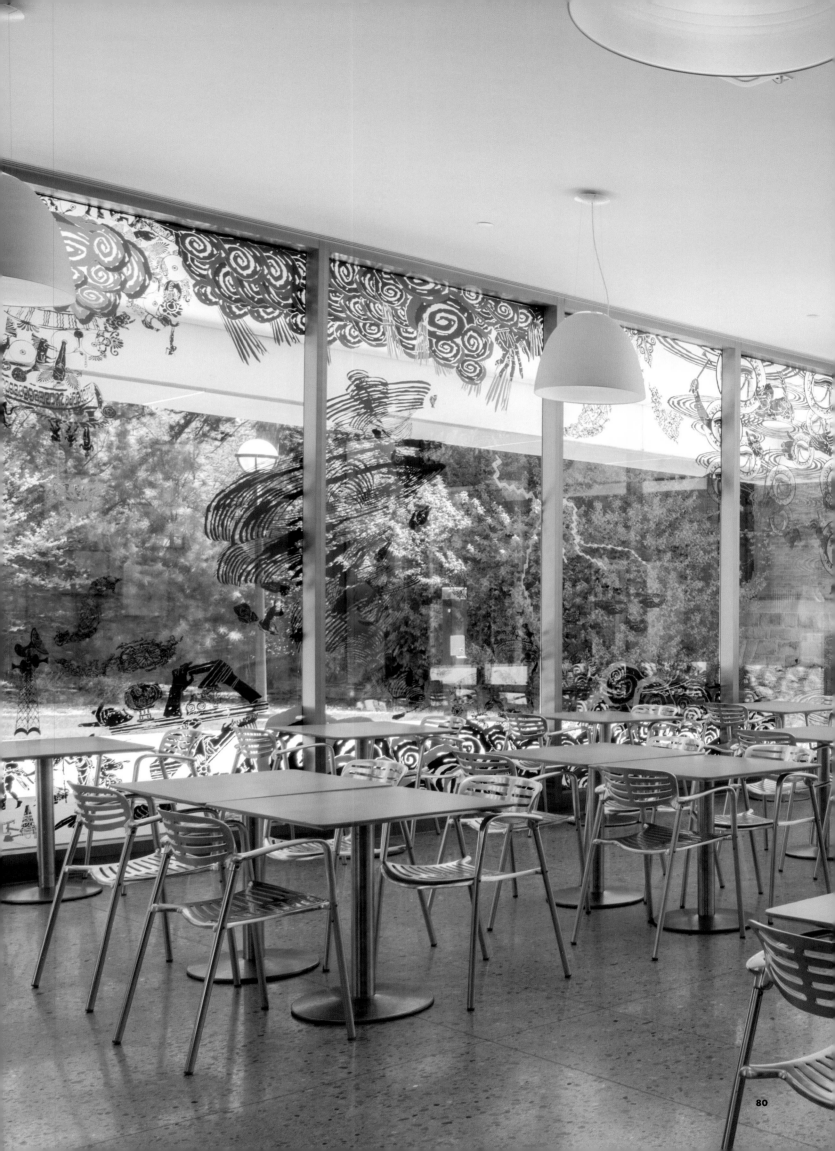

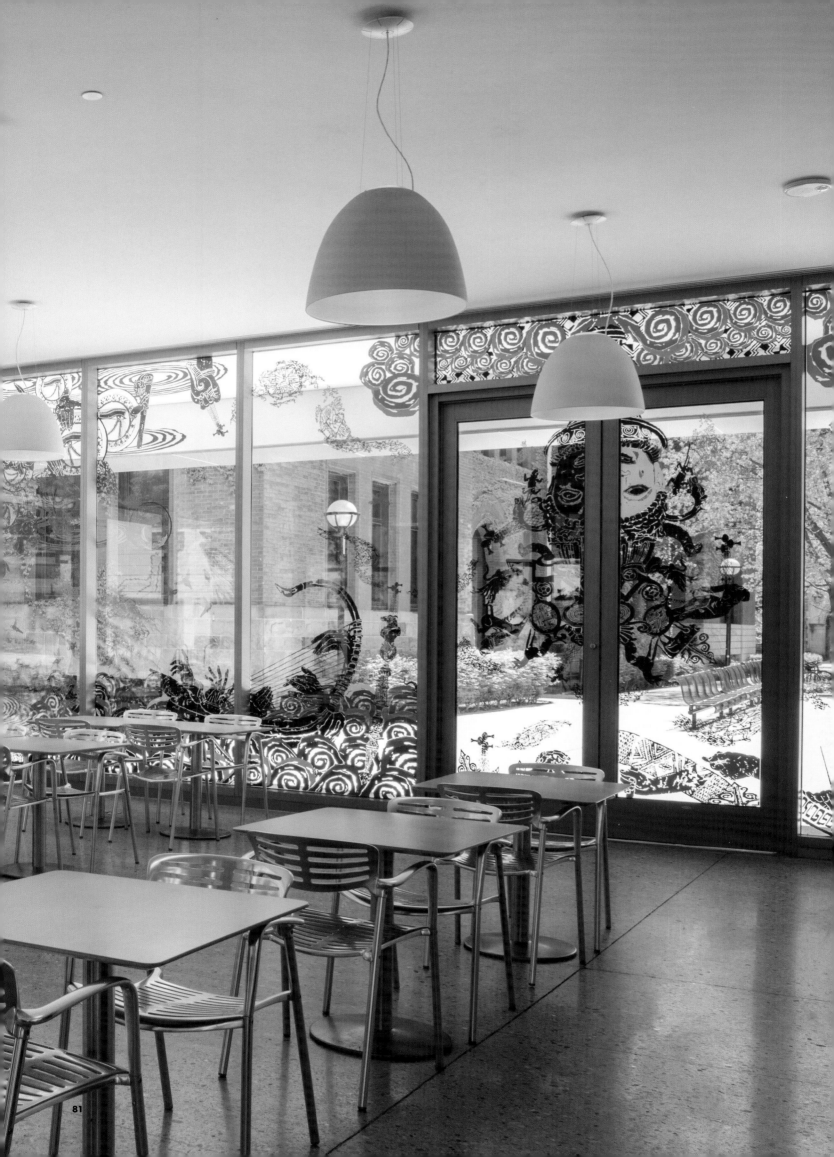

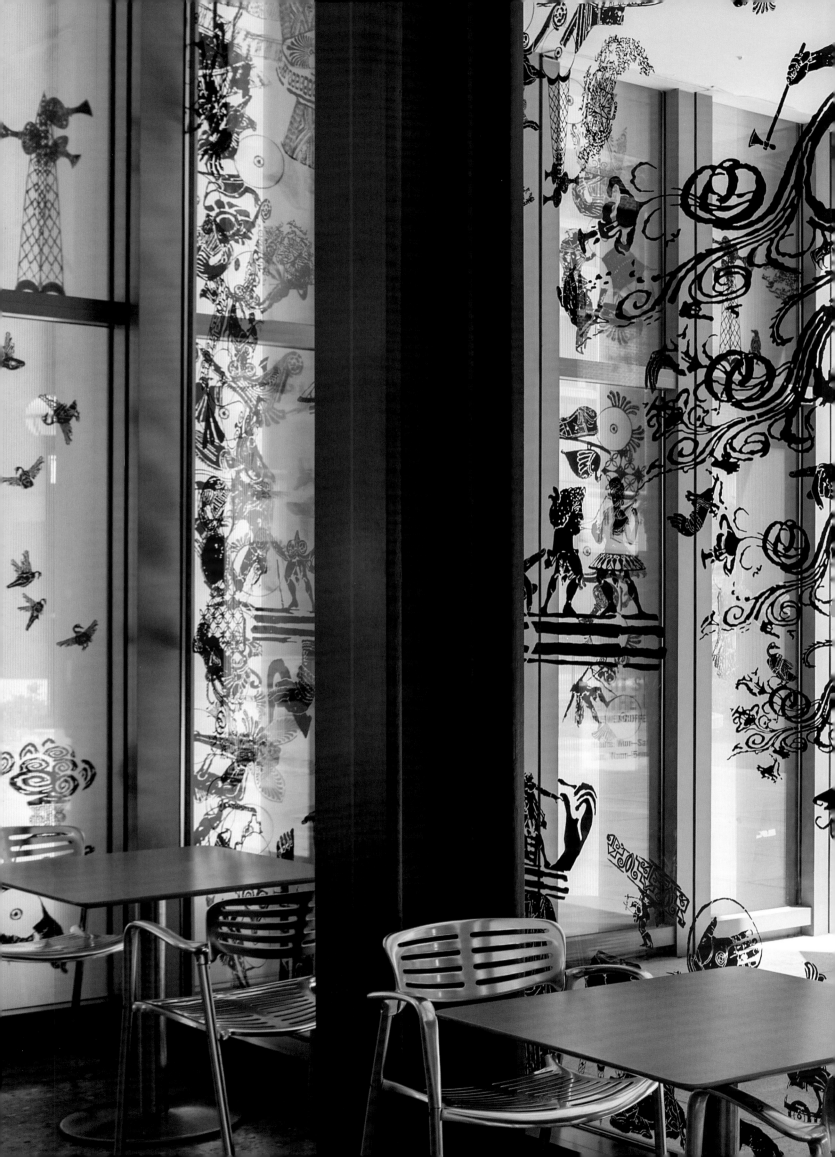

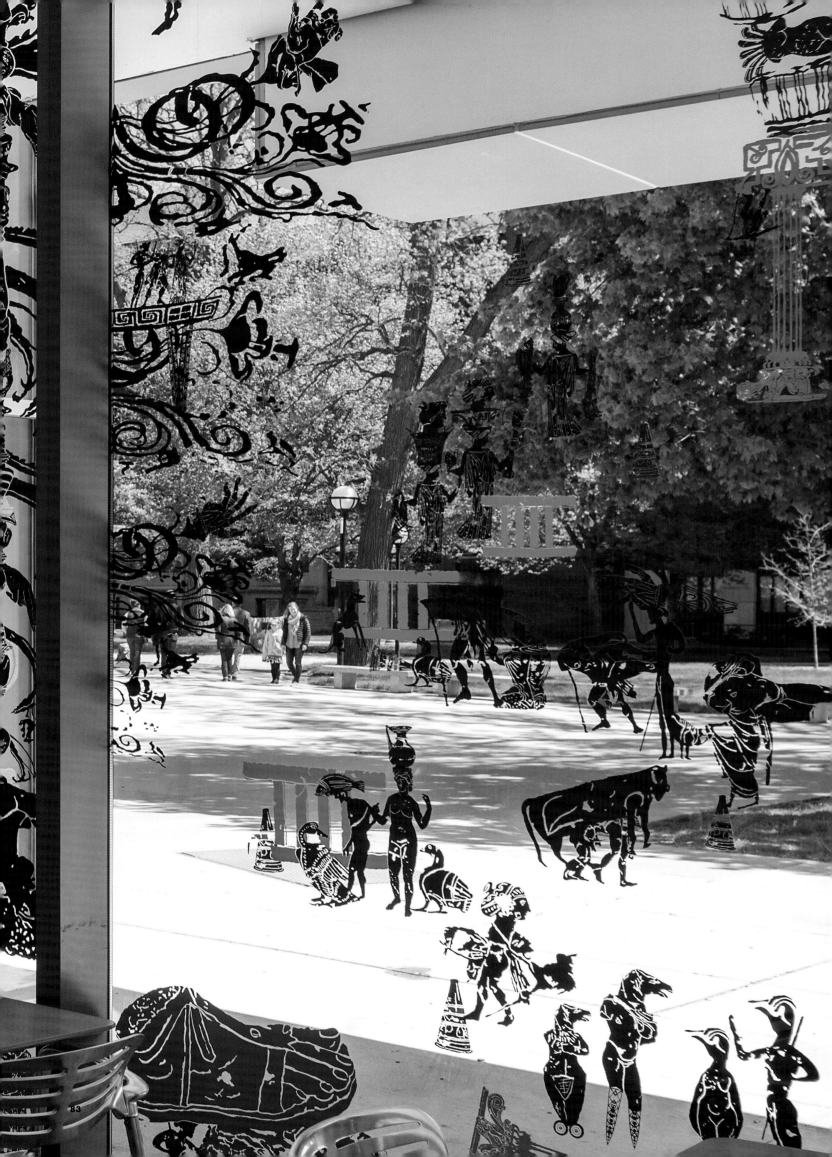

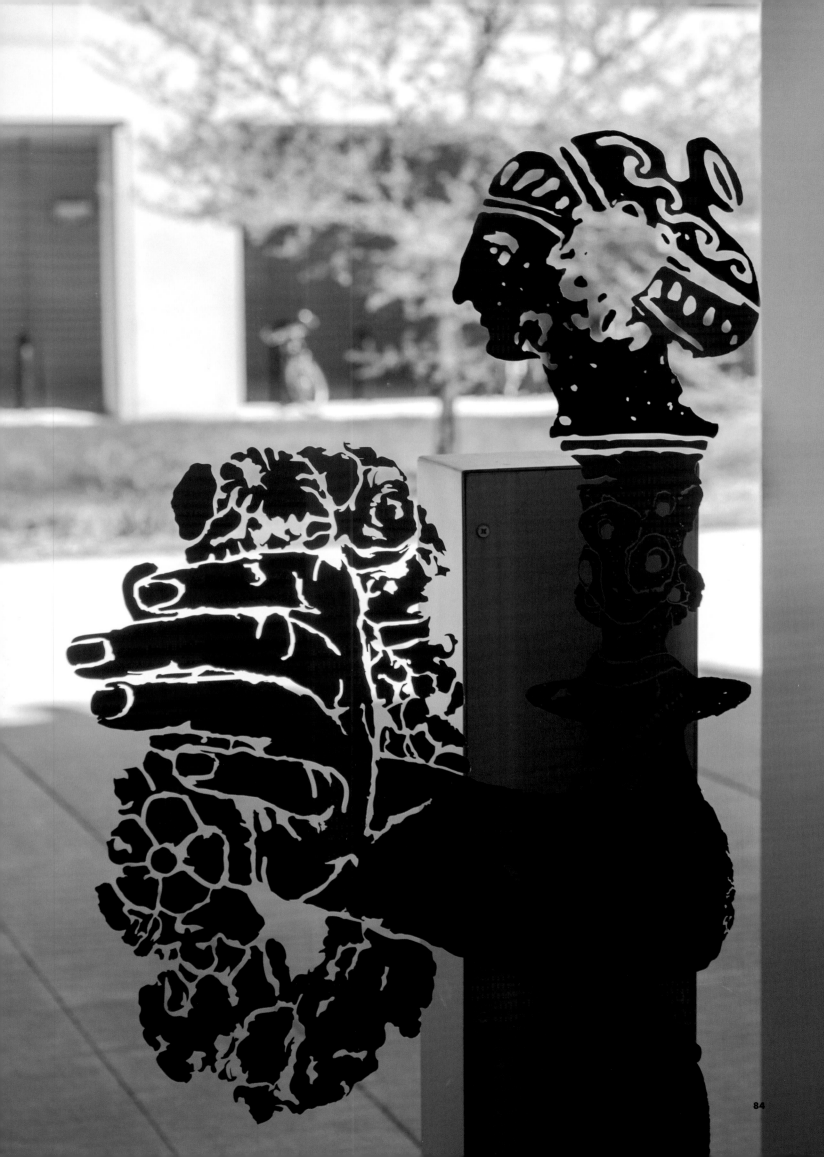

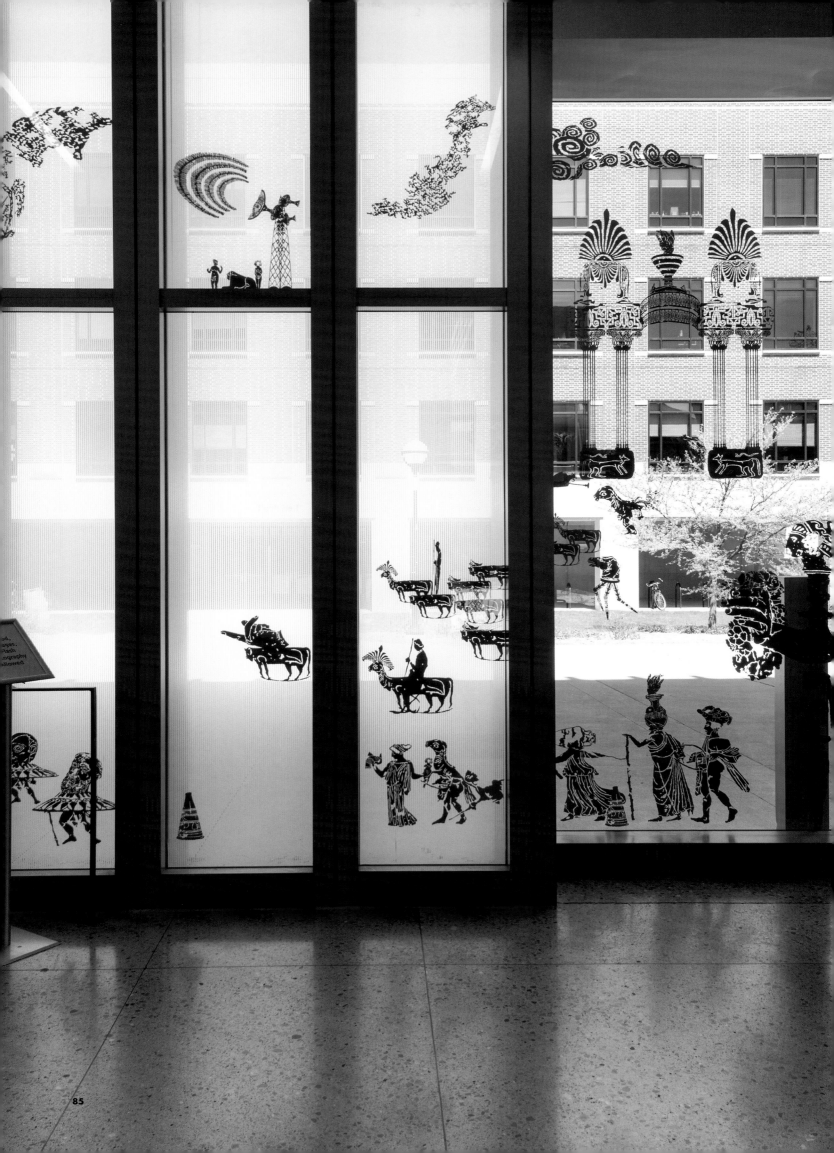

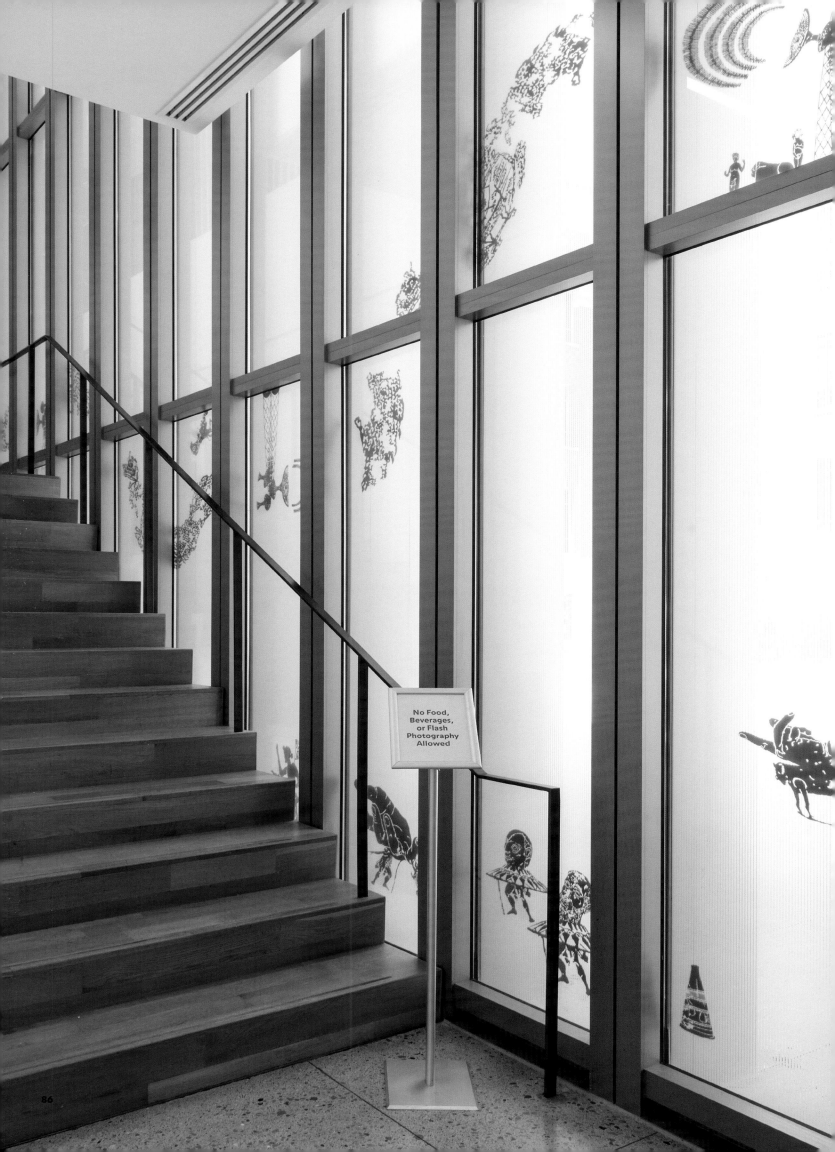

No Food,
Beverages,
or Flash
Photography
Allowed

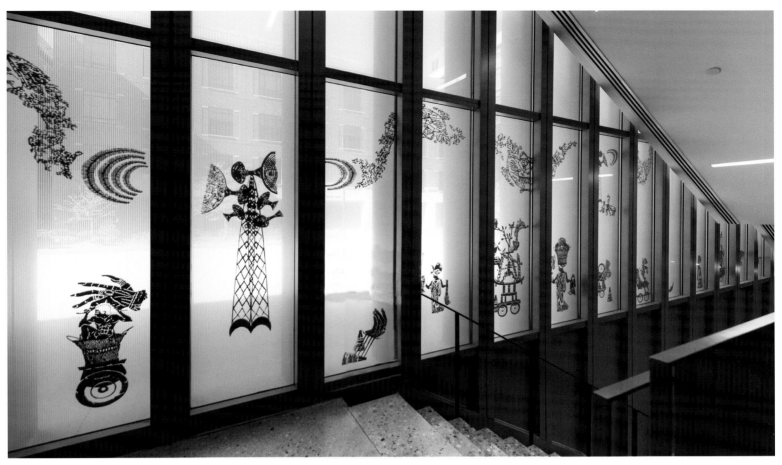

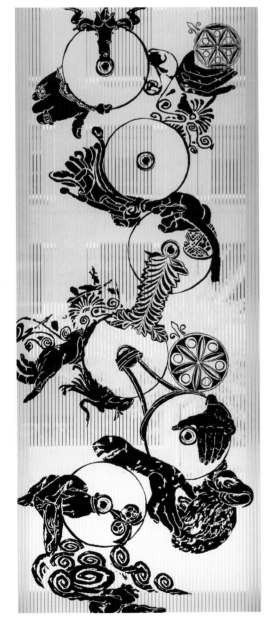

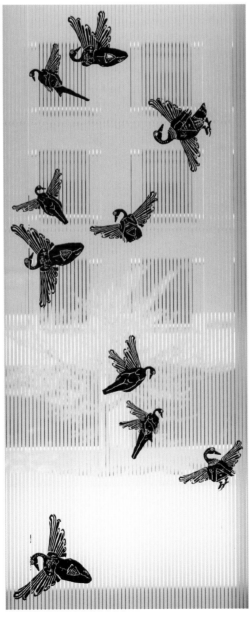

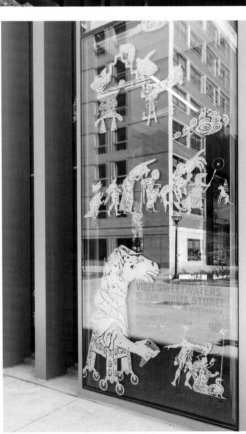

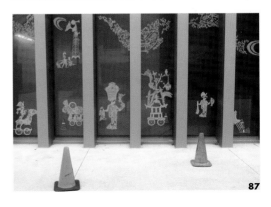

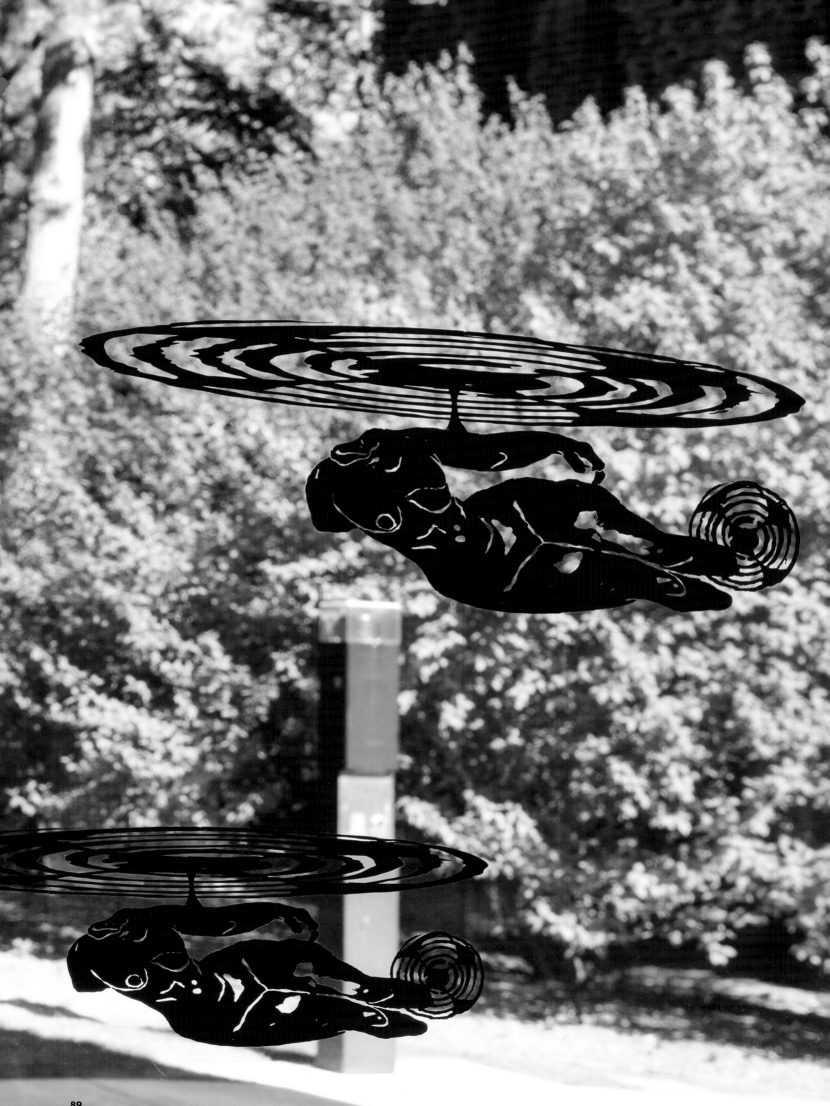

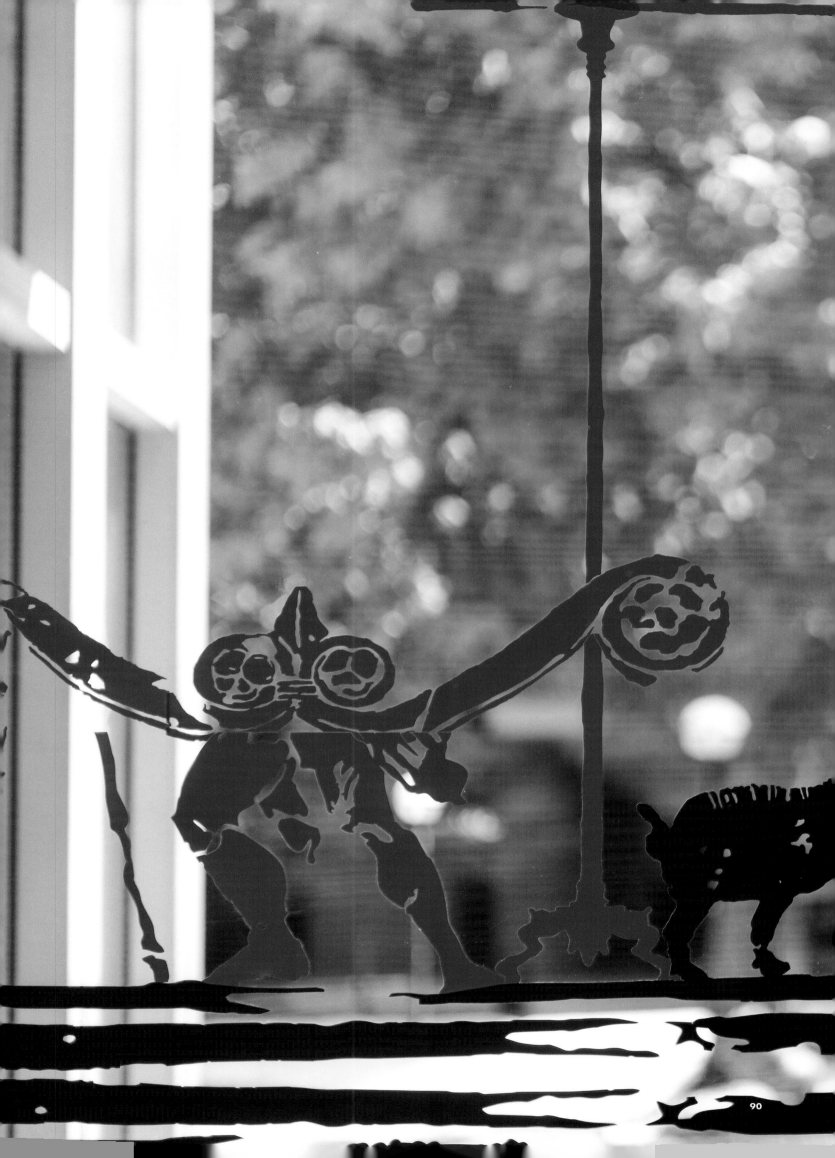

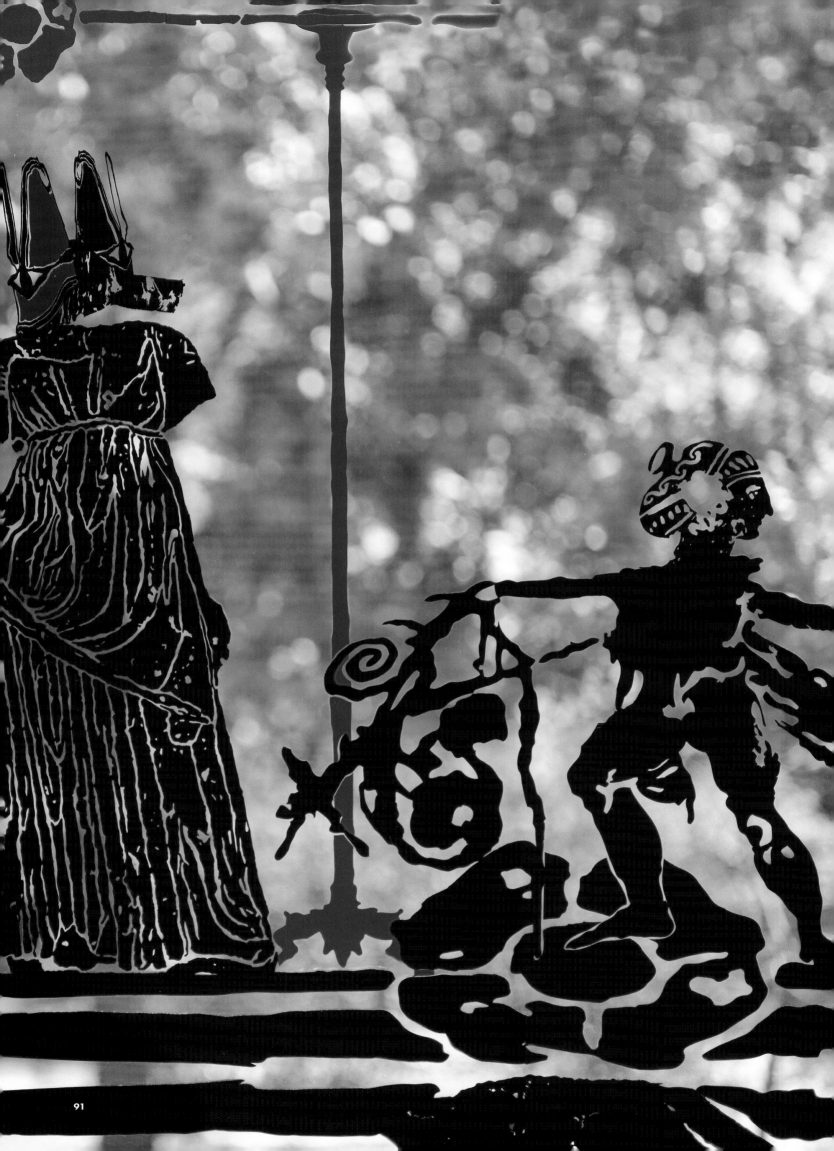

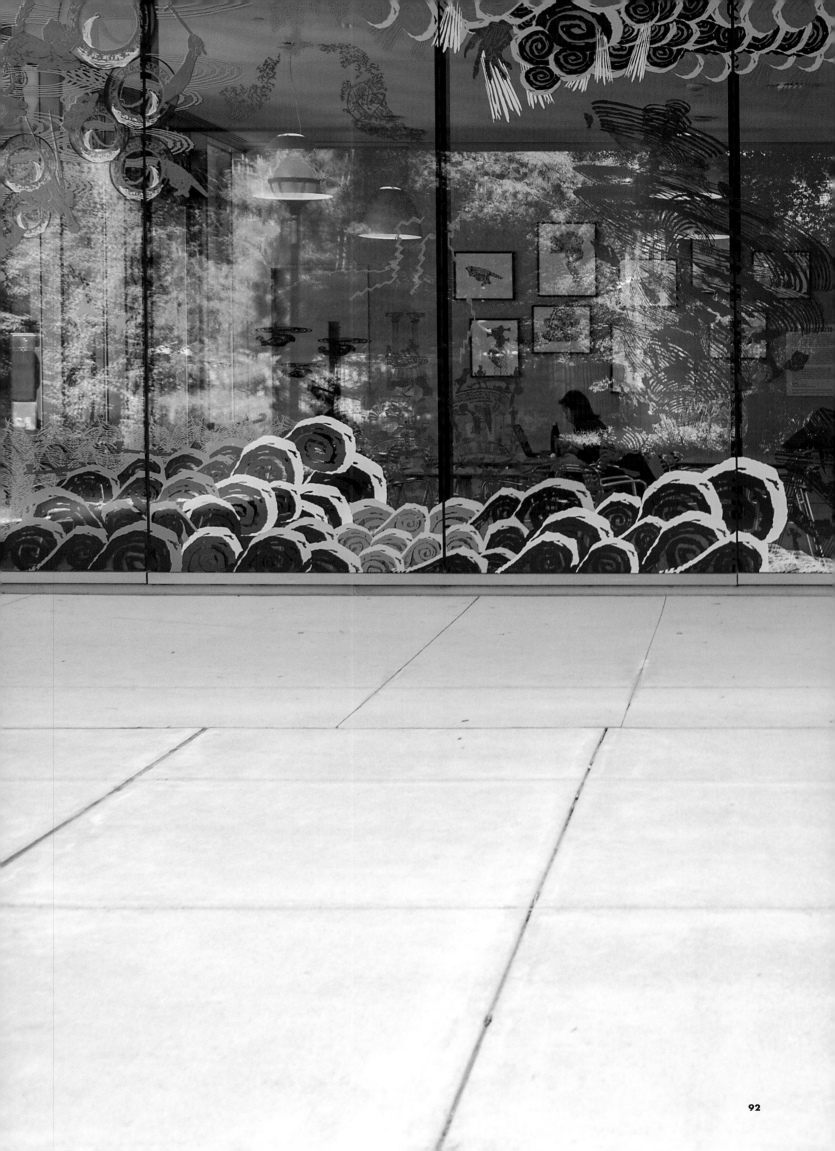

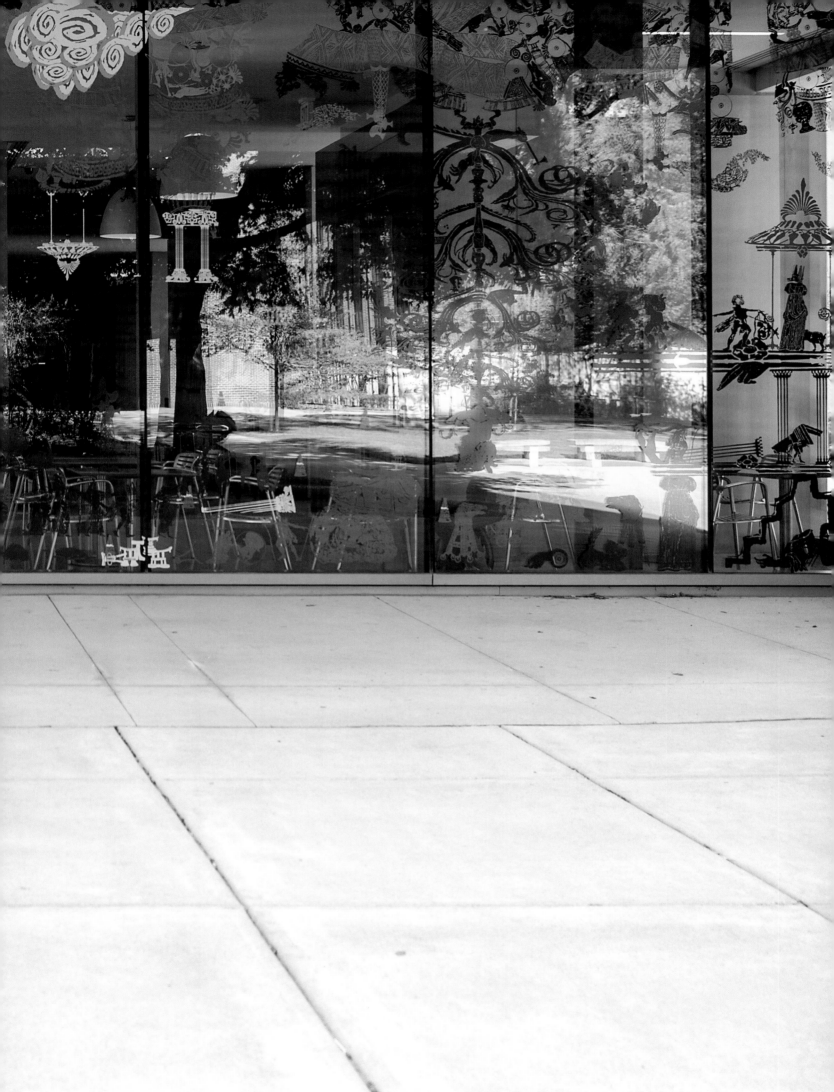

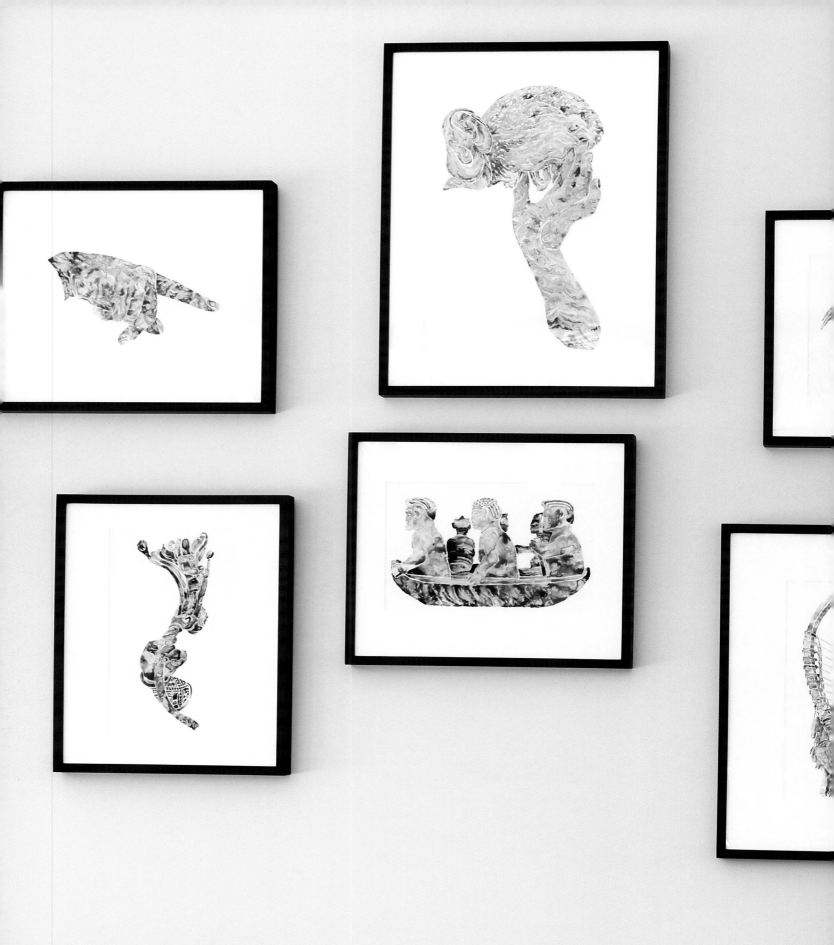

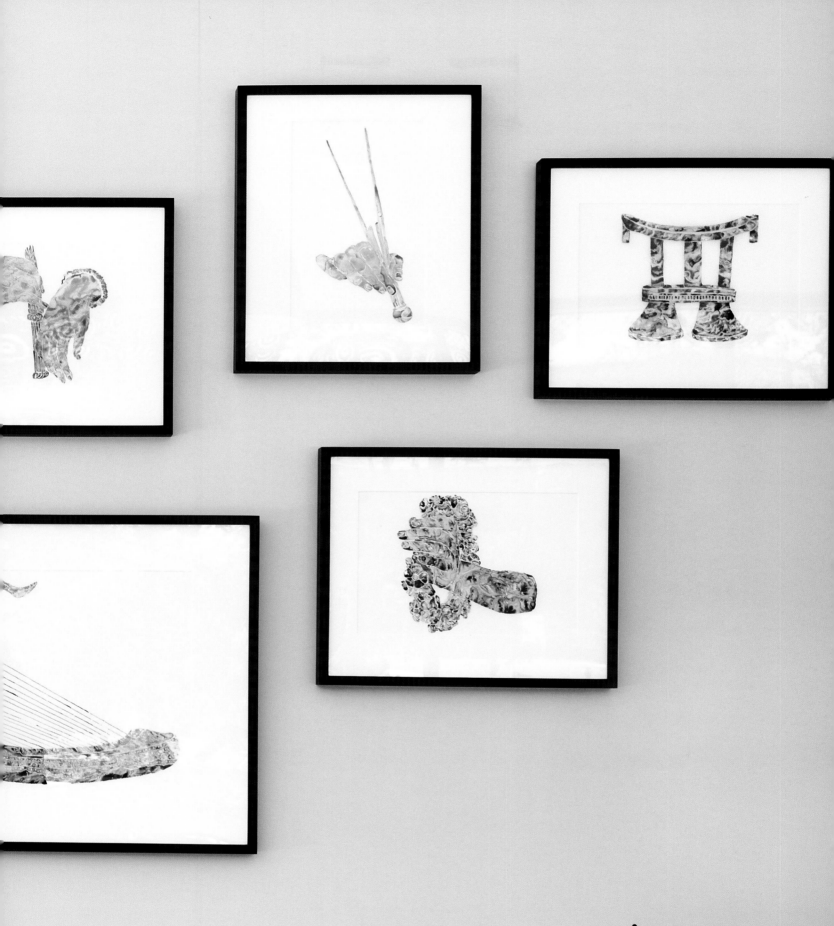

Exhibition in the University of Michigan Museum of Art Commons of paintings of objects from the collections.

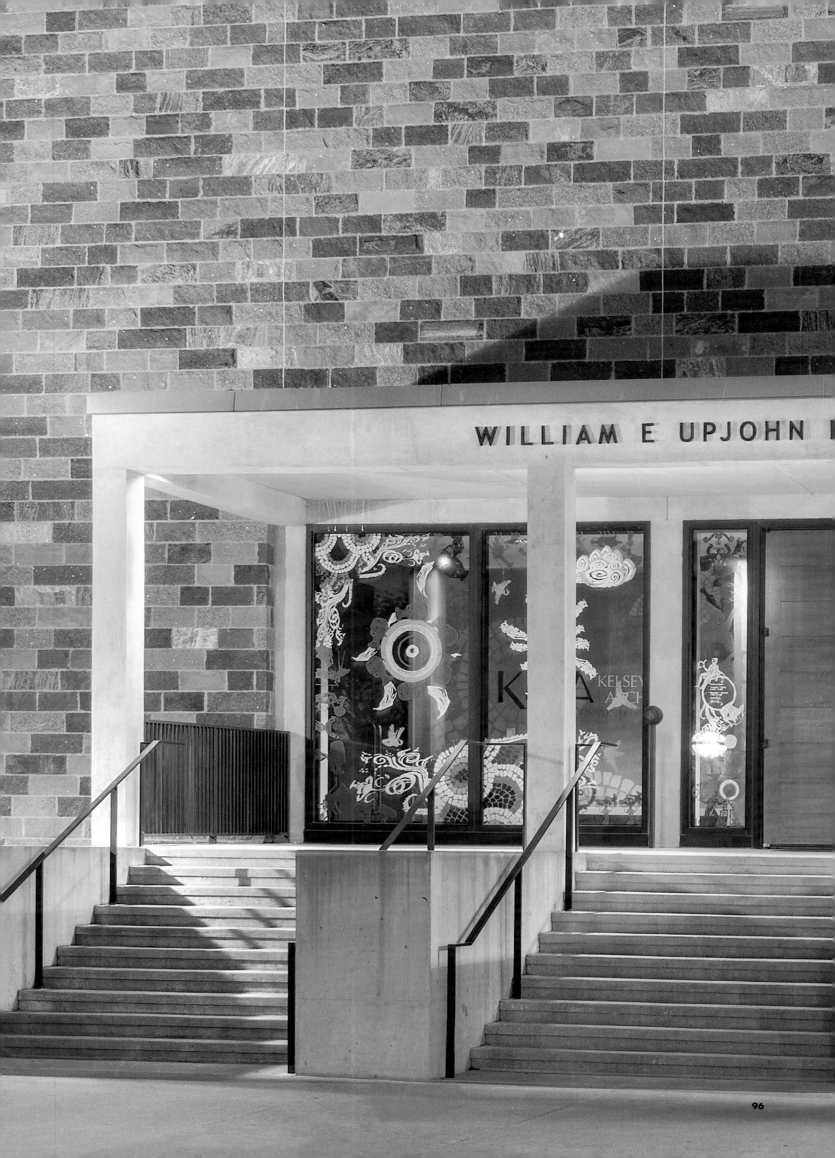

WILLIAM E UPJOHN

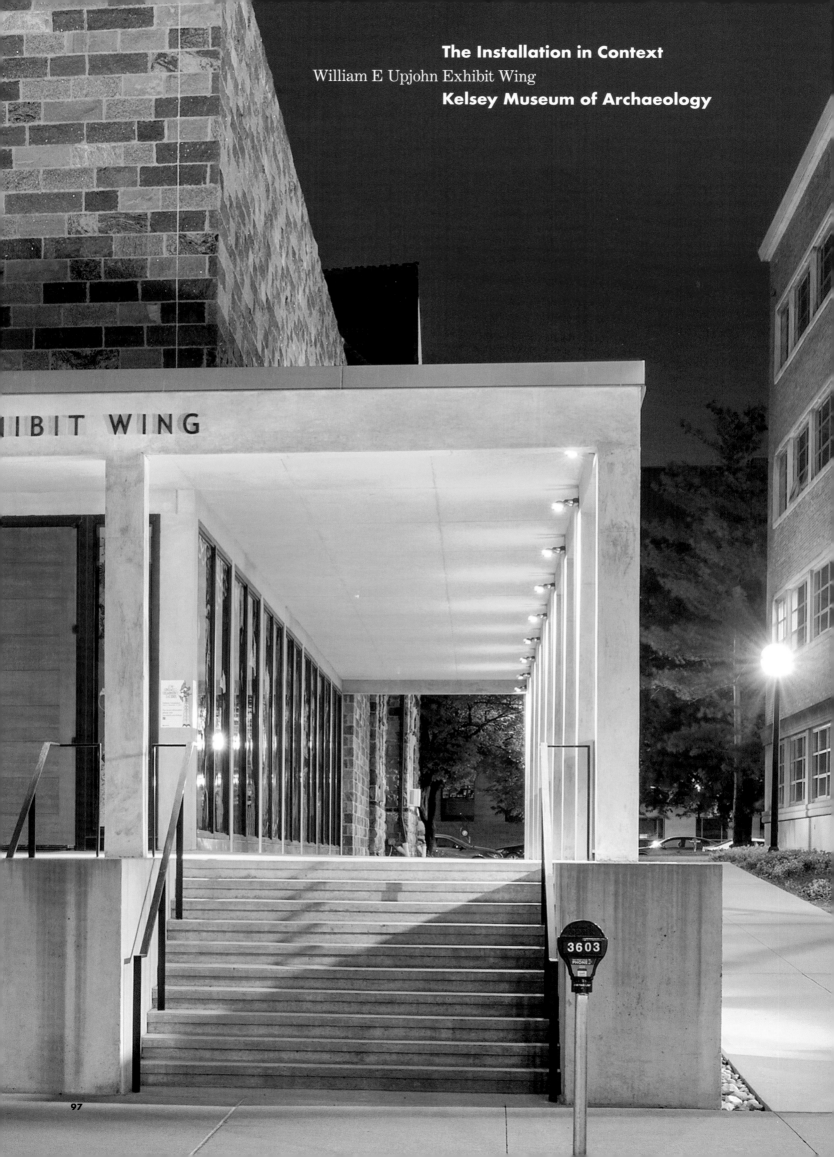

IBIT WING

3603

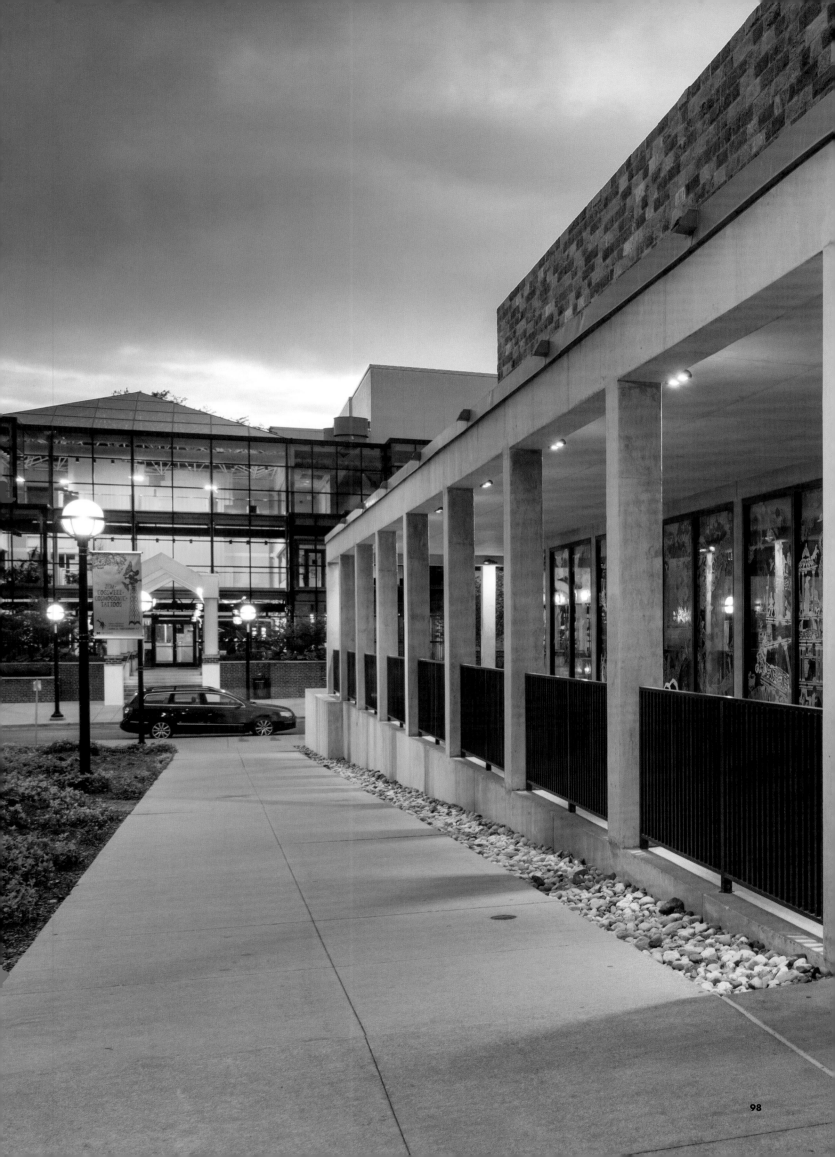

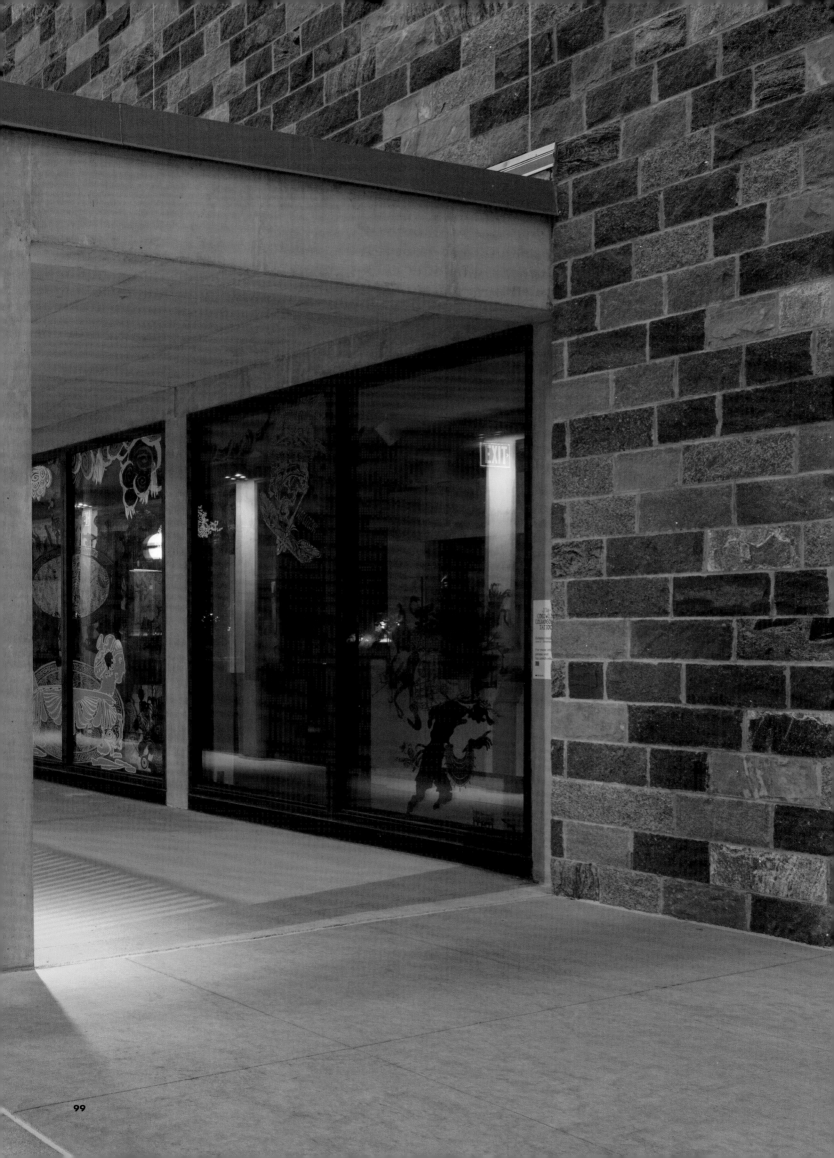

William E. Upjohn Exhibit Wing

Design for exterior windows

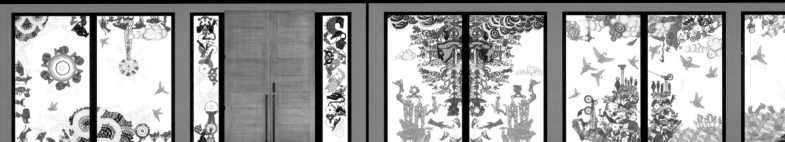

West facade

South facade

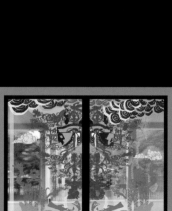

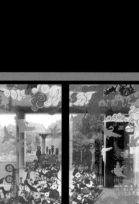

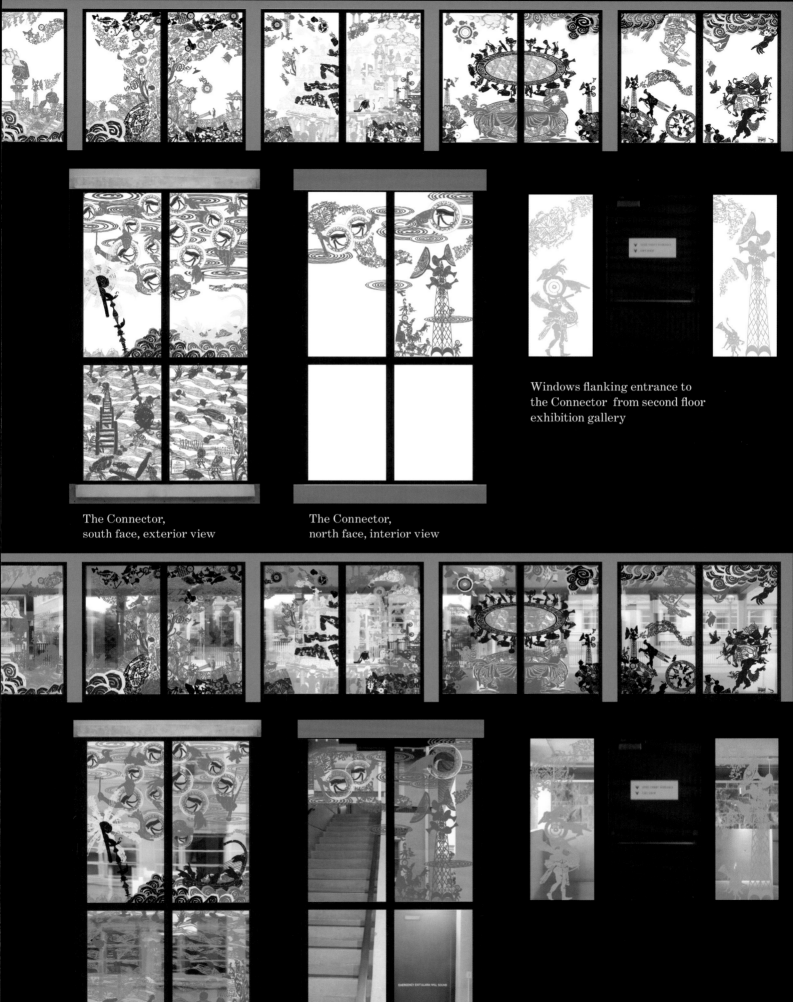

Windows flanking entrance to
the Connector from second floor
exhibition gallery

The Connector,
south face, exterior view

The Connector,
north face, interior view

William E Upjohn Exhibit Wing

Design for exterior windows with
examples of source artifacts from
the Kelsey Museum of Archaeology

Text by Jim Cogswell

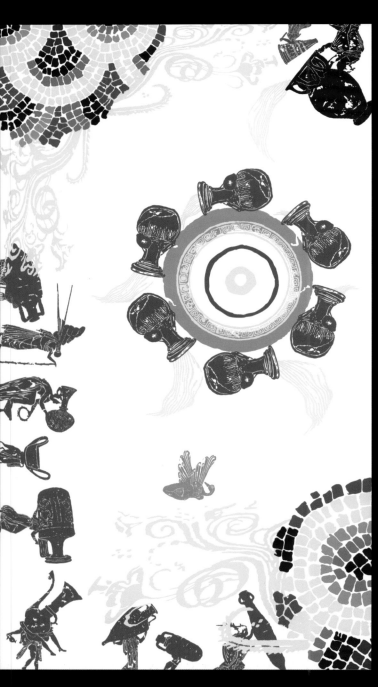
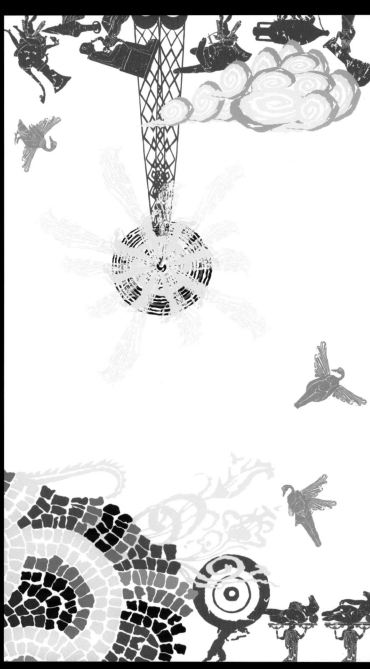

• The Kelsey entrance is not a terminus but a turning point.
Like a cable on a spool, the strand of travelers arrives there,
marches across the top of the glass, descends the far side,
then turns back across the bottom, returning to UMMA
across the street. The Kelsey entrance has become a
traffic roundabout for the march of ancient figures traveling
endlessly in a loop of influences and understandings.
The pairs of windows along the portico provide the
settings for a series of linked incidents along their pathway.
Each episode brings to the window surfaces the story of

• We enter the Kelsey between vinyl scrolls in narrow
windows flanking its massive wooden doorway. My scrolls
are counterparts to figured scrollwork patterns ornamenting
Hellenistic architecture, originating in Dionysian vine
scrolls, adapted to Imperial Roman architecture and
found throughout the Roman Empire, passing from there
into the symbolic language of the early Christian church.
Borrowings of borrowings of borrowings.

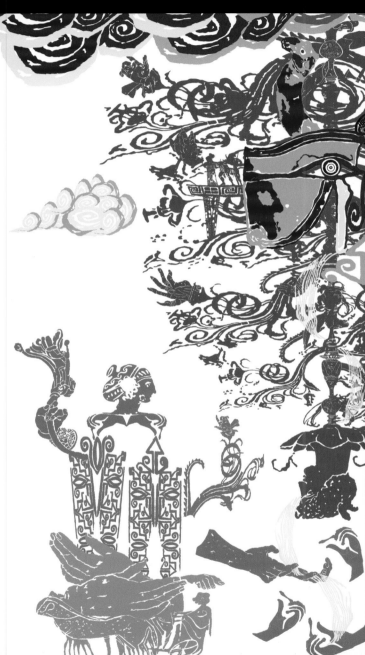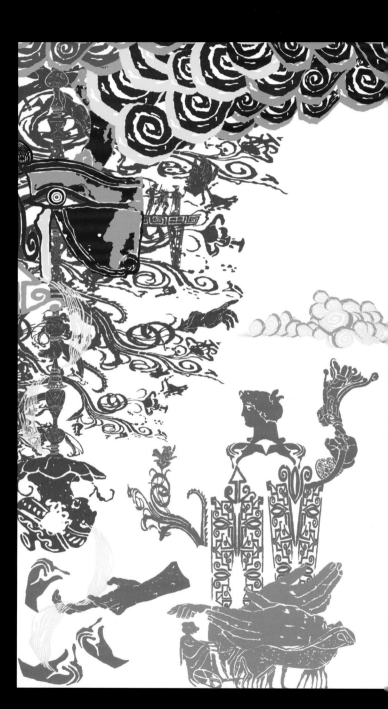

• The first pair of windows on the south side of the portico looks into the museum's entrance foyer, centered on its imposing interior doorway. Behind those doors lies the power of the classical past, a specific set of cultures from a small corner of the universe, the ancient Mediterranean, revered by European societies as the home of our cultural ancestors. An inverted tree protects that entrance with its watchful eyes. Tears trickle through its branches to a cluster of hands that catch them below. Like the Yoruba blurs the distinctions between the animate and the inanimate, archaeology and ancestor worship. Two smaller figures stand to either side below the tree, heads from two Greek vases mounted on the scrollwork of a Parthian frieze, cradled in hands plundered from a Flemish Madonna painting, borne on a chariot from a 6th-century BCE Attic wine cup.

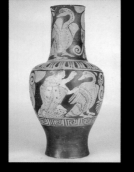

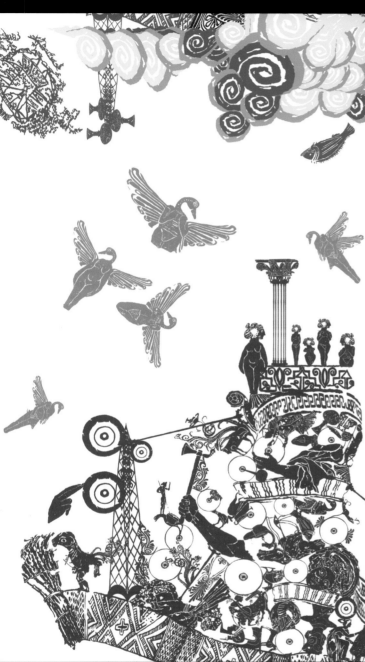
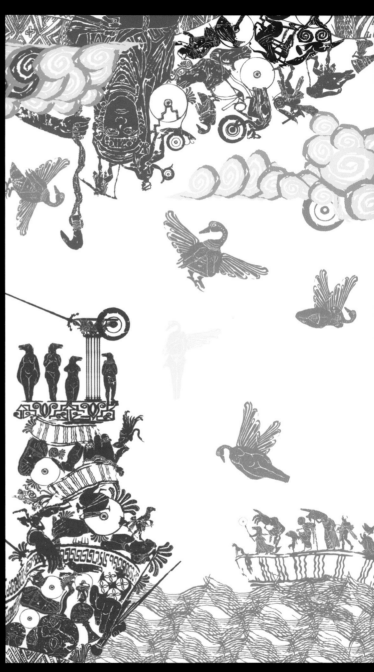

● The permanent exhibition gallery occupying the ground floor of this building is visible inside the next six pairs of windows. Standing directly against the glass of the first pair of windows is a display case of small female figurines from the eastern Mediterranean, headless torsos arrayed like beauty contestants on their individual plinths. I have placed a vinyl outcrop of accumulated cultural debris in front of the case. Atop those layers, two clusters of figurines on either side of the mullion have acquired new heads. One group bears the heads of a Roman marble horse, the other a coifed beauty from a 4th-century BCE South Italian storage jar. Around them hover a flock of female torsos that have sprouted wings borrowed from the corners of a Roman architectural ornament and the features of a goose from the painting on a 4th-century BCE wine jug.

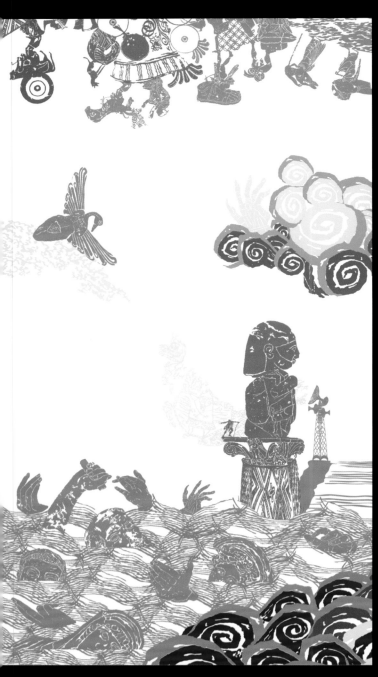
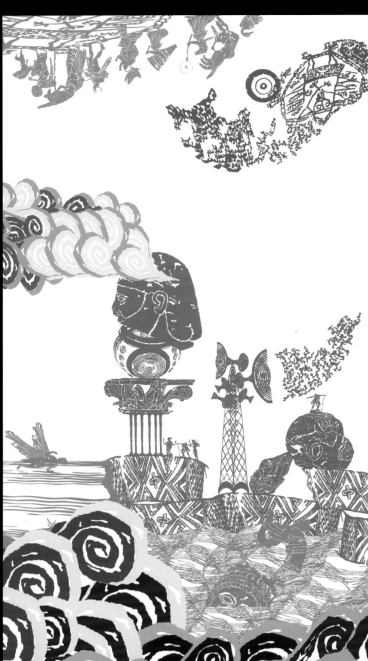

- Across the top of these windows, burdened figures march upside-down toward the museum entrance. In the center of the windows two colossal heads face each other across the entrance to a harbor. Visible on its pedestal through the window between them is the limestone head from Cyprus from which they were taken. That carved head embodies a transitional moment between Egyptian and Greek cultural influences, when Cyprus was the destination for refugees fleeing the collapsing centers of Mycenaean

Greece. At the bottom of the windows, a flotilla of heads, a congregation from the exhibition hall inside, tilts and sinks, half-submerged in the waves just outside that harbor entrance, hands gesturing wildly above a lovely rippling surface that seals them in. A small winged figurine splashes into the aqua lines of the sea between them. From the shore, distant figures regard those curious breaks in the patterned waves.

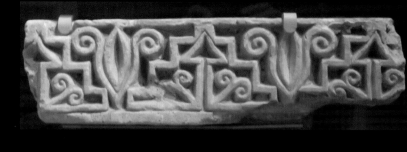

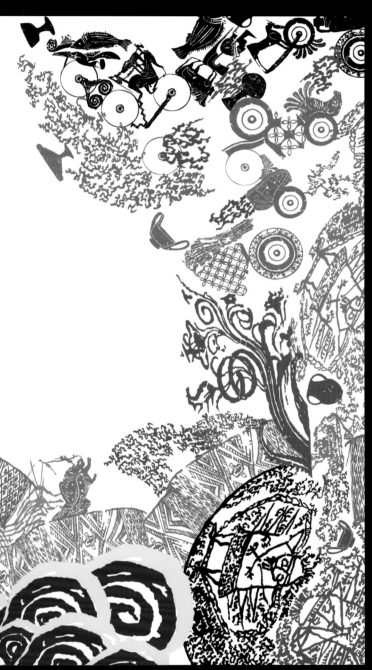

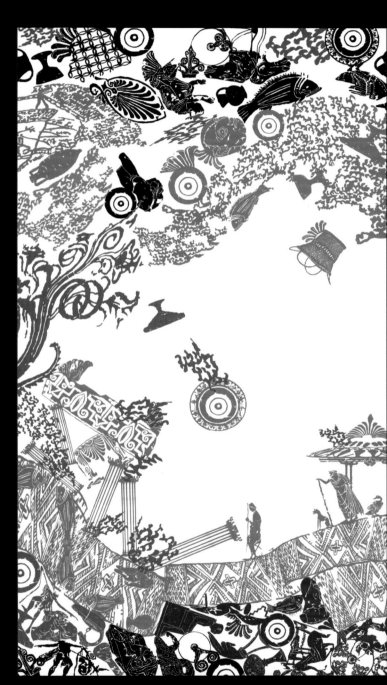

- A volcano seems to explode from a display case. Its dark clouds and tongues of flame are the first thing a visitor sees when passing the security desk into the exhibition hall inside. Etruscan goblets, bowls, and pitchers are being spewed into the upper atmosphere by the Parthian demons exercising their subterranean mischief at the bottom of the window–there is a violent fragmentation, a shifting of geological strata, and a rearrangement of

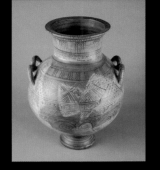

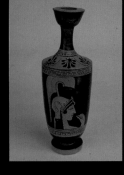

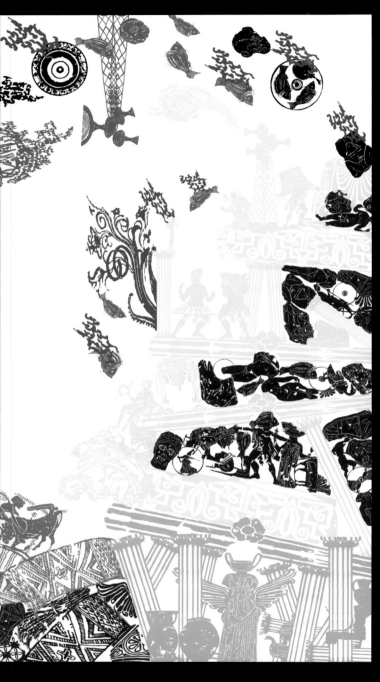
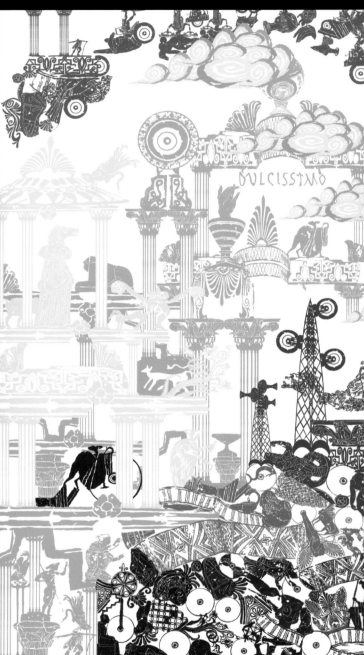

108 • The palace next door is receiving a rain of burning debris from that eruption. The basement on the near side has begun to collapse under the weight of blackened figures. In the adjacent window, life goes on, sweetly and serenely, in layer after ascending layer of architectural fantasy built from fragmented artifacts. Atop that palace, the word *DULCISSIMO* acts like a neon sign advertising the house of unending bliss at the very moment of its collapse, text borrowed directly from a Roman memorial tablet recording the sorrow of a mother mourning her lost son, the most precious and sweetest there ever was.

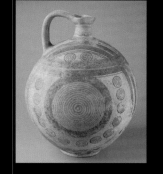
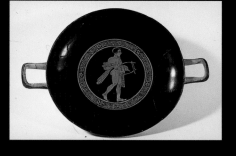

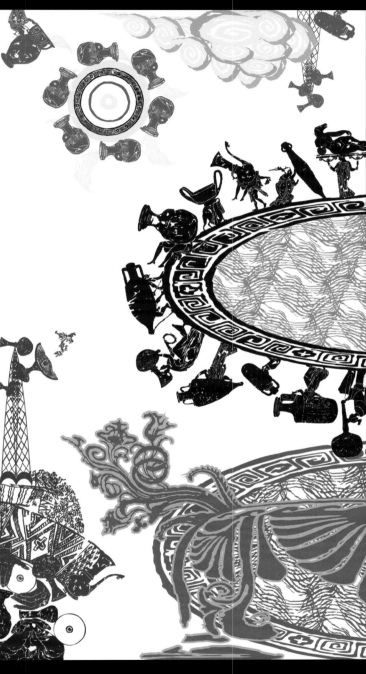
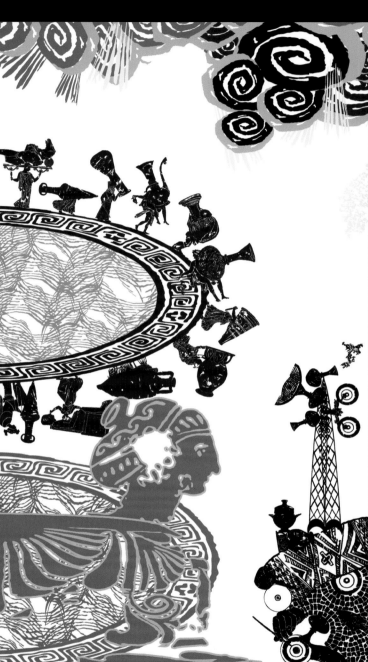

• A procession of figures liberated from nearby
ceramic vases parades around the perimeter of an
ornamented pool. Just inside the window a display
case of glassware is visible through the rippling
transparency of that framed oval. The figures
circling the case each heft oversize vessels from
the displays inside. They have become containers
with legs, migrating cultural vessels. If, as Tom
Robbins has said, water invented humans in order
to transport itself from one place to another, culture
seems to find humans useful in much the same way.

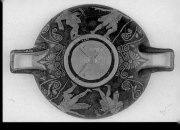

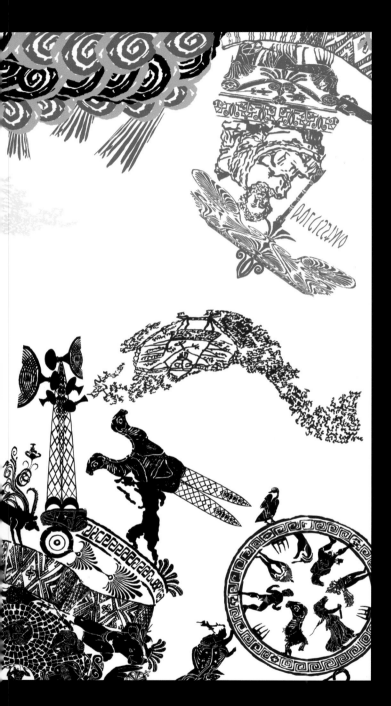

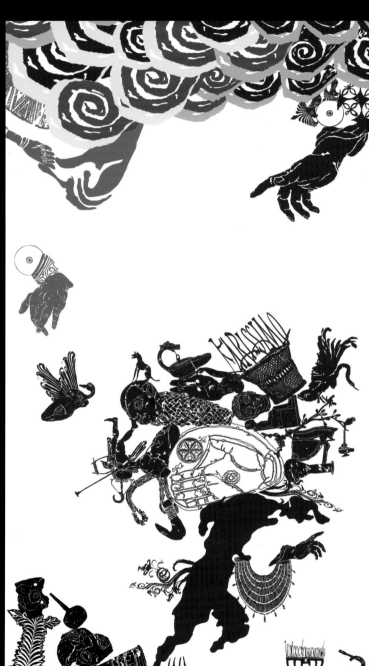

• In the last pair of windows under the portico a darkly
silhouetted figure dashes away under a mountain of
plunder. A faience necklace from Egypt is draped on
his arm, snatched from a display case in front of the
window. To the right of that case, the truncated torso
of Nilus, god of the Nile, reclines atop a pedestal.
At the top of that window, as if being transported
across the bottom of the sky, Nilus has been propped
aboard a wagon being pulled by the hand of Athena,
which reaches from enveloping clouds. Plundered for
millennia for its riches, the Nile itself is finally being

• At the end of the portico, a two-story connector
links the exhibit wing with the rest of the museum.
Its tall windows loom over the outside walkway,
divided horizontally by a heavy structural mullion.
The ship of hands from UMMA sails across that
mullion, guided by the great torch of Vishnu, radiating
concentric circles of light from the Cypriot wine jug.
Over them hovers a cloud of gesturing hands filling
the sea with their tears. The connector space has
become inundated below the mullion. A rippling
pattern of water from a Theban vase fills the windows

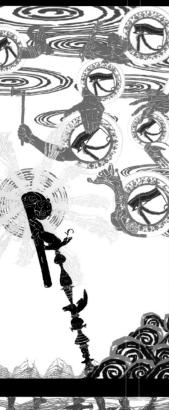

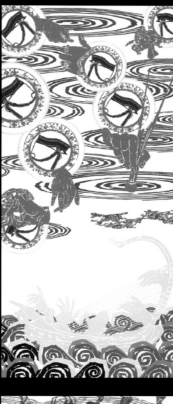

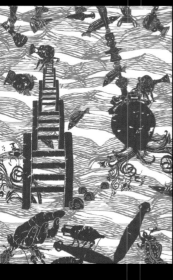

the mullion, below sea level, under the threshold
of consciousness. Floating jars, pitchers, and vases
have sprouted fins. Giant hands have sunk to the
seabed. Others, like crabs, emerge from barnacled
amphora among a scattering of cracked Mesopotamian
heads, like bivalves on the floor filtering the debris.

• A tablet at the bottom of the sea announces the title
of the installation in letters borrowed from the
memorial tablets inside the museum. It sits in the deep
ocean of time, in the ebb and flow across the divide
between the present and the past, the briefly living
and the long dead; somewhere in the gap between the

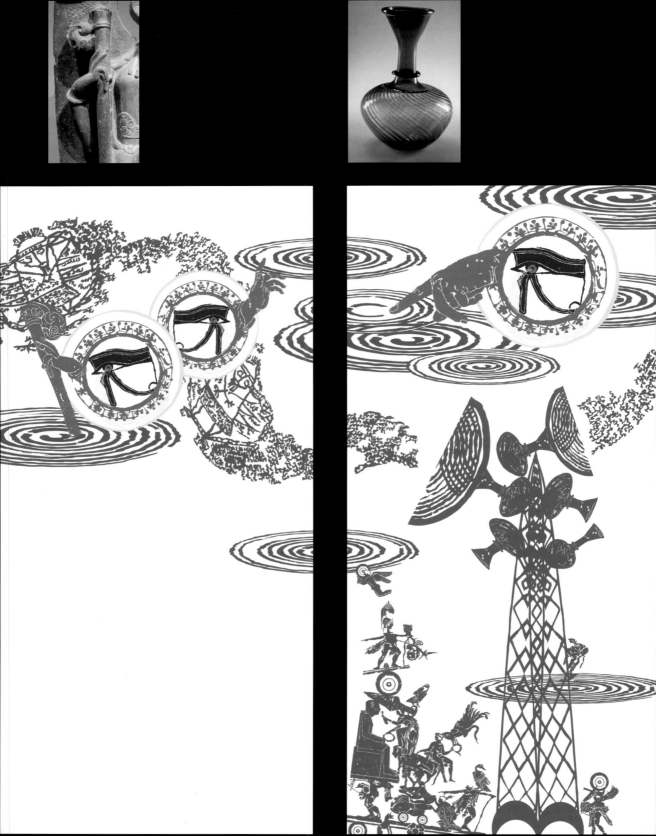

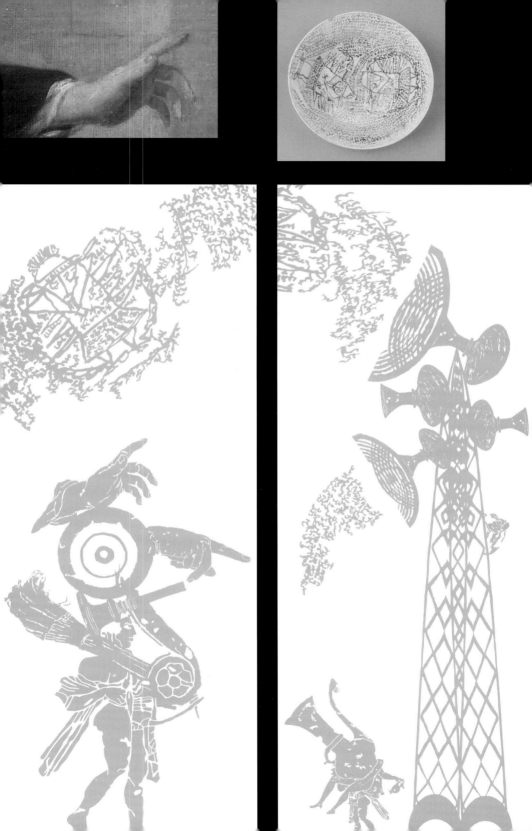

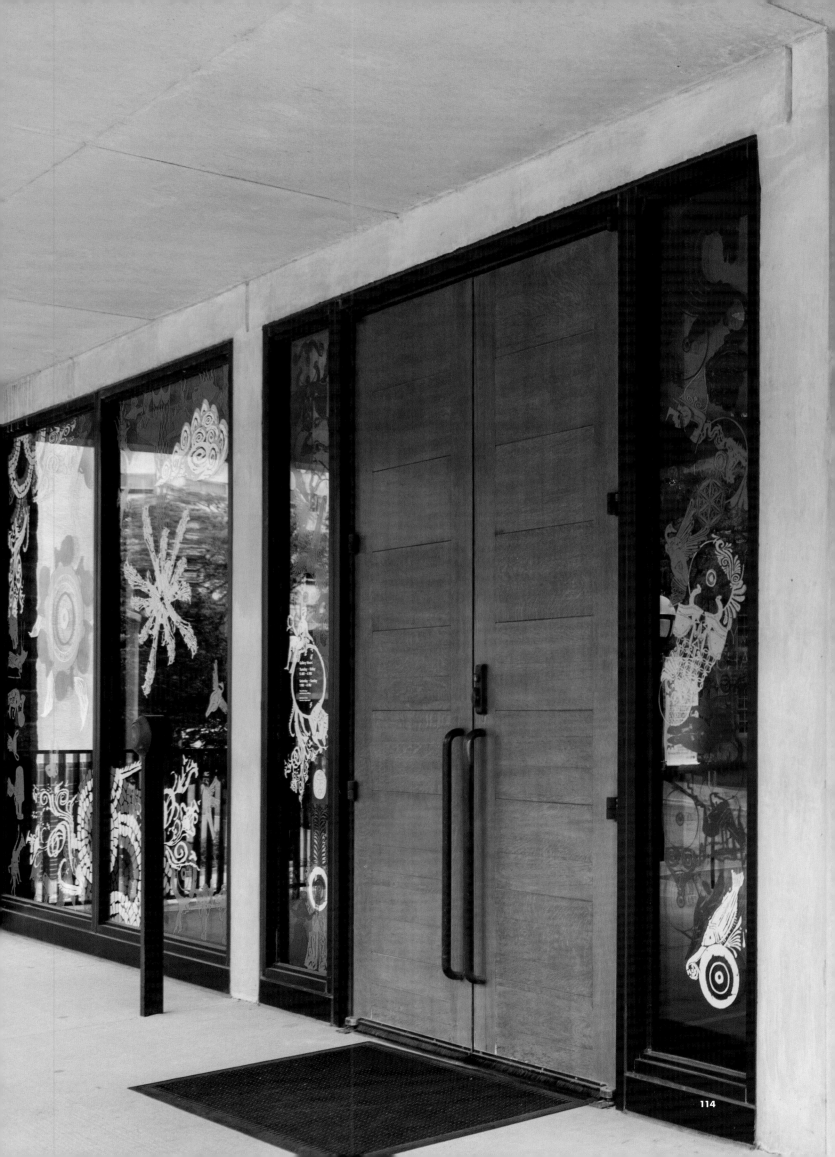

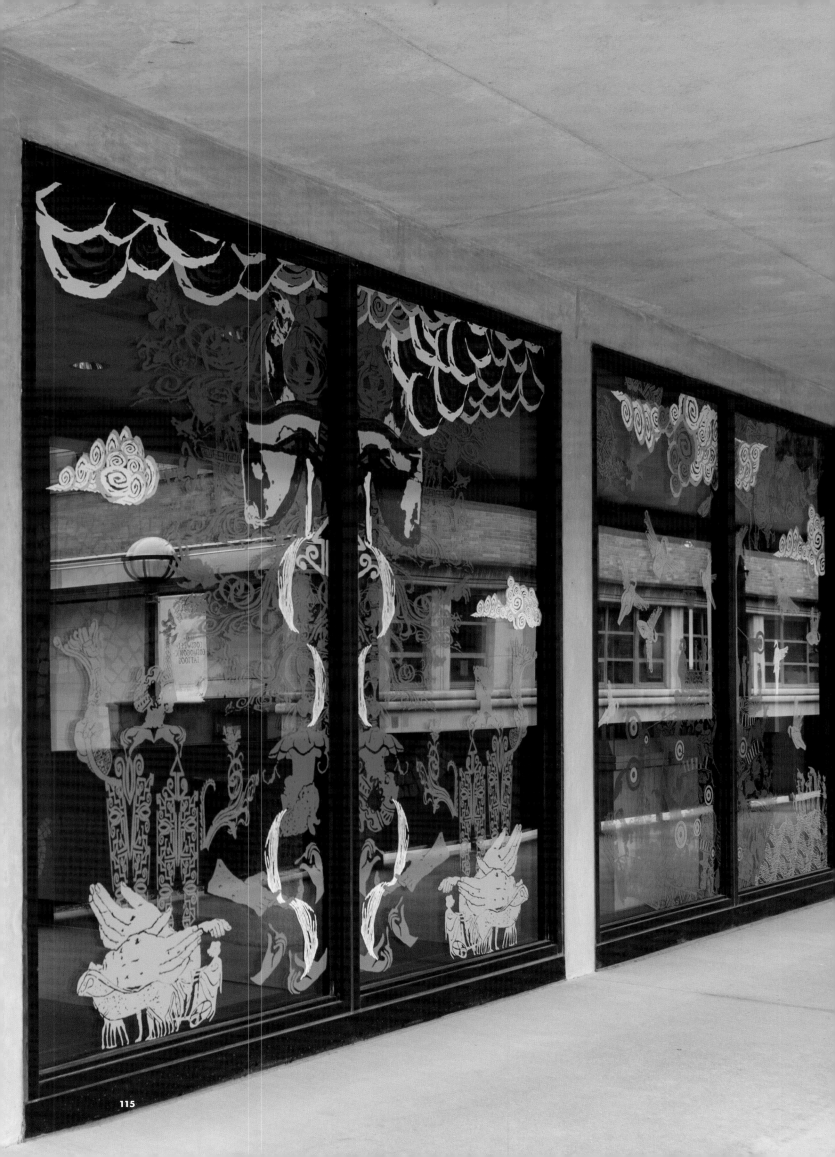

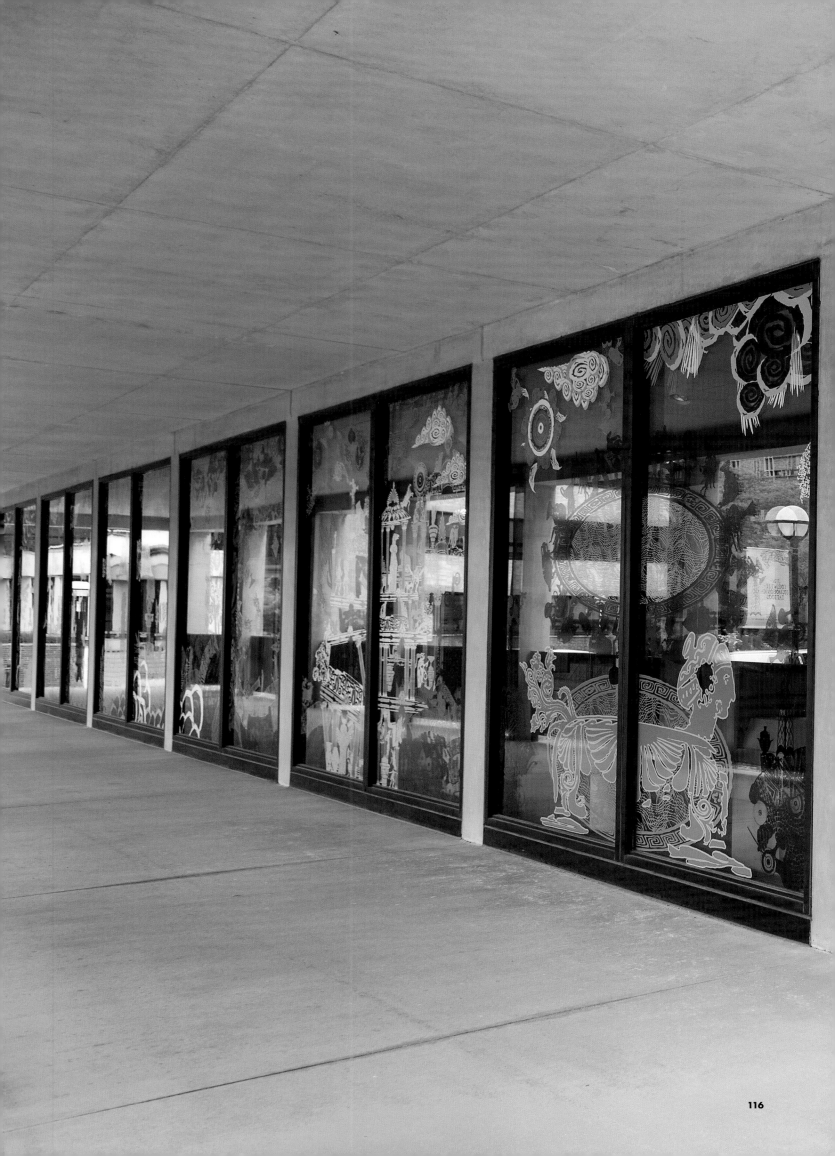

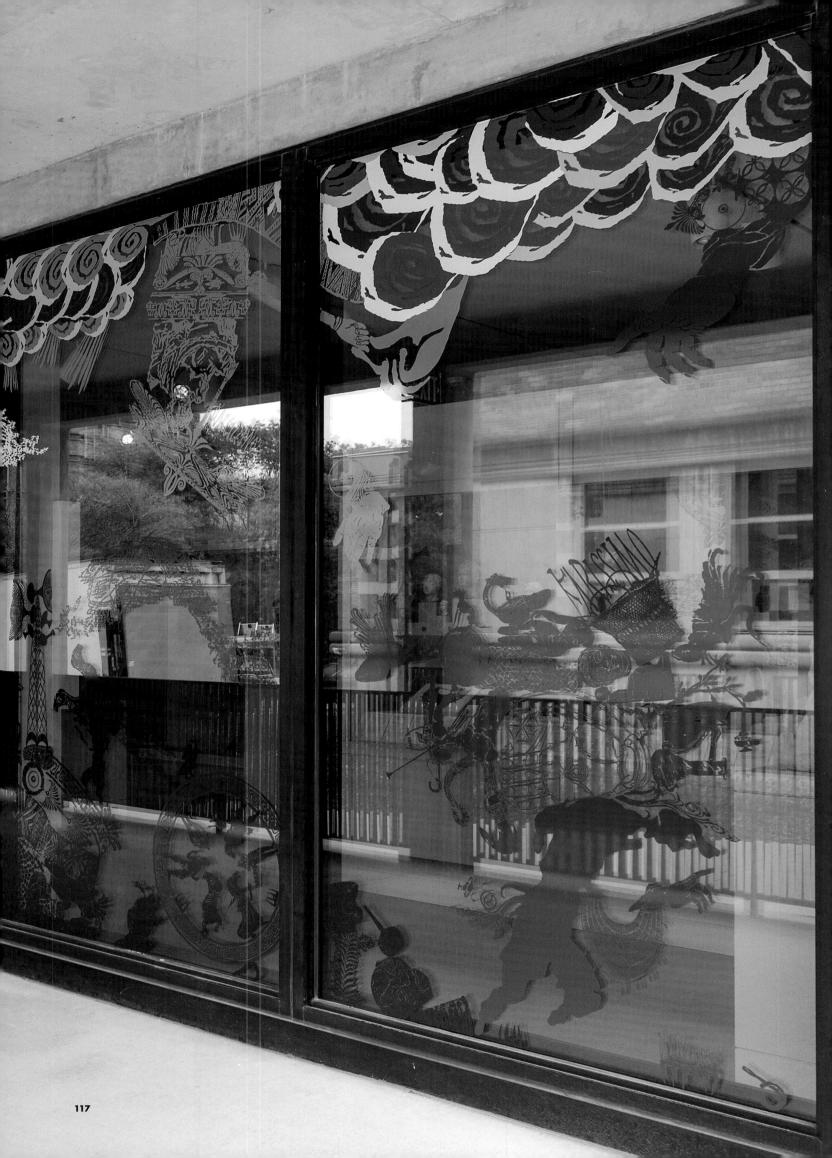

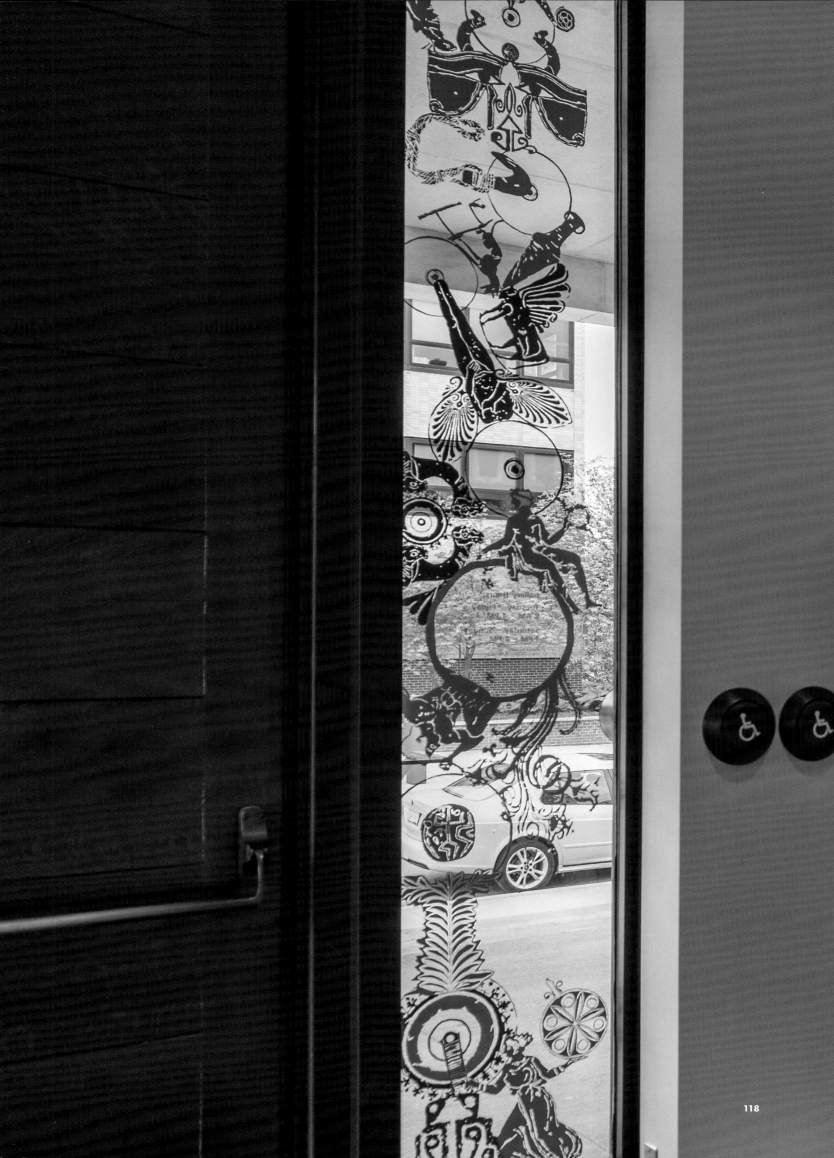

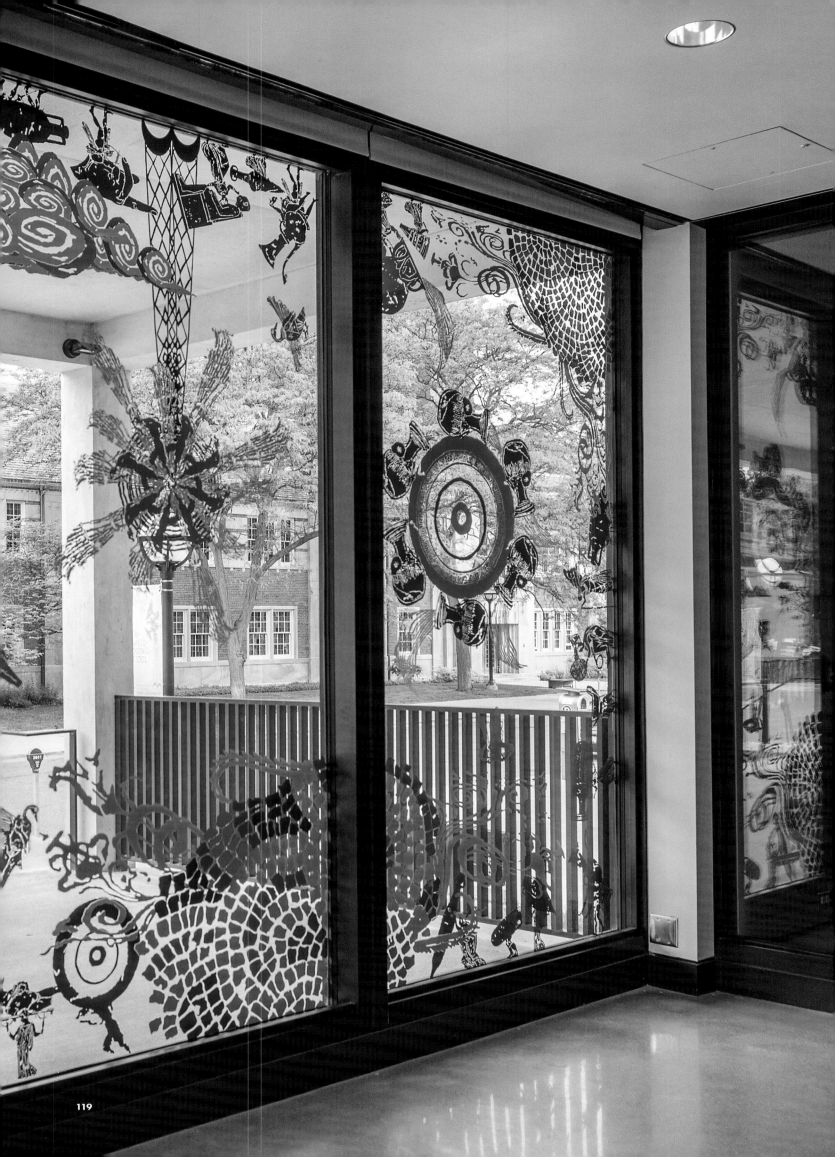

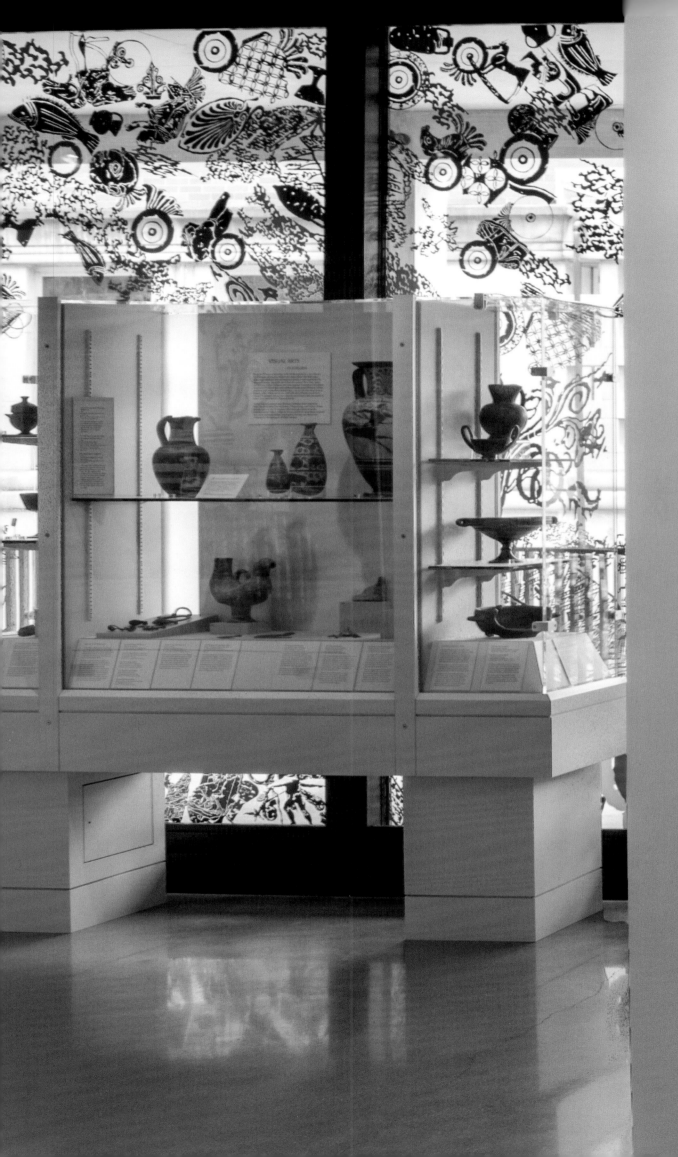

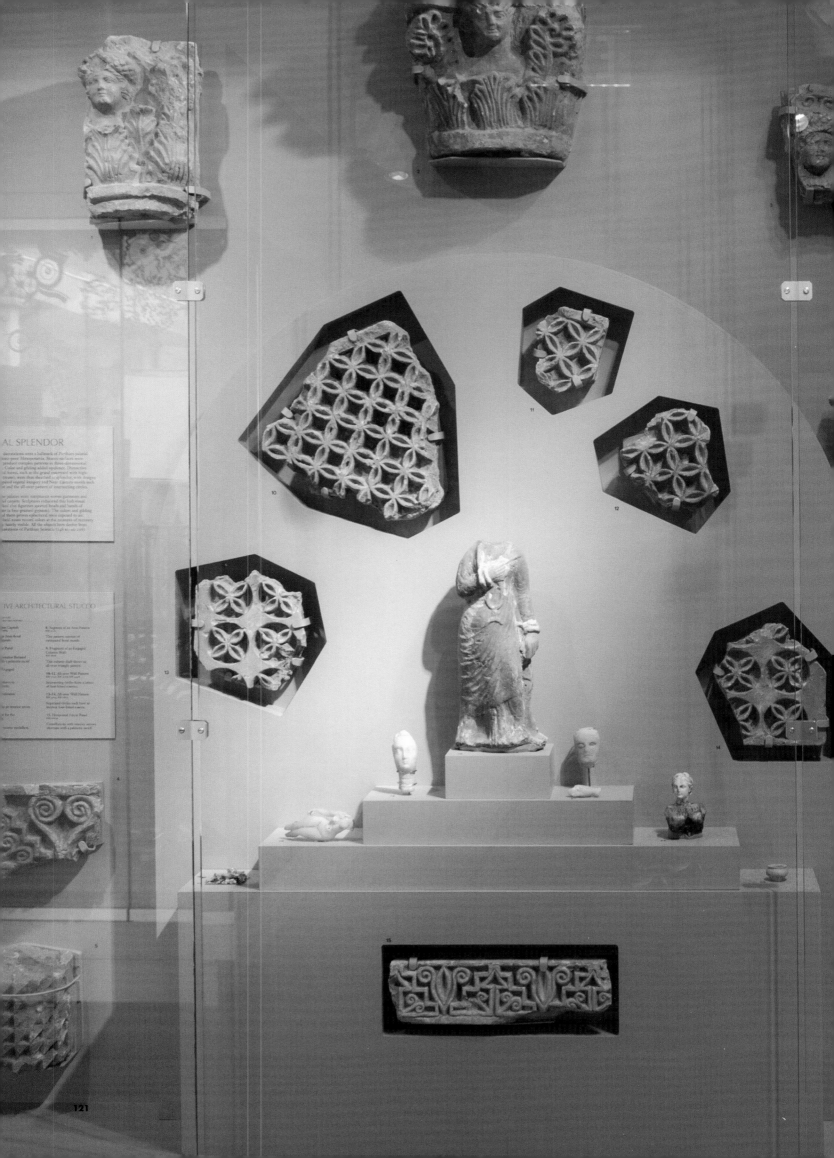

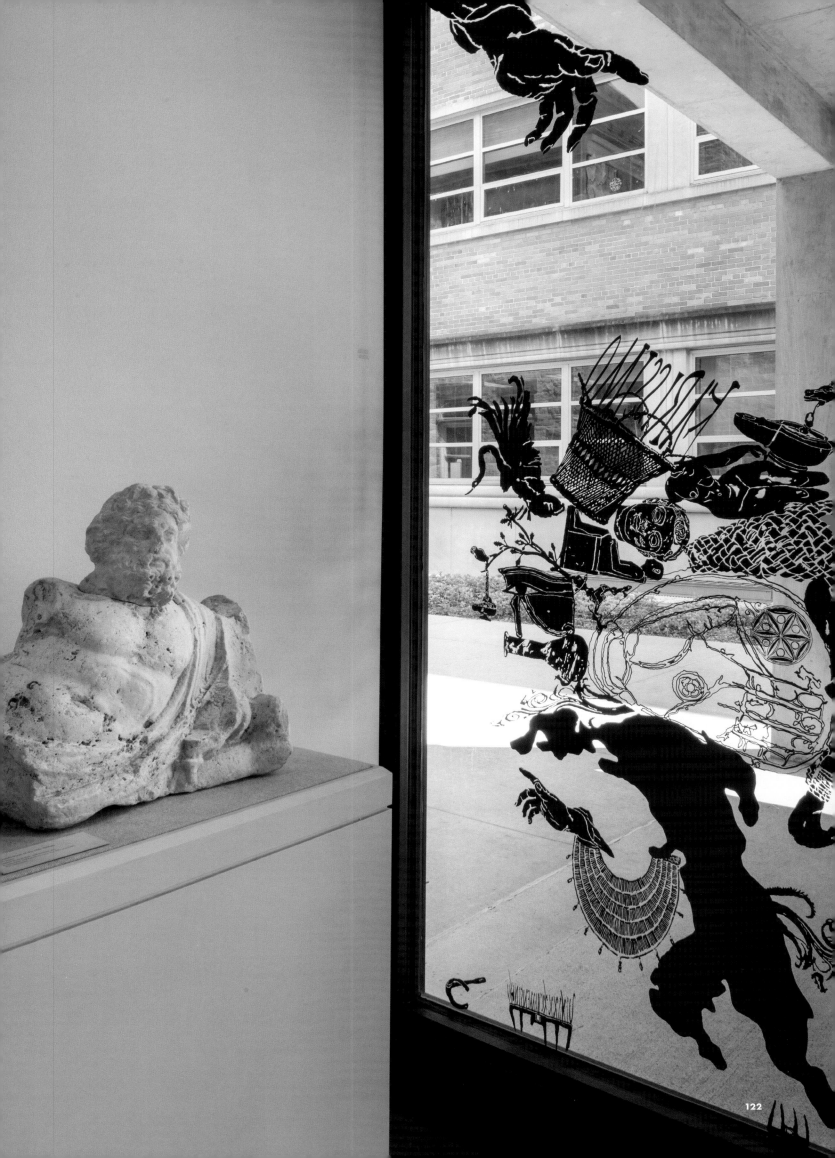

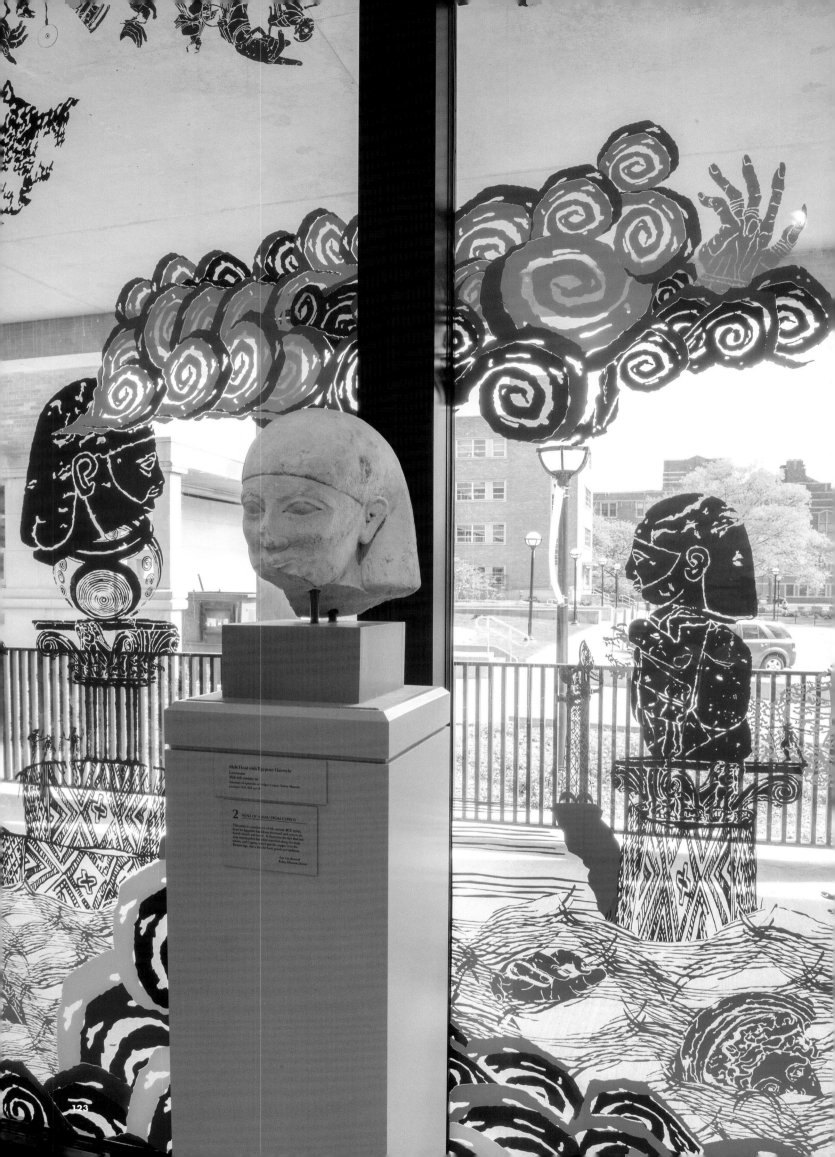

Male Head with Egyptian Hairstyle
Limestone
Mid-6th century BC

Sanctuary of Apollo at Golgoi, Cyprus, Kelsey Museum
purchase 1928, KM 74026

2 HEAD OF A MAN FROM CYPRUS

This piece is a combination of 6th-century BCE styles,
from its Egyptian-like idiom, forehead, and eyes to its
Greek mouth and face off. It illustrates the fact that not
only manufactured but often travelled along the trade
routes, and Cyprus, which gave the copper into the
Bronze Age, was a hub for both goods and fashion.

Pat Van Russell
Kelsey Museum Docent

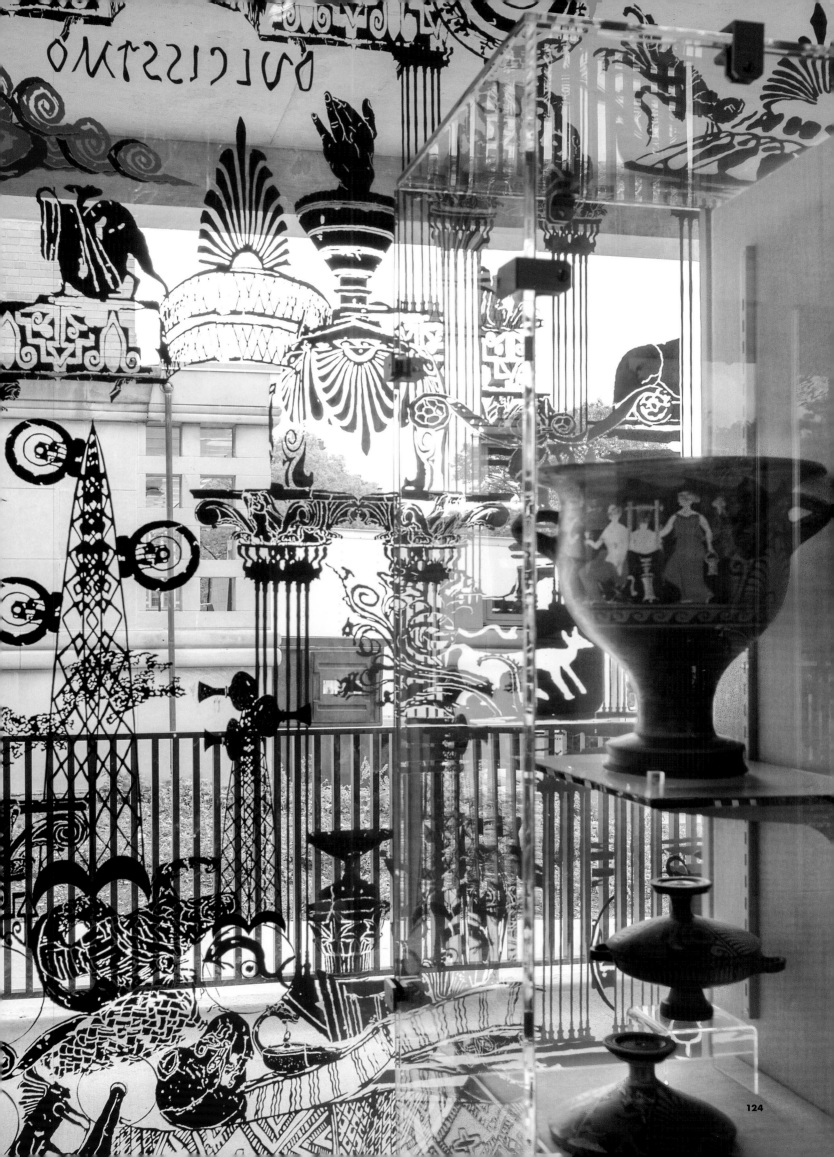

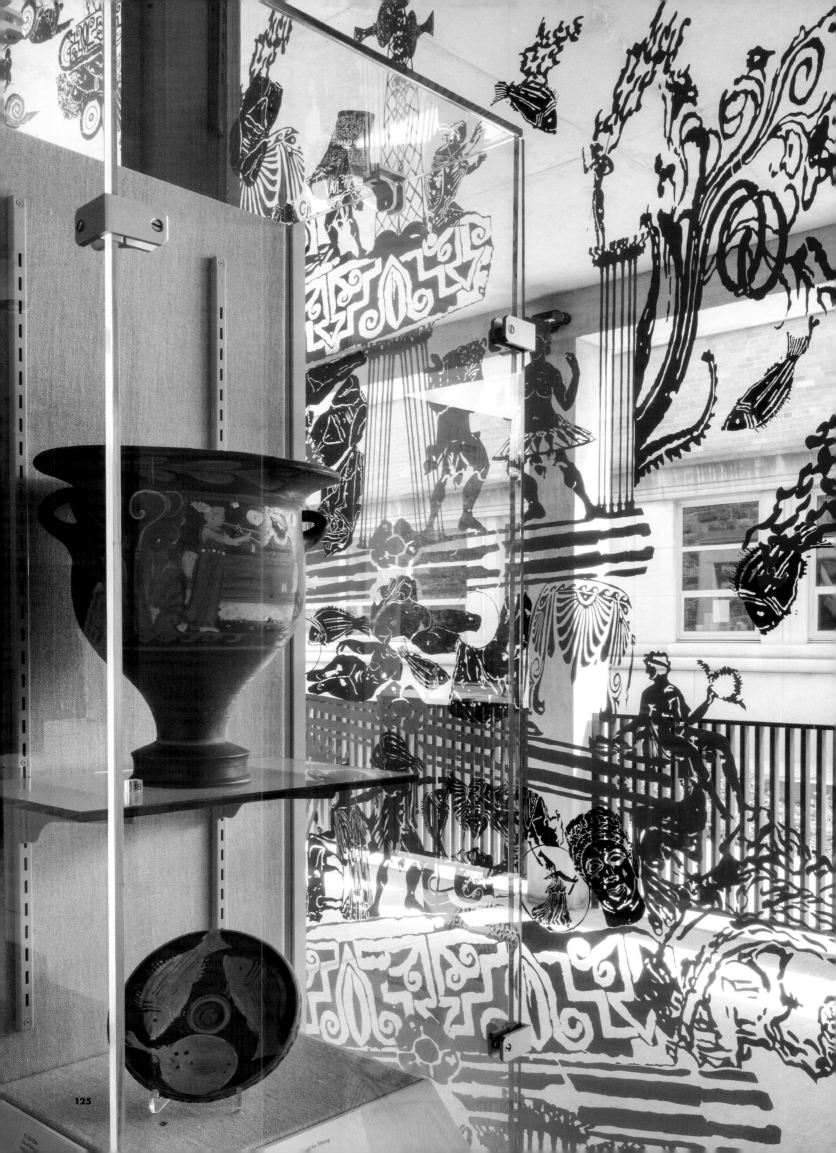

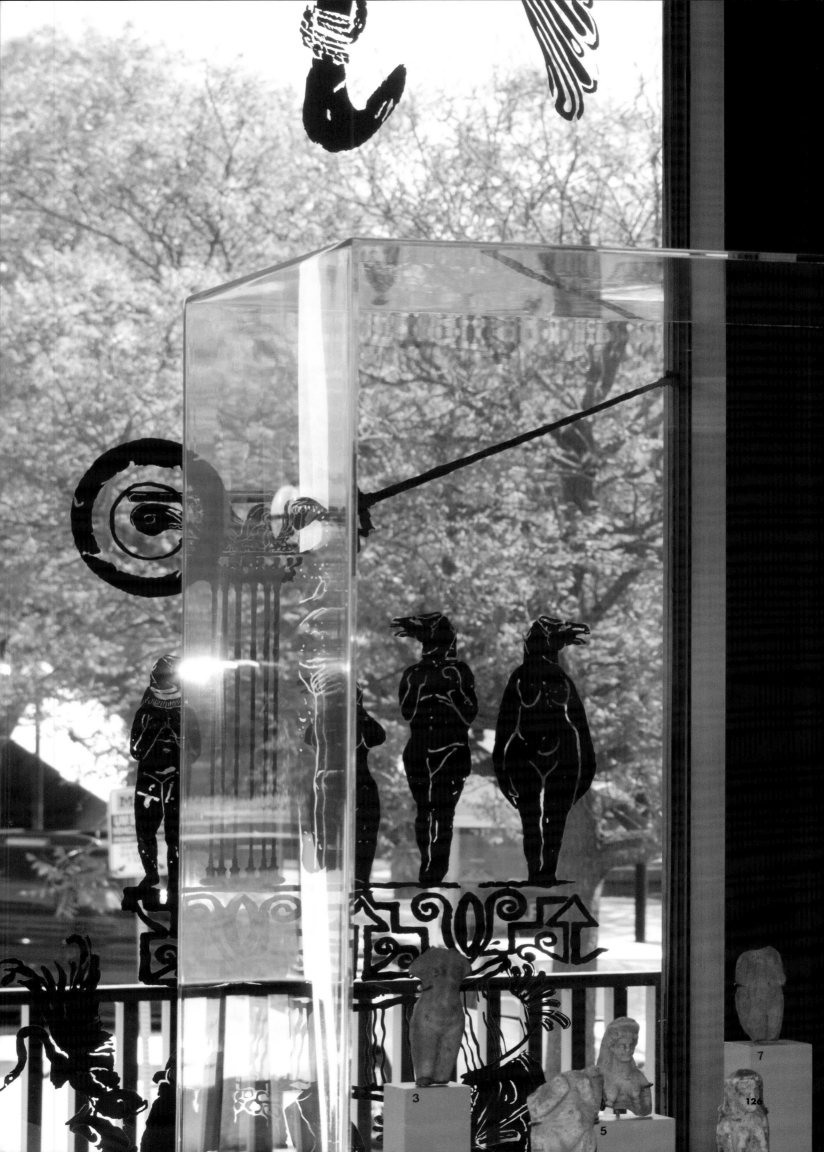

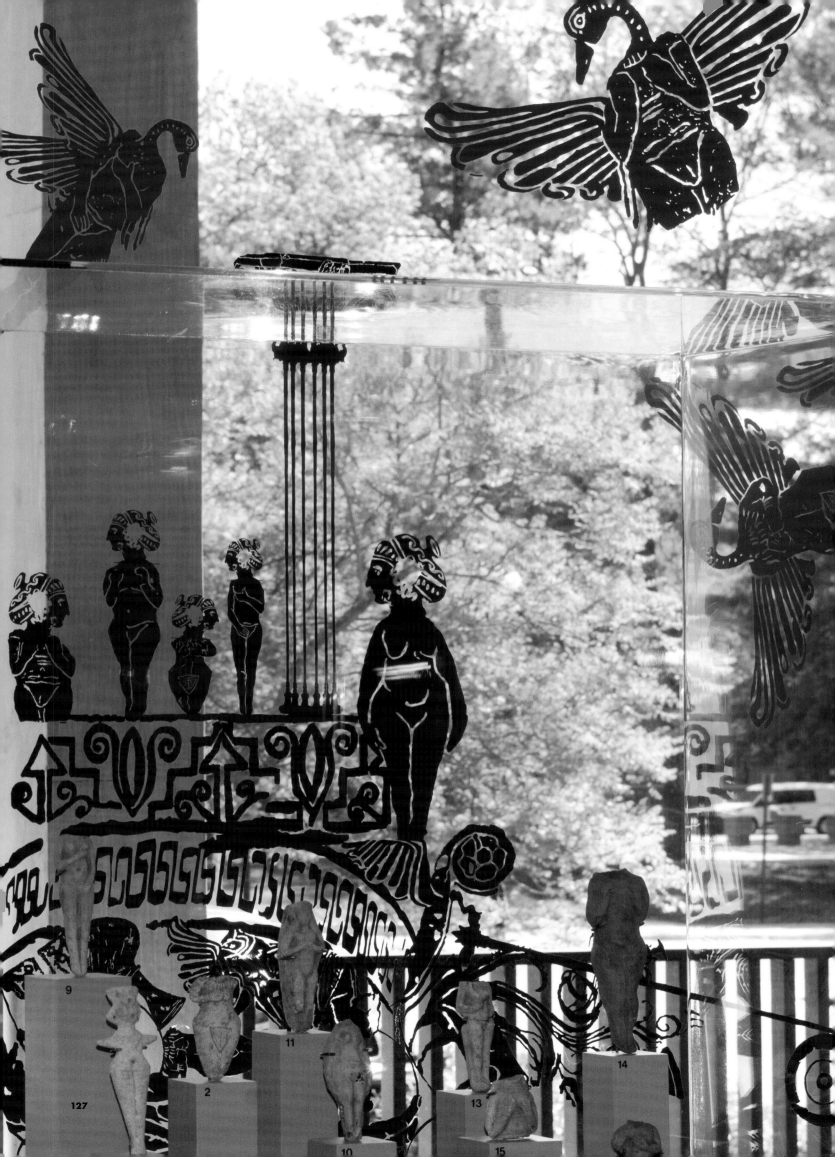

127

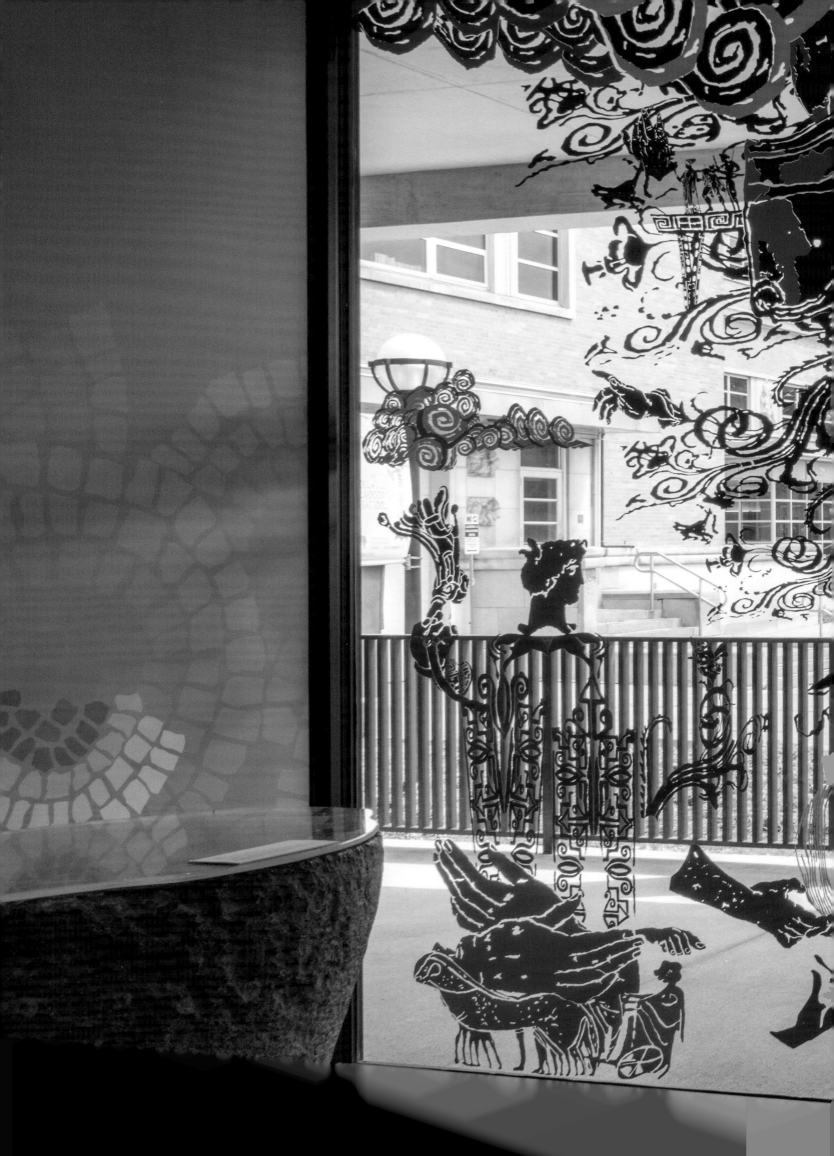

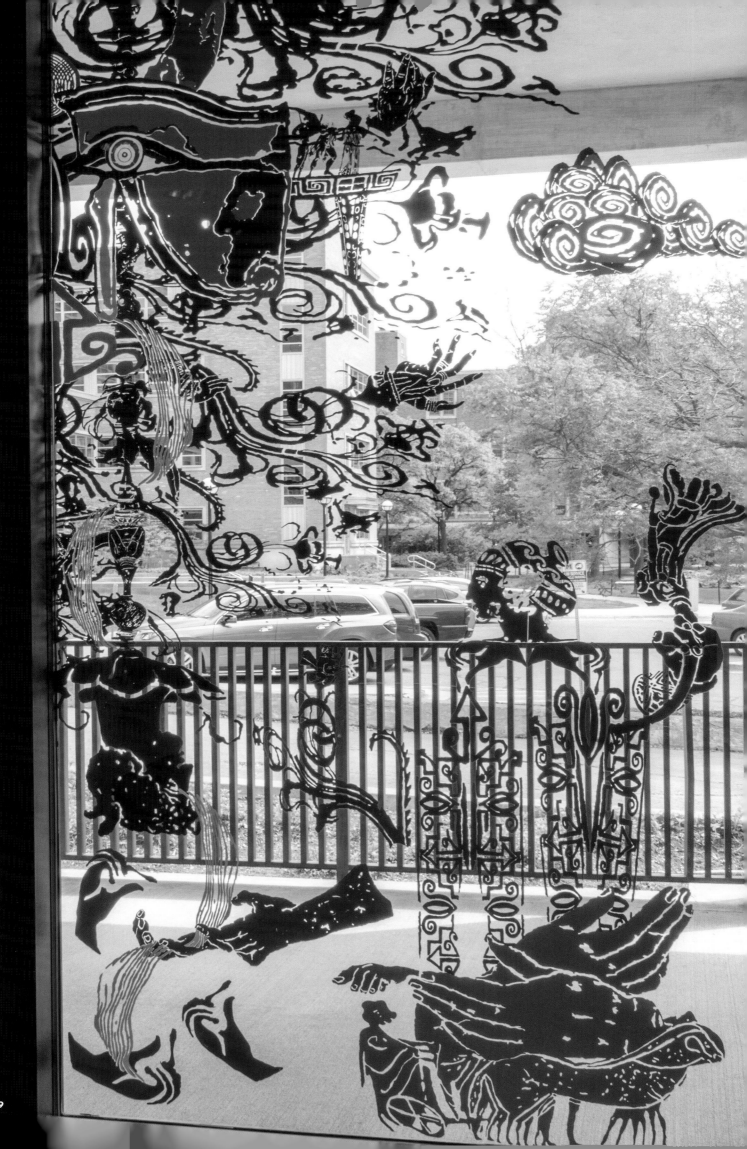

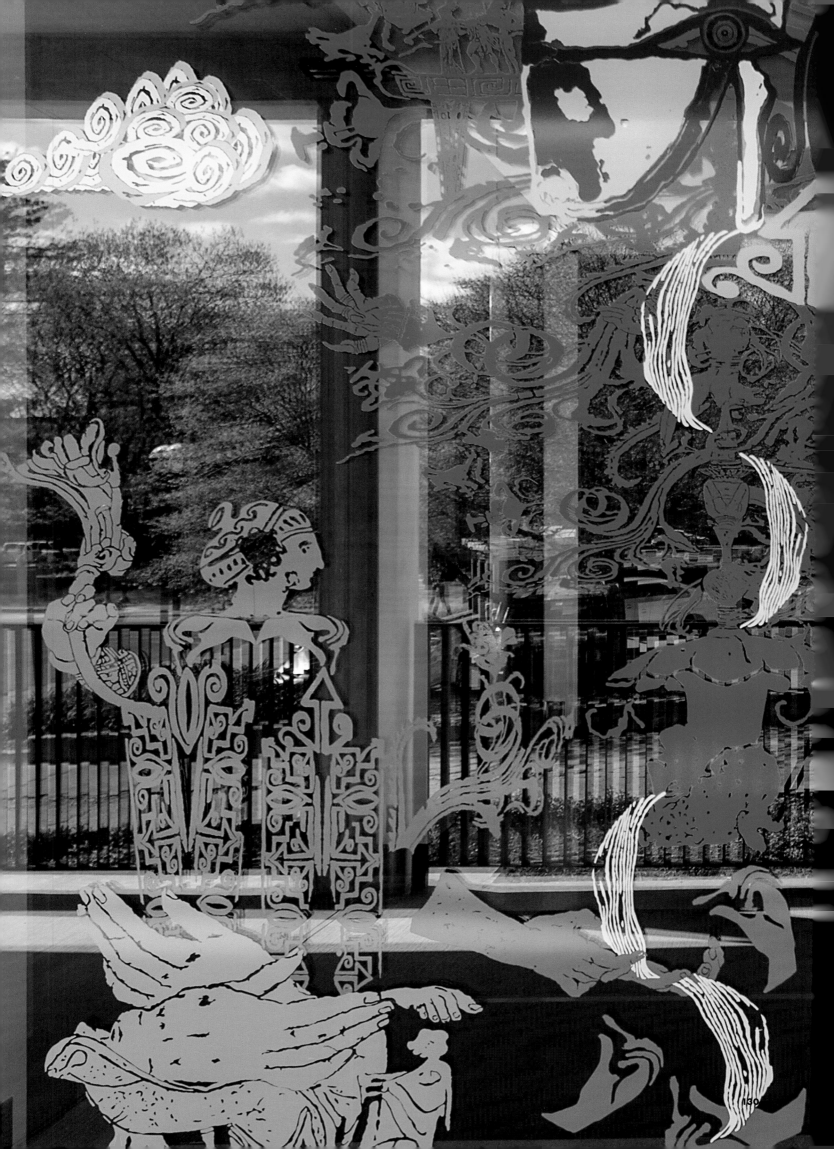

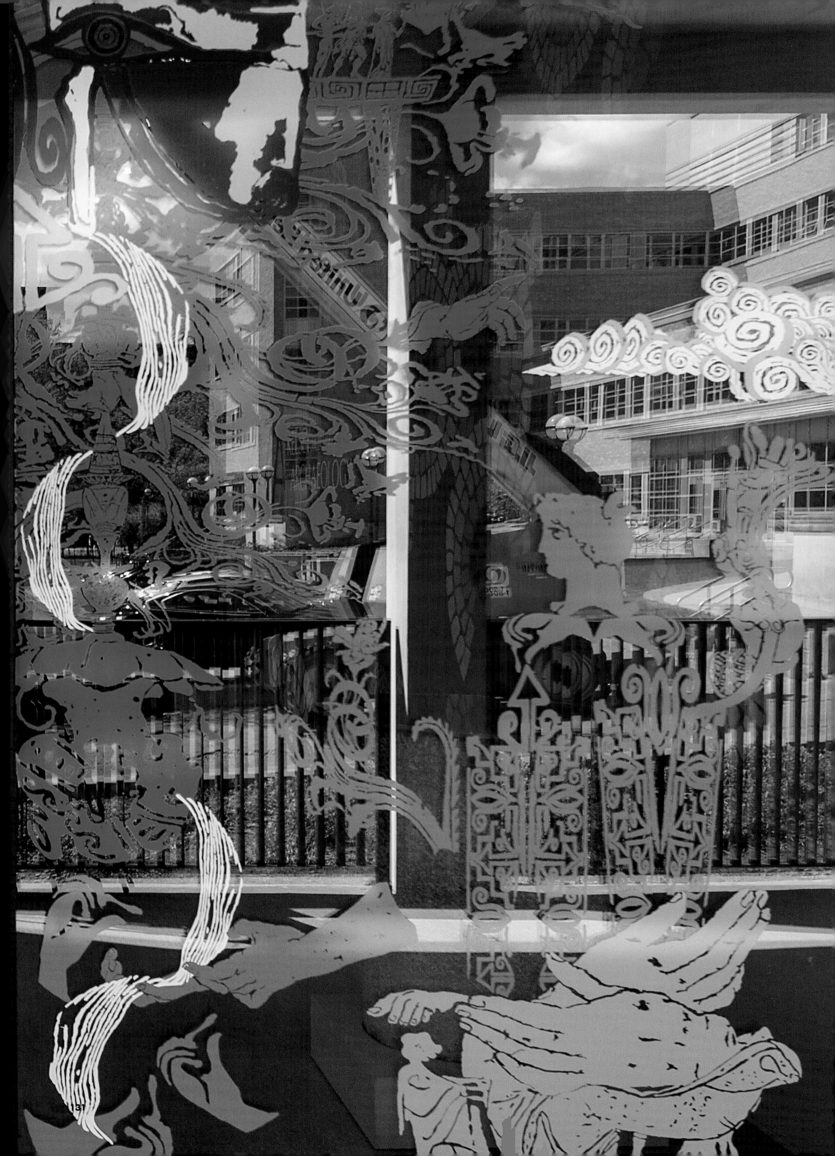

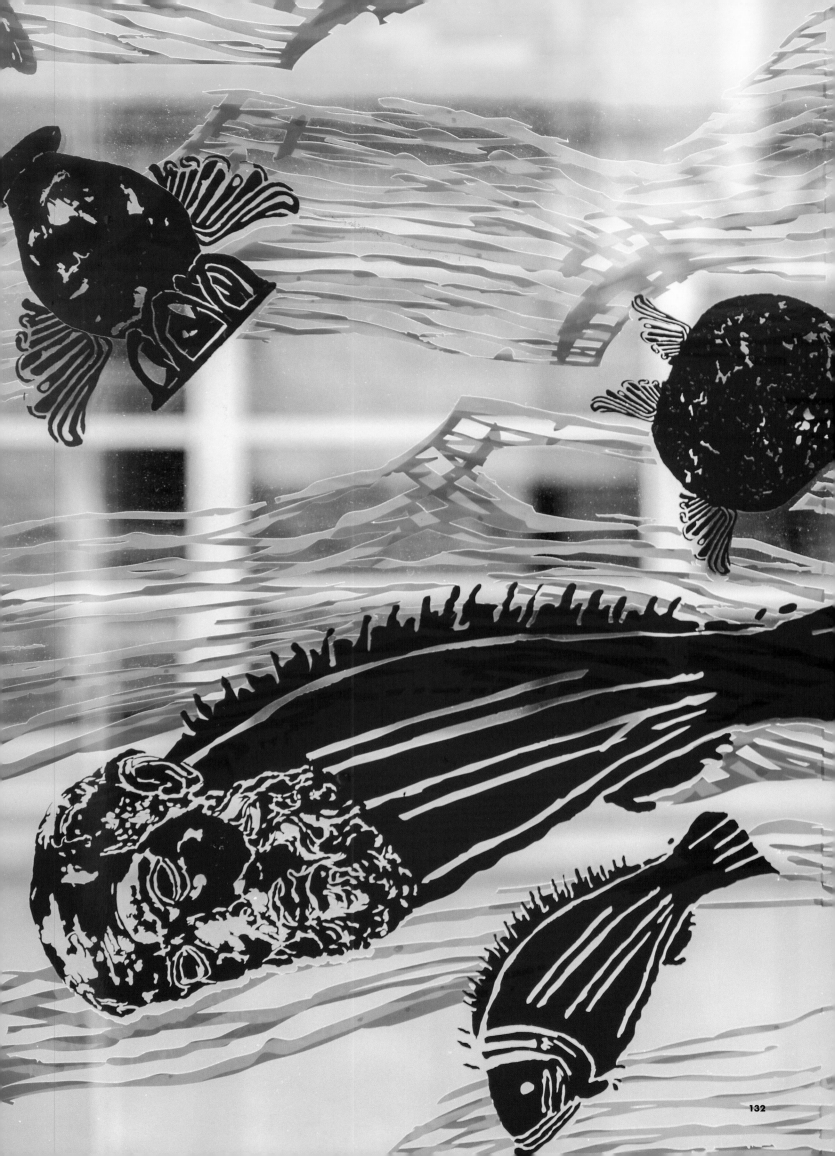

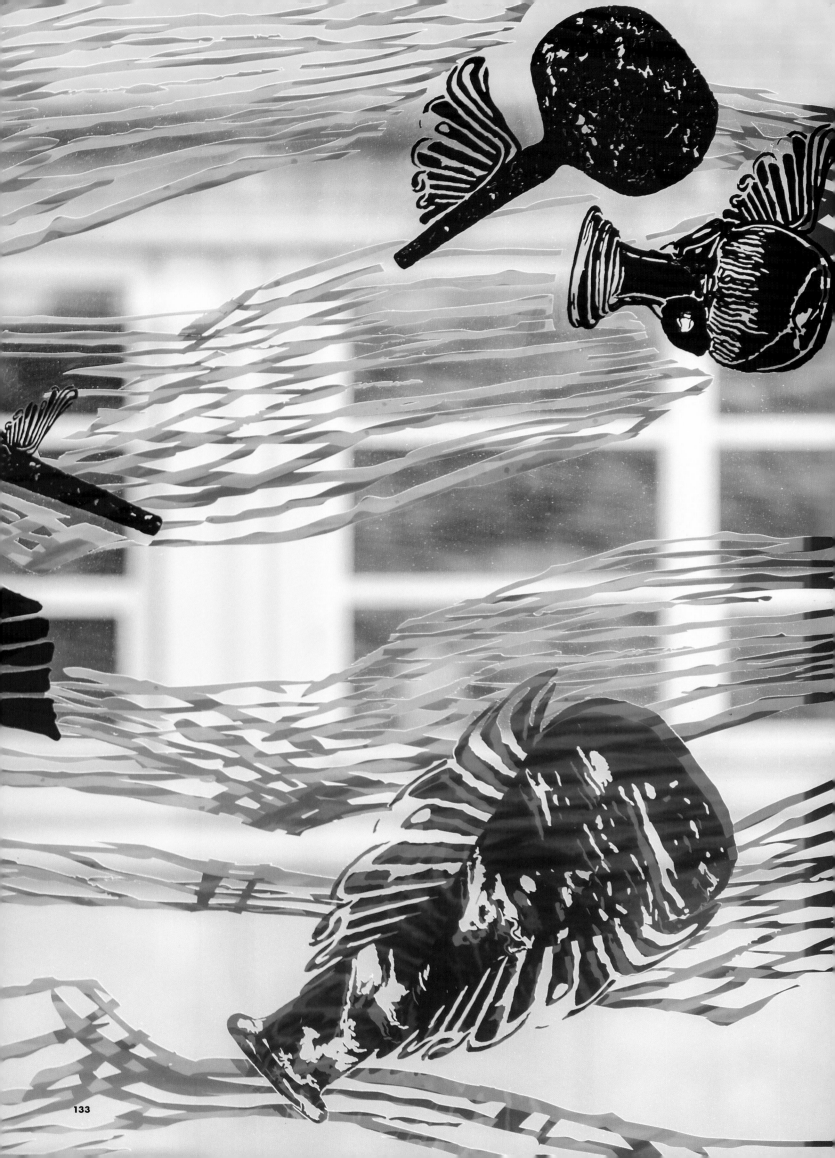

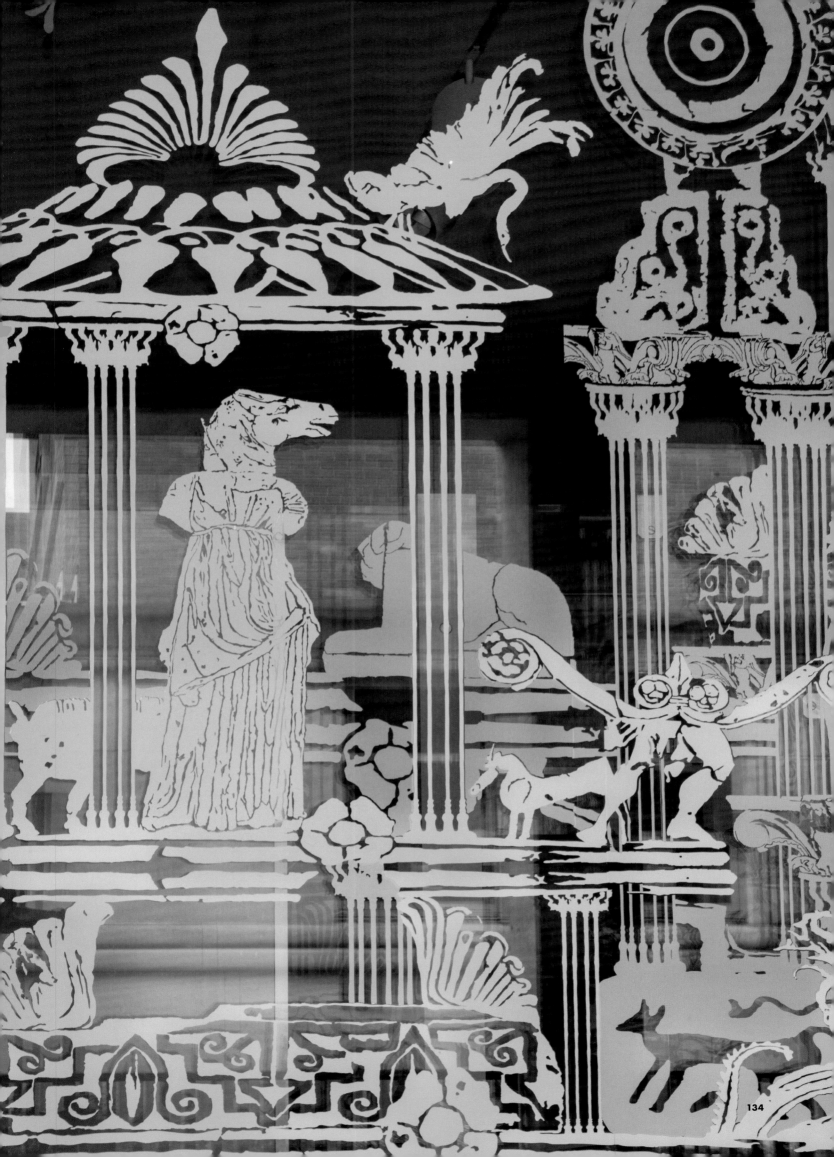

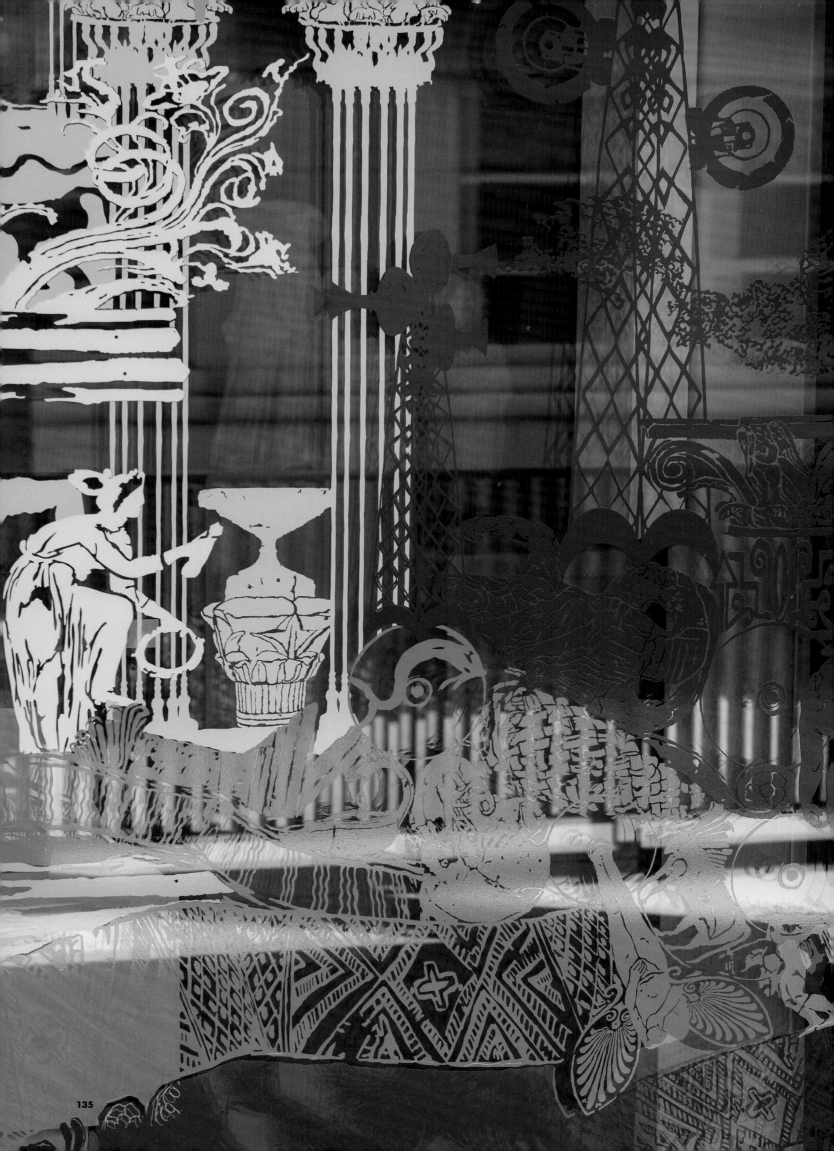

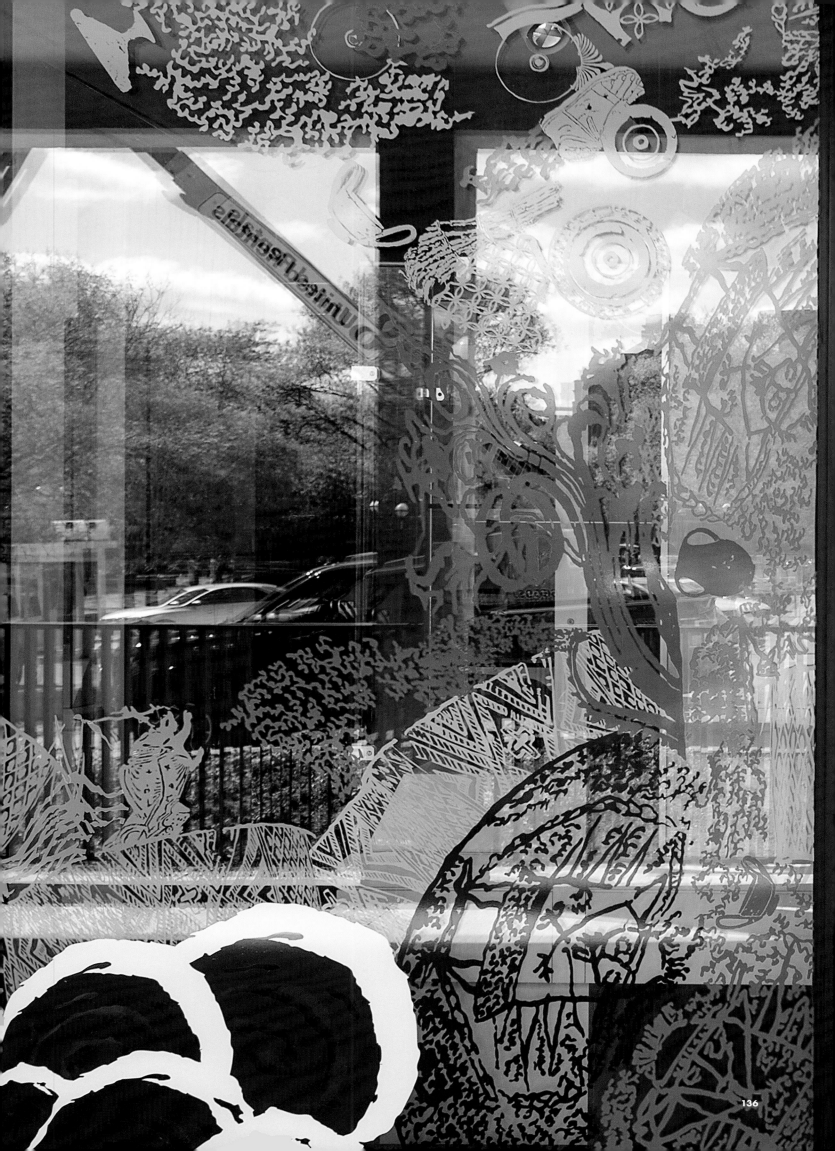

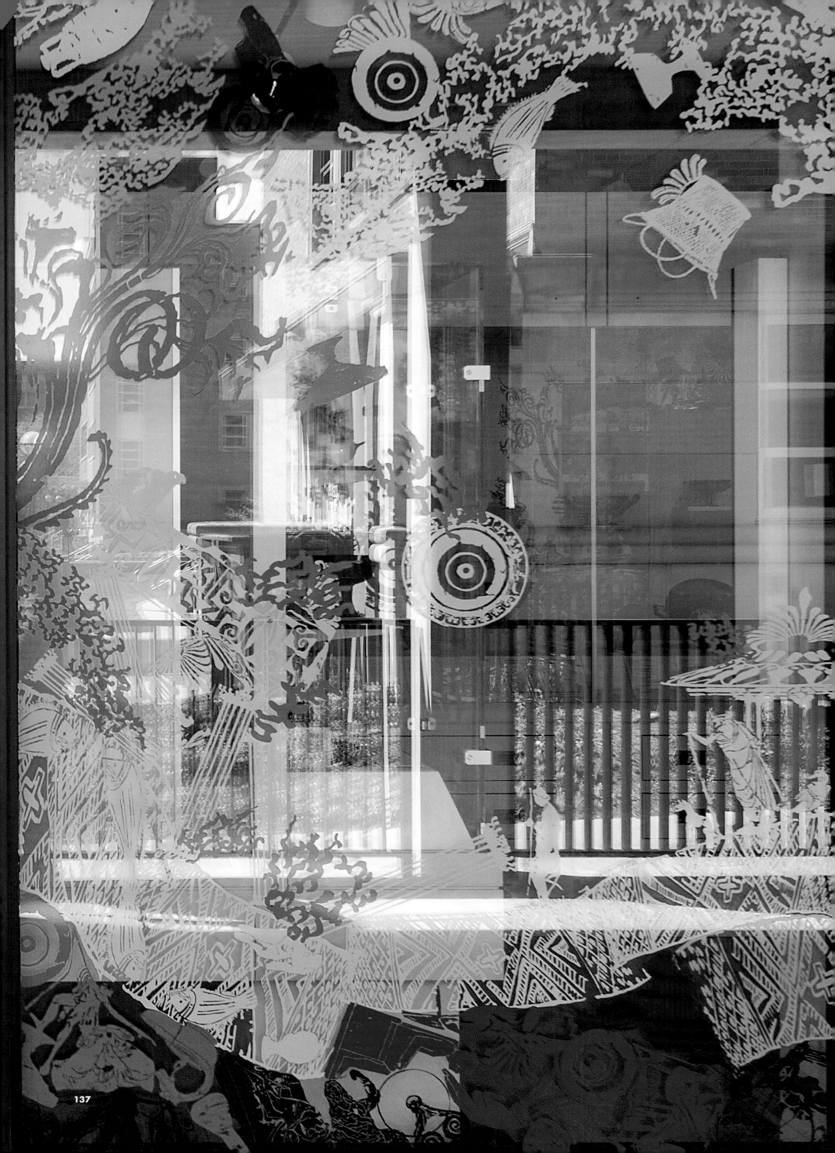

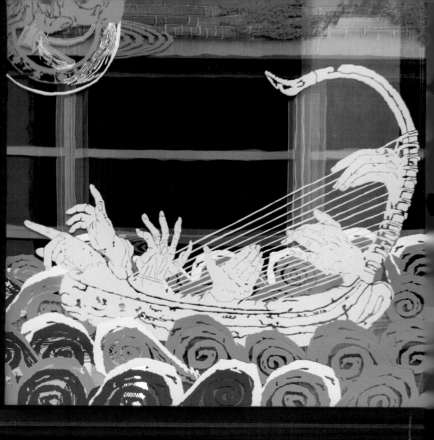
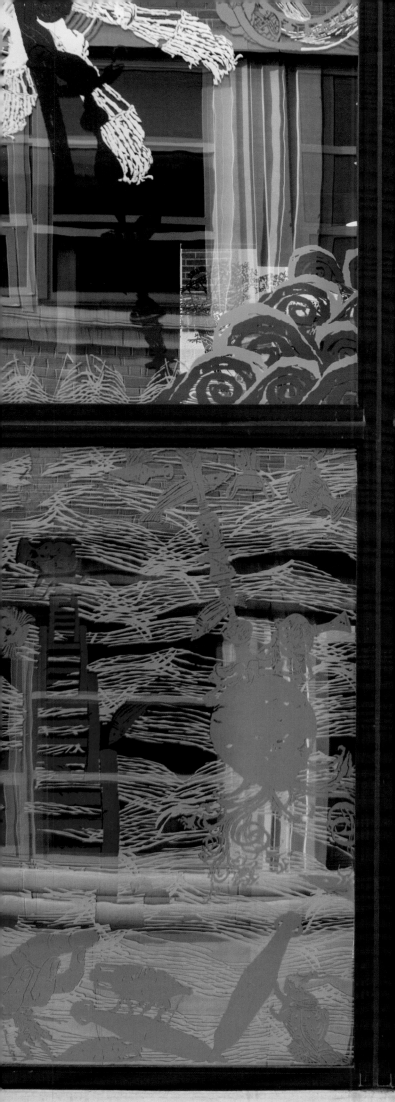
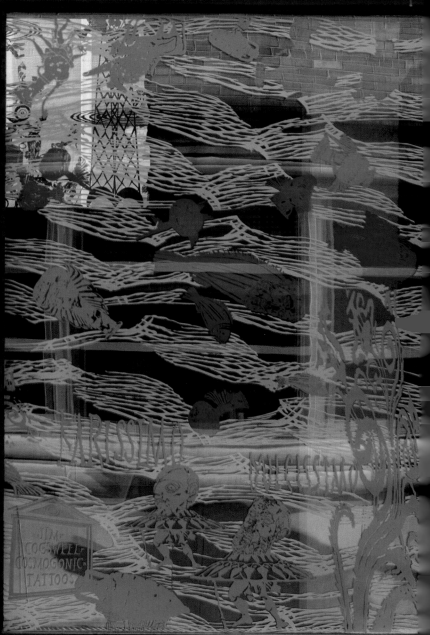

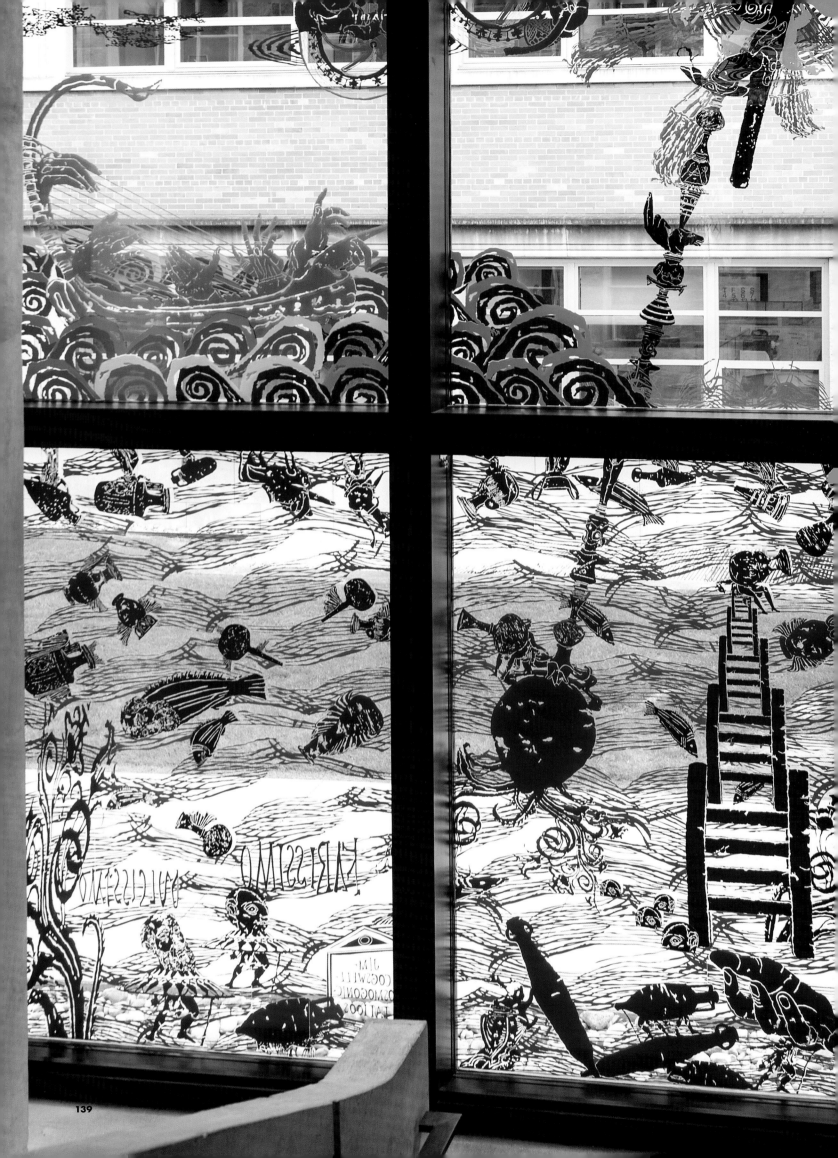

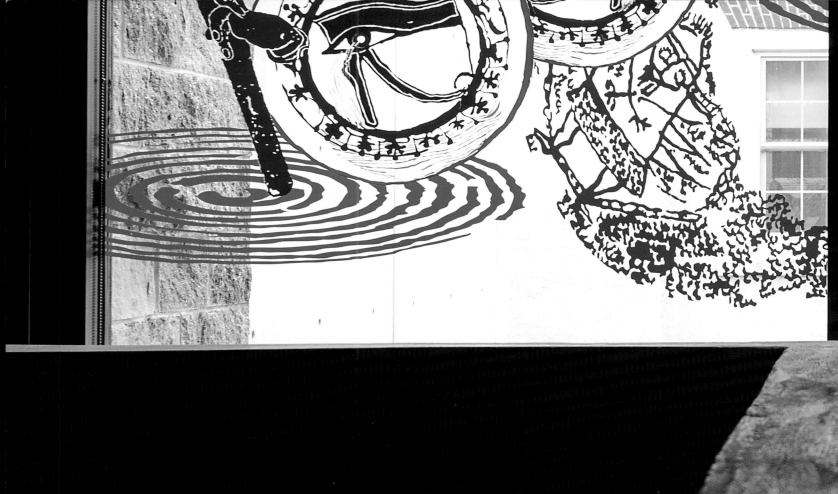

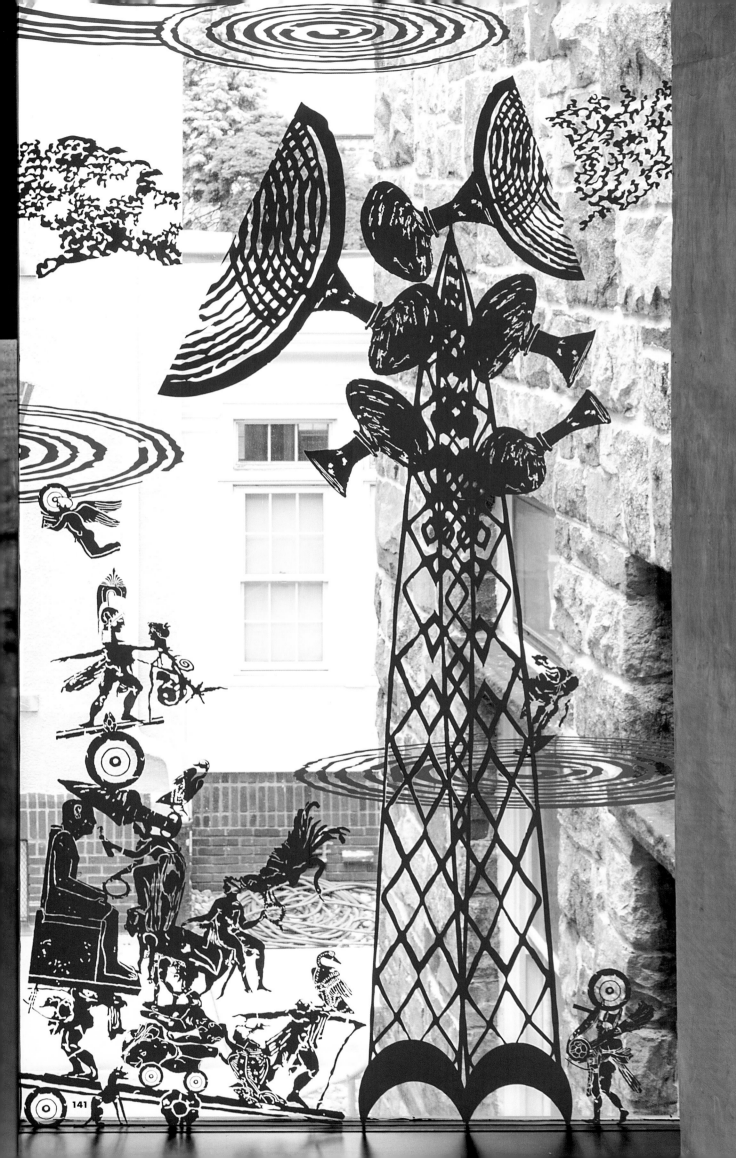

141

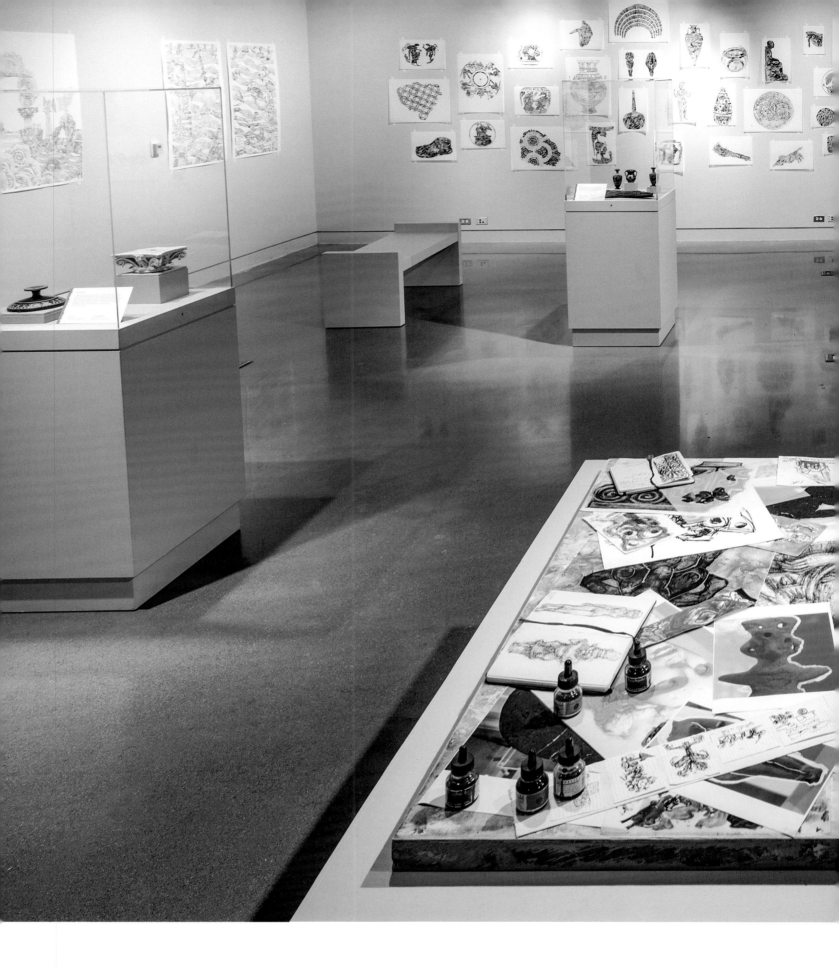

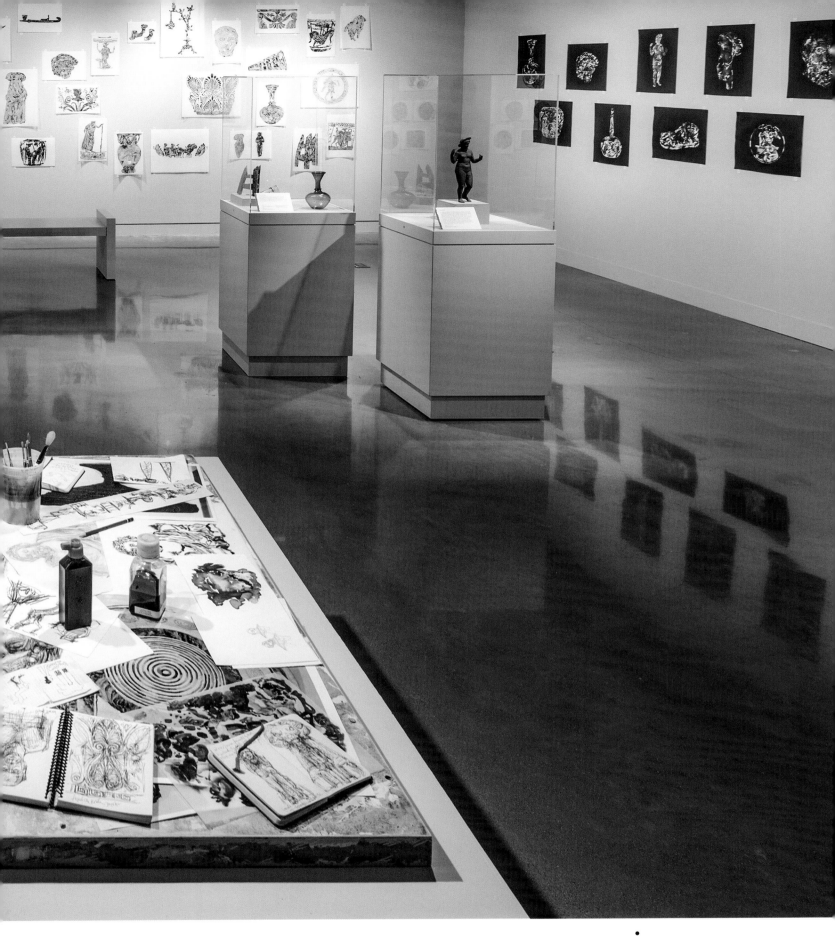

•
Exhibition in the Kelsey
Museum of Archaeology's
William E. Upjohn Exhibit
Wing of drawings and
paintings from the collections
of both museums.

Selection of Source Artifacts

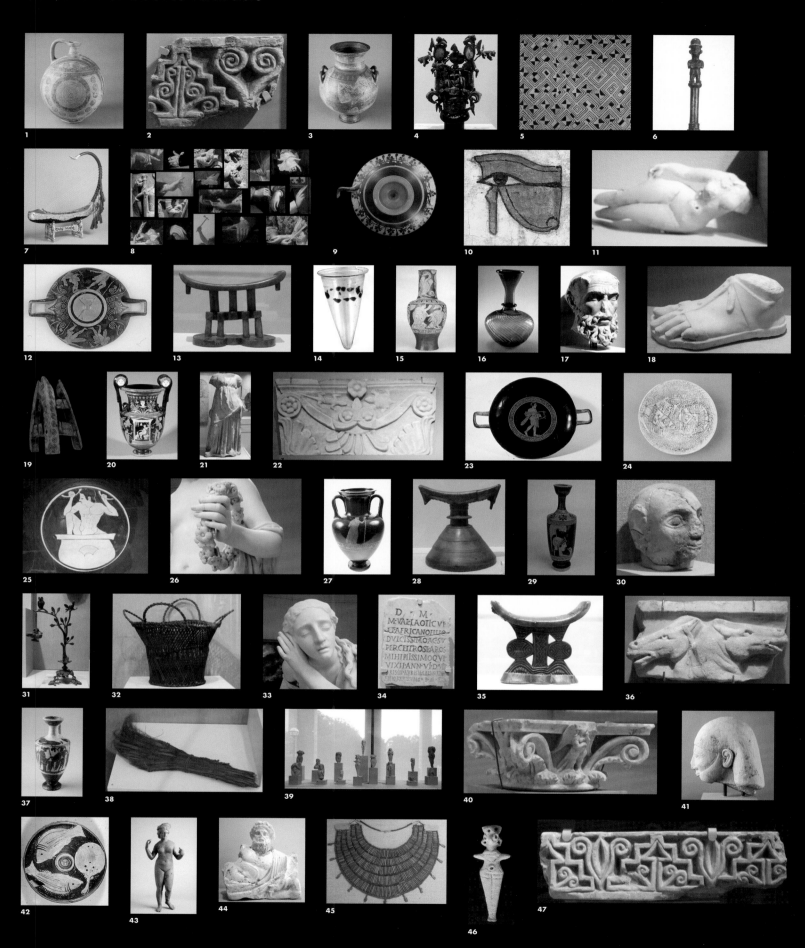

1

2

3

4

5

6

7

8

9

10

11

12

13

14

15

16

17

18

19

20

21

22

23

24

25

26

27

28

29

30

31

32

33

34

35

36

37

38

39

40

41

42

43

44

45

46

47

Kelsey Museum of Archaeology
University of Michigan Museum of Art

1 Wine jug (*oinochoe*) with handle, clay, Cypro-Archaic period (ca. 750–500 BCE) (Kelsey)

2 Horizontal frieze panel, stucco, Parthian period (248 BCE–CE 226) (Kelsey)

3 Amphora, clay, Boethian Geometric period (ca. 1000–700 BCE) (Kelsey)

4 Egúngún headdress, Erin type, Adugbologe workshop of Abeokuta, Yoruba, Nigeria, wood, mirrors, pigment, gourd, beads, metal (mid-20th c.) (UMMA)

5 Raffia textile panel, Kuba (ca. 1920) (UMMA)

6 Staff, Kongo peoples, Democratic Republic of Congo, wood (UMMA)

7 Burmese arched harp, lacquered wood, deerskin, and silk strings (post-1960) (UMMA)

8 (UMMA)
– *Parable of the Unmerciful Servant*, detail, Jan Sanders van Hemessen, oil on canvas (1548–1552)
– *Self-Portrait*, detail, Bartholomeus Bruyn the Elder, oil on canvas (c. 1520)
– *Vishnu Varaha*, detail, Central India, Madhya Pradesh, Chandella workshop, sandstone (ca. 10th c.)
– *Green Tara*, detail, India, Bihar or Bengal, black schist, Pala period (10th c.)
– *Fame and Erato*, detail, Sebastiano Conca, oil on canvas (1725)
– *M. Bachelier, Director of Customs at Lyon*, detail, Jean Baptiste Oudry, oil on canvas (1715)
– Vishnu stele, Northeastern India, Bengal, Pala or Sena workshop, black schist (10th c.)
– *Joseph Interpreting the Dreams of Pharoah's Servants*, detail, Noël Hallé, oil on canvas (1747)
– *Madonna and Child with St. Thomas Aquinas and Bishop Saint*, detail, unknown Umbrian artist, tempera and gold on panel (1475)
– *Judith with the Head of Holofernes*, detail, Gaspare Traversi, oil on canvas (1760)
– *Esther before Ahasuerus*, detail, Guercino, oil on canvas (1639)
– *Annunciation*, detail, artist unknown, Antwerp (ca. 1520)
– *M. Bachelier, Director of Customs at Lyon*, detail, Jean Baptiste Oudry, oil on canvas (1715)
– *Portrait of a Young Man Holding a Copy of Milton's Work*, detail, Ammi Phillips, oil on canvas (1823)
– *The Attack on an Emigrant Train*, detail, Charles Ferdinand Warner, oil on canvas (1856)
– *Joseph Interpreting the Dreams of Pharoah's Servants*, detail, Noël Hallé, oil on canvas (1747)
– *Portrait of a Lady*, Johann Valentin Tischbein, oil on canvas (1754)

9 Drinking cup (*kylix*) with palmette design, clay, Attic black figure (625–600 BCE)

10 Eye of Horus from the mummiform coffin of the priest Djehutymose, wood, plaster, paint, Saite period, 26th dynasty (625–580 BCE) (Kelsey)

11 Reclining nude female figure, alabaster, Parthian period (248 BCE–CE 226) (Kelsey)

12 Stemmed drinking cup (*kylix*), clay, Attic red figure (430 BCE) (Kelsey)

13 Headrest, Southwestern Shona or Tsonga peoples, wood, Mozambique, South Africa (UMMA)

14 Conical lamp, glass, Roman period (1st–4th c.) (Kelsey)

15 Wine jug (*oinochoe*), clay (4th c. BCE) (Kelsey)

16 Flask, glass, Roman period (1st–2nd c.) (Kelsey)

17 Head of Silenus or an old satyr, marble, Roman period (1st or 2nd c.) (Kelsey)

18 Foot wearing a leather shoe, marble, Roman period (1st or 2nd c.) (Kelsey)

19 Lampstand, wood, Roman period (1st–4th c.) (Kelsey)

20 Apulian volute crater, clay, red figure (ca. 340 BCE) (Kelsey)

21 Statue of a young girl, marble (late 4th c. BCE) (Kelsey)

22 Pilaster capital with turtle and salamander, marble, Roman period (1st c.) (Kelsey)

23 Stemmed drinking cup (*kylix*), clay, Attic red figure (430 BCE) (Kelsey)

24 Incantation bowl, painted clay, Parthian period (248 BCE–226 CE) (Kelsey)

25 Detail from stemmed drinking cup (*kylix*) with man pressing grapes, clay, red figure (early 5th c. BCE) (Kelsey)

26 *Flora*, detail, Richard Wright, marble (1850) (UMMA)

27 Amphora by the Berlin Painter (ca. 480–460 BCE) (Kelsey)

28 Headrest, Gurage peoples, Ethiopia, wood (UMMA)

29 Oil bottle (*lekythos*) with Athena, clay, Attic red figure (ca. 480–460 BCE) (Kelsey)

30 Head from a statue of a scribe, stone, Early Dynastic III period (2600–2350 BCE) (Kelsey)

31 Lampholder with hanging lamps, bronze, Roman period (1stc. BCE–1st c. CE) (Kelsey)

32 Basket, reed, Roman period (1st–4th c.) (Kelsey)

33 *Nydia, the Blind Girl of Pompeii*, detail, Randolph Rogers, marble (1861)

34 Young boy's funerary stele, marble, pigment, Roman period (late 2nd–early 3rd c.) (Kelsey)

35 Headrest, Central or Northern Shona peoples, Zimbabwe, wood and leather (UMMA)

36 Relief fragment of addorsed horse's heads, marble, Roman period (late 2nd–early 3rd c.) (Kelsey)

37 Shouldered oil bottle (*lekythos*) with departure scene, clay, Attic black figure (6th c. BCE) (Kelsey)

38 Broom, palm fiber, Roman period (1st–4th c.) (Kelsey)

39 Display case of clay figurines, Aegean Middle Bronze age (1900–1625 BCE), Early Dynastic period (2900–2350 BCE), and Seleucia–on–the–Tigris, Late Seleucid-Parthian periods (ca. 150 BCE–CE 226)

40 Siren capital from a miniature column, limestone, Roman period (2nd c. BCE or later) (Kelsey)

41 Male head with Egyptian hairstyle, limestone (mid-6th c. BCE) (Kelsey)

42 Fish plate, clay, red figure ware, South Italian Greek (late 4th c. BCE) (Kelsey)

43 Statue of goddess Aphrodite, bronze, Roman period (1st–4th c.) (Kelsey)

44 Personification of the Nile (Nilus), travertine, Roman period (late 2nd c.)

45 Broad collar necklace, faience, gold, reconstructed from ancient beads, Later Period to Ptolemaic (650–30 BCE) (Kelsey)

46 Bird-faced figure, clay, Aegean Middle Bronze age (1900–1625 BCE) (Kelsey)

47 Horizontal frieze panel, stucco, Parthian period (248 BCE–CE226) (Kelsey)

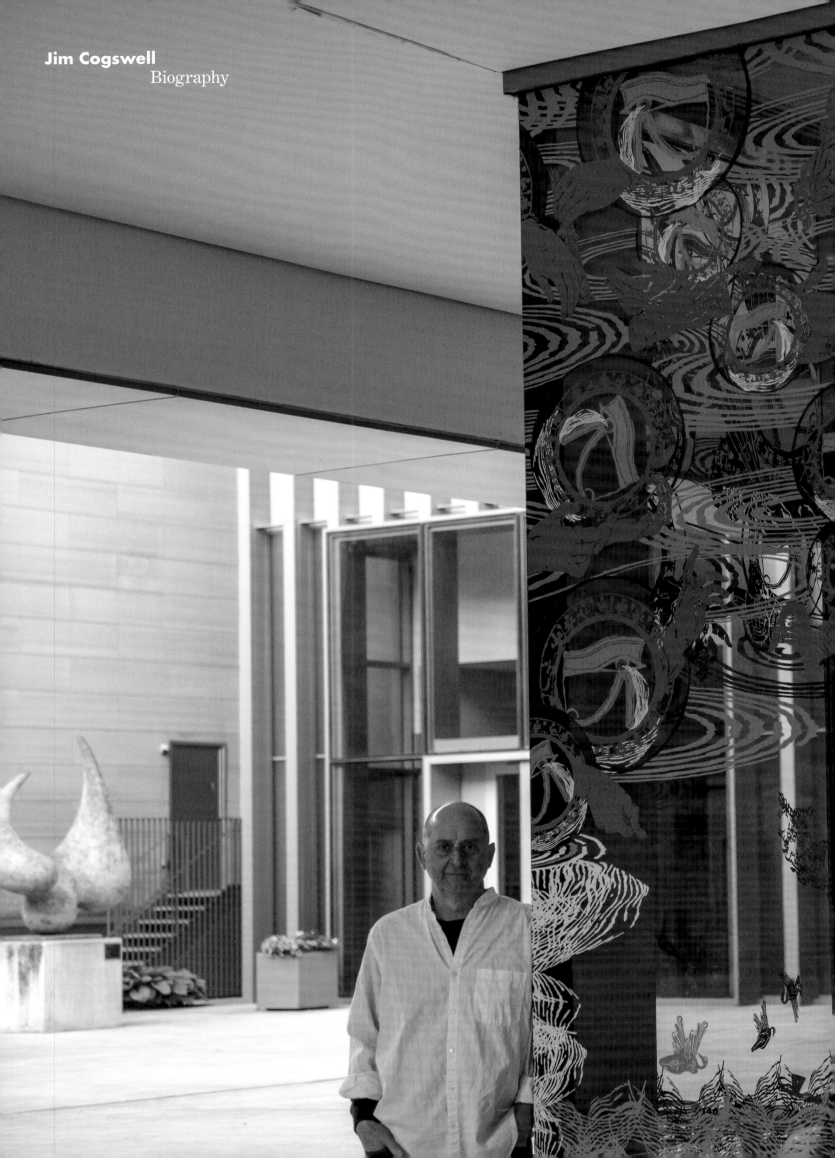

- In 1990, Jim Cogswell joined the faculty at the University of Michigan Stamps School of Art & Design, where his teaching has focused primarily on painting and drawing. He was born and raised in Japan, studying literature, philosophy, and religion as an undergraduate English major. Using painting and drawing as the knowledge base for his artistic practice, he has explored a variety of media languages in his work, using printmaking to invent an anthropomorphic alphabet, digitally translating the alphabet into rubber stamps to inscribe literary passages onto gallery walls, using those stamps to devise installations of low relief ceramic tiles exploring language and pattern, creating giant adhesive shelf paper collages based on phonetic letters and celestial maps, using painted paper plates to evoke the interstellar molecular soup and an installation of brilliantly decorated paint cans to represent an astronomical model of the birth of stars. He has collaborated with cosmologists to digitally visualize dark matter, constructed an acoustically interactive mechanized painting, and designed machine cut adhesive vinyl window murals to visually interact with architectural structures and landscape vistas.

- Attracted to interdisciplinary projects, Cogswell has collaborated in performance works, videos, and installations with poets, dancers, musicians, composers, cosmologists, astronomers, a biostatistician, a computer science engineer, and a mechanical engineer. In 1997, he collaborated with dancer/choreographer Peter Sparling to help create the stage performance *Seven Enigmas*, with contributions from biostatistician Fred Bookstein and space physics research scientist John Clarke. The stage performance *Ariel Web* (2000) was created with poet Richard Tillinghast, Peter Sparling, Fred Bookstein, and composer Andrew Mead. In 2000 he worked with dancer/choreographer Evelyn Velez-Aguayo on a new performance work in collaboration with MacArthur-prize-winning composer Bright Sheng. In 2010 he completed a set of pen and ink illustrations for U-M historian and anthropologist Tom Trautman's *A Brief History of India* (Oxford University Press). In 2014, he collaborated with cosmologist Gregory Tarlé and composer Stephen Rush to create *Jeweled Net of the Vast Invisible*, an immersive multi-media experience of dark matter.

- During the 1992–93 academic year, Cogswell was the Charles P. Brauer Faculty Fellow at the University of Michigan Institute for the Humanities. In 2000 he received the Michigan Arts Award. Throughout his career at the University of Michigan he has received numerous grants from the Office of the Vice-President for Research and the Horace P. Rackham School of Graduate Studies. In 2008 he was appointed Arthur F. Thurnau Professor in recognition of his outstanding contributions to undergraduate teaching. In 2014 he was elected a Senior Fellow in the Michigan Society of Fellows. During the 2016–17 academic year, he was again Charles P. Brauer Faculty Fellow at the University of Michigan Institute for the Humanities.

- Cogswell has had solo exhibitions at Florida State University Museum of Art, the Urban Institute for Contemporary Art in Grand Rapids, the Walton Art Center, Purdue University, the Nashville Parthenon, the Krasl Art Center, the Amarillo Art Center, the Frances Wolfson Art Gallery of Miami, the Institute for Contemporary Art in Tallahassee, and the Jacksonville Art Museum. He has lectured at colleges and universities around the country and has been invited to speak on his work at conferences in Japan, Ireland, Hungary, France, Italy, Israel, Greece, Poland, Portugal, and the UK. Cogswell's work can be found in the public collections of the Yale University Art Gallery, Yasuda Life Company of New York, Mbank of Houston, Barnett Banks of Florida, the Museum of Albuquerque, the City of Tallahassee, the Tamarind Institute, Washtenaw Community College, Valencia Community College, Florida State University, and the University of Michigan. His 11,000 square foot vinyl window mural *Enchanted Beanstalk* occupies eight floors of windows on the Mott Children's and Von Voightlander Women's Hospital at the University of Michigan Medical Center.

www.jimcogswell.com

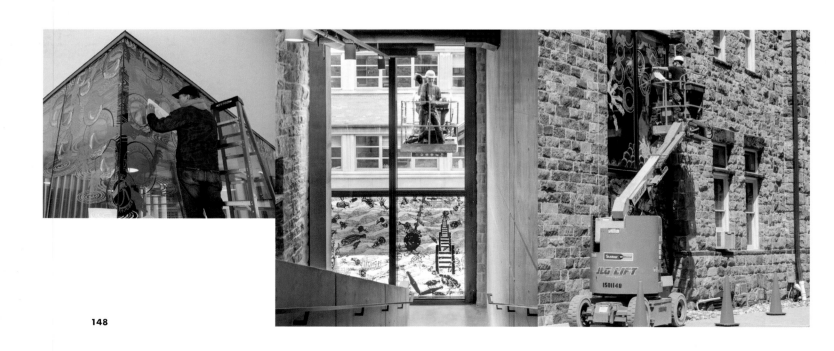